SIMON &
SCHUSTER

The Tattoo Encyclopedia

A GUIDE TO CHOOSING YOUR TATTOO

TERISA GREEN

Illustrations by Greg James

SIMON &
SCHUSTER

London · New York · Sydney · Tokyo · Singapore · Toronto · Dublin

A VIACOM COMPANY

This edition first published in Great Britain
by Simon & Schuster UK Ltd, 2003
A Viacom Company

1 3 5 7 9 10 8 6 4 2

Simon & Schuster UK Ltd
Africa House
64–78 Kingsway
London WC2B 6AH

www.simonsays.co.uk

Simon & Schuster Australia
Sydney

A CIP catalogue record for this book is available
from the British Library

ISBN 0-7432-5226-8

Printed and bound in Great Britain
by Bath Press, Bath

Contents

Introduction

Throughout the history and prehistory of the human race, stretching back thousands of years, we have deliberately and permanently marked our skins for myriad purposes: rites of passage; protection from evil; to display group identity, proof of status or wealth; medical therapy; beautification; memorial; and even to guarantee entry into the afterlife, to name only a few. Underlying most of these experiences, though, and providing a common thread among them, is the unspoken understanding that tattoos carry meaning. Sometimes it is general, as in the desire for beauty and appeal, other times specific, as in the display of familial descent. In either case, tattoos are forms of expression.

The thought that tattoo is capable of expressing so many different concepts, and is therefore a means of communication, is not a new one. Writers, observers, tattooists, and the tattooed have all remarked upon this aspect. We seem to intuitively seek something beneath the surface and behind the obvious to explain what we see. The silent exchange that takes place between the bearer and viewer of a tattoo may be one of the most interesting and important aspects of the whole process. Nevertheless, it is an aspect that receives curiously little attention over and above its mention. That light treatment may be due to the fact that much of what we understand when we see a tattoo is communicated through symbolism. By its very nature, symbolism eludes capture in so many words, while the words that we do have to offer are sometimes imprecise. Tattoo symbolism is many times not a direct expression but instead an appeal to the subconscious and intuition. It may call upon ancient forms and graphic representations that, if not ingrained in the human psyche, are at the very least everywhere present and shared across miles and millennia.

When viewed in different countries around the globe, there can be no doubt that the practice of tattooing encompasses enormous variety. De-

signs, colors, tools, circumstances, and meanings might change from country to country and even from individual to individual. A close inspection of and a thorough delving into the details of the practice reveal a sometimes overwhelming diversity. At the same time, however, there is another way to look at tattoo—from the more distant vantage point made possible by the passage of time and the accumulation of tattoo history and ethnography. When viewed from afar, quite striking similarities and patterns through both time and space become evident, which speak to a common, even fundamental, experience. Certainly not everything in the universe of tattoo warrants deep analysis or is imbued with significance. In fact, we may never understand what it meant, or means, for certain people and their cultures to be tattooed. Even today, some designs are so idiosyncratic or personal that they defy interpretation. In addition, some people simply do not ascribe symbolic content to their tattoo, nor is there any reason why they should.

However, most people and most cultures, for various reasons, do associate tattoos with some deeper meaning. They can be the outward sign of inner transformation, an appeal to the forces of luck, or a declaration of loyalty, love, or sometimes even hatred. They can be whimsical and ironic or reminders of events both grim and uplifting, but as containers of meaning, they are often rich in symbolism, providing a glimpse into our collective and varied past and the range of emotions and experiences that motivate us.

A VERY BRIEF HISTORY OF TATTOOING

Unfortunately, we don't know where tattooing originated, or when, because the historical and archaeological records of most forms of body art are incomplete. Although skeletal material may be preserved for tens of thousands of years in fossilized form, human skin survives only where intentional or accidental mummification took place. Given the simple technology required and the widespread evidence of tattooing in far-flung places, the practice probably developed independently, many times over, in many different locations, since time immemorial. We know also that, in some parts of the world, it spread amongst peoples who were in close proximity to one another. This section serves to introduce the depth and variety of this enormous subject.

The very earliest evidence of the practice of tattooing is also the most ambiguous. Artifacts recovered from archaeological sites dating from the Upper Paleolithic era (38,000 to 10,000 B.C.E.) in Europe have been interpreted as puncturing tools and pigment reservoirs. The sharp bone nee-

dles that might have been used to puncture skin could possibly have served other aims as well, such as general purpose awls. Clay and stone figurines with engraved designs that may represent tattooing have been found in association with these bone tools. It could also conceivably be the case that the bone tools were used in modeling the clay figurines. However, given the artistic elaboration and achievement that is a hallmark of the Paleolithic era (such as the well-known cave paintings of Lascaux) and the ancient roots of tattooing in many parts of the world, it is not unreasonable to speculate that Paleolithic people practiced tattooing.

Tattooed mummies provide the earliest concrete evidence of tattoo, and these have been found in various parts of the world, from Nubia to Peru. A few of the most remarkable of these tattooed people have become famous not only for their tattoos but also for the extraordinary circumstances of their discovery. Probably the most well known of these is a Bronze Age man who has come to be known as "Otzi," named for the glacial region in the Alps where he was discovered. Dating to approximately 3300 B.C.E. his skin bore clear evidence of dark blue tattoos in several locations: groups of parallel lines near the lumbar area of the spine as well as the ankles, and a cross on the inside of one knee. The purpose of these marks is unclear but it has been suggested that they may have served as ethnic markers or identifiers and, alternatively, that they may have served as therapy for maladies that left traces on his bones. From the Twenty-first Dynasty of Egypt (2160–1994 B.C.E.) comes a woman named Amunet, a priestess of the goddess Hathor at Thebes, who was tattooed with parallel lines of dots. Some of these tattoos appear on the upper arms but most appear on the abdomen, in curved and elliptical lines below the navel—a design that has been viewed as sensual.

Perhaps some of the most spectacular tattooed mummies come from the Iron Age of Siberia, from a culture known as the Pazyryk, a group of nomadic horsemen, hunters, and warriors who lived in this steppe region from the sixth to the second centuries B.C.E. In particular, a man who has been characterized as a chief, accompanied by sumptuous grave goods, was elaborately and profusely tattooed with a number of fantastic animals and also realistic ones that included rams, deer, and fish. However, some circular tattoos along his spine are strangely reminiscent of those of Otzi and may have been therapeutic in nature. The similar but separate burial of a young woman of this culture was discovered on the Siberian plateau. She was likewise accompanied by ornate items of great craftsmanship and her arms were tattooed with similar types of designs. The variety in these few early examples hints at the myriad tattoo images found today. The purposes of the tattoos, although unknown, are likely varied and at least

some of them are highly charged symbolically. While the earliest tattoos preserved on human skin are abstract designs comprised of combinations of dots and lines, the earliest representational images utilize animals. It is probably no coincidence that animal tattoos are *the* most popular type of tattoo done today. In terms of more recent evidence, we can trace the development of tattoo in nearly all regions of the world. In particular, one of the earliest and most famous encounters of Western culture with tattoo took place in Polynesia.

According to Merriam-Webster, 1777 is when the word "tattoo" entered into English usage—referring to inked images on skin—and was put into the dictionary. Although its derivation is unclear, we can trace a likely source. We know from the records of the 1769 expedition of Captain James Cook to the South Pacific that there was a Tahitian word *tatau*, which meant "to mark." However, the actual word "tattoo" existed before Cook and his voyages—about 150 years before. In an interesting coincidence, the earlier meaning of the word was "a rapid rhythmic rapping" and the term was used by military personnel (such as Cook and his crew) when referring to the call sounded before Taps. The coincidence arises from the fact that the sound made by tattooing in Tahiti was, in fact, a rapid tapping, as the set of needles, looking like a small rake, was hit with a stick to drive ink under the skin. Although the Tahitians called it *tatau* and Cook wrote "tattaw," it may be that he and his men eventually substituted a near sound-alike word from their own background. Ever since this era of early exploratory sea voyages, the practice of tattooing in Polynesia has fascinated people in the West, and justifiably so.

Many, if not most, of the island groups of the South Pacific practiced tattooing. In Hawaii, the Marquesas Islands, Samoa, Borneo, New Zealand, the Marshall Islands, Tahiti, Melanesia, Micronesia, Rapa Nui (Easter Island), Fiji, Tonga, and elsewhere, the practice of tattooing reached extraordinary heights of achievement and shared many features across these different cultures. Both archaeological and anthropological research point to early migrations from Southeast Asia (beginning at least 30,000 years ago) that dispersed into the South Pacific region and whose people likely carried the technology, ritual, and symbolic content of tattooing with them. As in the earliest evidence noted above, the artifacts in Polynesia include both decorated human figurines and tattoo tools, dated to ca. 1000 B.C.E. Today in Samoa, for example, where tattoo practices have managed to continue uninterrupted by the intrusion of European culture, the remarkable waist-to-knee tattoo of the men is still done in traditional fashion, sometimes with traditional tools (striking the back of a toothed comb to drive the inked needles under the skin). Full of social and

ritual significance and conferring both beauty and the outward sign of maturity, the process remains a harrowing one. Also in the South Pacific, Borneo is known for the Dayak rosette tattoo typically done at the front of the shoulder. Among the Dayak, some tattoos may have been linked with headhunting and other matters of spiritual significance. But perhaps the most well-known examples of tattooing in Polynesia occur in New Zealand. Maori tattooing has become famous for the *moko,* an actual carving of the skin achieved with fine chisels before applying pigment. Undoubtedly an exceedingly painful and lengthy process, it is all the more remarkable because it is placed primarily on the face. The elaborate, symmetric, and sometimes very full treatments of the face, especially for the men, are some of the most recognized types of tattoo in the world. Composed of curved lines, spirals, and other designs, there was much meaning imbedded in *moko,* only some of which is understood today. We do know, however, that it was variously a mark of distinction, a proclamation of achievement, a signal of rank, and it also showed tribal and familial memberships. As in other parts of the world, much of what was symbolized with Polynesian tattoos is both lost to time and also to the clash of different cultures and the oversight of intolerant political and religious systems. In a tiresome and frightful pattern, traditional tattooing around the world has repeatedly been victim to these forces, seemingly without exception.

The South Pacific forever changed the modern West when early explorers and sailors absorbed this part of the culture of Polynesia and brought tattooed natives and their own tattoos back with them. Of course Europe was not a stranger to the early use of tattoos, although they had faded from memory by the time of these sea adventurers. Constantine I, the first Roman emperor to profess Christianity, had banned tattooing of the face in the early fourth century because it could be interpreted as a defilement of God's image. Banning in Northern Europe occurred at the Council of Calcuth (Northumberland) in C.E. 787, and undoubtedly tattoos were discouraged in many small ways throughout the growing Christian world in an effort to discourage superstition and paganism. In their belief that tattoo was connected to ritual and symbolism, these early Christians were likely on target. The Roman historian Herodian described observations of the first century where the animal body markings of the Celts, which could have been either tattoos or paintings, were purposely left unconcealed by clothing. In fact, the people of northern Britain were called "Picts" after the display of just such images. They were even described by Julius Caesar in 55 B.C.E. in his description of the Gallic Wars. The Danes, Norse, Saxons, Gauls, and Teutons all had traditions of tattooing that focused on family and tribal symbols. Nor was tattooing un-

known in other ancient cultures on the European continent. In the Mediterranean region it was practiced in Greece (adopted from the Persians) and Rome (adopted from the Greeks). In these societies, however, the practice was associated with barbarians and tattoos were used to identify slaves, criminals, and mercenaries and also occasionally used as punishment. In fact, the Latin word used for tattoo was "stigma."

However, elsewhere in the world, particularly in the Orient, in places such as the Philippines, Burma, Thailand, Cambodia, Laos, China, and Japan, tattoo as an artistic and spiritual endeavor was pursued. In many parts of Southeast Asia, tattoos are very much bound up with religion. Thailand is noted for the practice of Buddhist monks giving and receiving tattoos, along with prayers and offerings, as talismans for a good life's journey. As a general rule, tattoos serve a similar purpose in many of these areas, that of protection. From possessing mystical powers to simply warding off bad luck, the symbols include ancient designs that are drawn from calligraphy, numerology, the world of natural animals, and that of mythical ones, such as dragons. The Ainu of western Asia and northern Japan are known for tattoos that were done around the lips, as though to exaggerate their size, but they also used tattoos on the cheeks, forehead, and eyebrows. Their purposes were many but they primarily symbolized virtue and purity while also serving cosmetic purposes and signaling sexual maturity. Tattooing in China was reserved for punishment and for a time the same was true in Japan, despite previous nonpenal use that has prehistoric roots. Ultimately, though, tattooing in Japan was raised to a lofty level of artistry, spurred on once again by influence from China.

Although abstract tattoo designs may go back as far as 10,000 B.C.E. in Japan, decorative representational tattooing may not have begun to flourish until the eighteenth century. The spectacular and sometimes nearly full-coverage tattoo known as the "body suit" originated sometime around 1700 as a reaction to strict laws concerning conspicuous displays of wealth. Because only the nobility were allowed to wear fine clothing, middle class people (generally laborers) who wanted to adorn themselves sometimes chose a tattoo. The idea of the full-body tattoo may derive from the samurai warriors' sleeveless campaign coats, which typically displayed heroic designs on the back, symbols of courage and pride, or perhaps a guardian deity or dragon. Similarly, tattoo designs began on the back and gradually extended to the shoulders, arms, thighs, and eventually the entire body. Tattooing over the entire front of the upper part of the torso, with the exception of a vertical strip running from the chest to the abdomen, gave the effect of an unbuttoned vest. The development of the body suit, though,

also coincided with the popularity of fictional tattooed heroes. At the end of the eighteenth century and the beginning of the nineteenth, an illustrated work of fiction imported from China created both unprecedented inspiration and desire for tattoos. The *Suikoden* (translated as *The Water Margin*) was a Robin Hood type of tale that recounted the exploits of 108 heroes, many of whom were tattooed. It was a tale that resonated with the repressed classes of the period, but it was not until woodblock prints of the heroes were illustrated by Utagawa Kuniyoshi and published in the early- to mid-nineteenth century that its popularity exploded. The images were extremely influential in the world of tattoo design and these original prints remain in use to this day.

In several other areas of the world, traditional tattooing is still in practice. We can point to Nepal, North Africa, India, and Jerusalem as places where traditional tattoo has been observed and recorded. In Nepal, the gods and goddesses of Hinduism are an ever-present theme, as are birds and flowers. In the Gujarat area of northwestern India, the tattoos are typically combinations of dots and symbols that form patterns designed to ensure fertility, ward off the evil eye, and offer all manner of protections. Although the Coptic church is centered in the principally Muslim country of Egypt, there are also enclaves in Jerusalem where the tradition of pilgrimage tattoos for visitors to the Holy City was already in place. Many of these designs, some with parallels in the larger body of Christian tattoo iconography, were compiled by John Carswell from the woodblock patterns of a tattooist in Jerusalem in 1956.

Evidence for the practice of tattooing in the New World is restricted almost entirely to the ethnographic reports of early explorers and the presence of some figurines whose designs resemble observed tattoos. In North America, tattooing was pervasive among indigenous peoples and carried much of the same cultural, spiritual, and symbolic significance observed in other cultures. From Virginia to California and from the Arctic to Louisiana, men and women were tattooed in every conceivable way. From representational family crests or tomahawks to abstract chin stripes and collections of dots, native peoples used tattoos to display identity and achievement, acquire spiritual strength and protection, gain entry into an afterlife, and achieve relief from physical ills. Very little of the breadth and depth of the symbolism and the meanings attached to their tattoos is left to us today. Some of the exceptions to this rule are tattoos performed in the Pacific Northwest among the Haida and Kwakiutl. In response to the native groups in Central and South America, early explorers of the 1500s were repulsed by the examples of tattooing that they discovered there, and as a result, we are unfortunately left with very little information.

Among the Aztec, the Maya, and the Inca, designs could be elaborate and apparently representational, sometimes signaling achievement but perhaps also occasionally used for penal purposes.

It was Charles Darwin, in *The Descent of Man,* who observed that "Not one great country can be named, from the polar regions in the north to New Zealand in the south, in which the aborigines do not tattoo themselves." Although more than a century has passed since these words were written, they ring more true than ever, supported by an increasing body of research, history, and interpretation. Ancient and modern peoples the world over have used tattoos as means to a seemingly infinite number of ends. Even as tattooing enjoys a modern renaissance, it is clear that we are taking part in a very long tradition, one whose origins we cannot discern exactly but whose continuation seems inevitable.

SYMBOLISM

Symbols are a profound type of expression, especially in the context of their placement on human skin and their permanence there. Appearing at times as a secret and inscrutable language, the symbols used in tattoos are instead open to investigation and interpretation on many different levels. Many have existed for centuries, others for millennia, and still others are evolving even now. Some must remain deeply mysterious to us while others seem more like signs than symbols.

Are all tattoos symbolic? The answer is plainly no. Indeed, in the more recent traditions of modern Western tattooing, both tattooists and the tattooed have tended to resist the overly philosophical or intellectual interpretation of their pursuits. From the mildly ironic to black (or gallows) humor, from the slightly lewd to the completely obscene, from the subtle and witty to the screwball, tattoo in the West has been used as a vehicle for humor, unlike most other places in the world. Perhaps because the connection with ritual and rites of passage has been lost or because tattoo was reintroduced into the West after an absence, tattoo can carry a more lighthearted content. In this milieu, tattooing can be fundamentally decorative or rebellious, going to some lengths not to take itself too seriously and glad to position itself somewhat outside the conventional. As a result, some of the tattoo images manage to capture something spontaneous. To attempt to read deep meaning into these tattoos would be to obscure their nature and to invite misinterpretation.

At the same time, we have seen that throughout history and prehistory much of the design in tattooing is quite symbolic—some designs being socially, emotionally, and even spiritually loaded. In many instances, it is

nearly impossible to separate the tattoo from the greater meaning or experience of which it is a part. However, the vast majority of tattoo images will fall into some middle area, between the extremes of sheer adornment and pointed emblem. Today, symbols and design motifs from the cultures and time periods that have come before are mixed and matched in many new ways. As our world becomes more tightly connected and cultural boundaries become more permeable, symbolic and artistic elements cross over to a much greater extent. Some of the symbols that we see, especially those that we see repeatedly, have lost meaning over time, replaced by our use of writing and the literal or our focus on the scientific and the logical. Previous civilizations used the power of symbols extensively in their art, bound up inextricably with their beliefs about monumental issues of birth, life, and death. They drew on very tangible parts of their experiences to construct symbols of great meaning to them, some of which have remained with us.

Symbols rise and fall in our consciousness and we draw upon them as needed. In the world of tattoos, symbolism still exerts a forceful hold. But because our symbols are seldom at our fingertips, the search for deeper meaning has perhaps necessarily become more purposeful and more studied. But as the increasing popularity of tattooing draws people to it, and simultaneously draws tattooing into the mainstream, there is a seemingly instinctive movement to find symbolic designs of some personal significance. The aim of this book is to open up this world of tattoo symbolism and to provide yet another way of looking at the designs that people choose for their skin.

HOW TO USE THIS BOOK

This is clearly a reference book, a source of information, regarding some 800 different tattoo symbols. In the course of selecting these designs and defining them, several types of information are combined, including data drawn from archaeology, anthropology, psychology, religious studies, history, and the experience and knowledge of professionals in the tattoo industry. The length and breadth of any definition varies but the overarching concern is to provide the type of information that might be of interest to a person who is considering a certain tattoo design for him or herself and can perhaps use the information to make a more informed judgment.

That said, in the way of a disclaimer, it is important to note that the nature of a tattoo symbol is sometimes so personal that the only definitive interpretation can come from the bearer of the tattoo. No matter the

established meaning in one culture, the obvious meaning derived from a historical fact, or the original source of a particular image, people will *and do* ascribe their own meanings to their designs. These are no less valid or meaningful than the definitions presented here, which are based on general and widely accepted knowledge. Similarly, many symbols have multiple meanings, especially across different cultures and time periods. The cautionary word, therefore, is that these definitions are not rules about how symbols should be used in tattoo imagery and they do not dictate how images can be borrowed, modified, drawn, colored, placed, or even ultimately interpreted. They are an entry point, a beginning in the search for information, an opening to a path that is meant to enable greater exploration in depth.

Many of the definitions given also provide some insight into the more general world of tattooing, in terms of geography, technique, or cultural groups, and many touch upon facts about the natural world or interesting examples of tattoo in history. Where warranted, the popularity or rarity of certain images as tattoos are noted, as well as variations on different themes. All of this additional information is meant to convey the richness of the culture of tattooing and the variety of avenues from which it can be approached and understood. While you may not be considering a tattoo for yourself, you may find your interest piqued and your curiosity satisfied.

However, if you are considering a tattoo, now is the time to expose yourself to the possibilities and gather as much information as you can. Consider each definition an introduction to research that can take you places and down paths that you may not expect to go. It is overwhelming at first, and maybe even a bit confusing, but that is the nature of the universe of tattoo. More than likely you will eventually find yourself returning over and over to images, symbols, and concepts that resonate with you. The organization of the book is meant to facilitate that process. Of course, the bulk of material consists of the alphabetical entries with selected illustrations. Where words used in a definition appear in bold, those words can also be found as their own entry. The category index at the end of the entry section groups tattoo symbols together under various headings, such as Celtic or Buddhist, for easy reference.

Basically, make this book work for you. Tattooists today will tell you that *everybody* ascribes meaning to their chosen tattoo, especially after having it done. Be someone who thinks about it beforehand, because, to put it simply, tattooing is always deeper than skin.

ACORN

The tiny acorn is an ancient representation of life and birth. In a literal sense, it is a seed that eventually grows into the mighty **OAK TREE**. In Scandinavia it was sacred to **THOR** and was used as a symbol of fertility and immortality. In an allegorical sense, it is unborn power and fruitfulness waiting to be released.

AEGISHJALMAR

An *aegishjalmar* can take on many different forms, but in general each is composed of the same small building blocks of ancient Norse **RUNES**. They begin with a simple cross in the middle and grow from there. Frequently they are used as talismans or protective devices. However, it is actually impossible to tell the meaning of any particular one, since the small runes serve general functions—such as collecting energy or routing it from one place to another. Only the person who creates each new *aegishjalmar*, giving it a certain purpose upon creation, can ever truly say what it means.

ALCOHOL

An integral part of the famous **MAN'S RUIN** tattoo, alcohol is certainly capable of standing on its own as a tattoo symbol. The particular spirits may

vary from a generic pint of beer to a favorite or well-known brand of whiskey. The theme of the design is equally hard to predict. Alcohol can represent good times, release, and celebration. Just as often, though, tattoo symbolism with alcohol revolves around its addictive aspects. Bottles that hang like an intravenous drip or that possess some demonic personality are all part of the repertoire. In the pictured example, a 40-proof bottle is marked not only with the **xxx** but also the **SKULL AND CROSSBONES** of death and poison. But it also rests on the pure **LOTUS** and is surrounded by the type of **MANDORLA** typically reserved for the **VIRGIN MARY OF GUADALUPE.** Whether we revere or revile it, alcohol seems destined to remain a notable feature of tattoo symbolism.

ALIEN HEAD

The alien head has become an icon in American pop culture that probably originated in the 1950s around the time of the Area 51 incident (the alleged site of a **UFO** crash, disclaimed by the **U.S. AIR FORCE** as a weather balloon). The head is shaped roughly like an inverted teardrop with two large, black, oval eyes. It has come to stand for the existence of UFOs, aliens, and extraterrestrial life. In tattoo art, the alien head is sometimes also accompanied by full alien body depictions and entire otherworldly scenes as well.

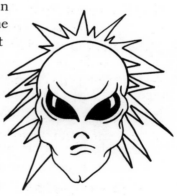

ALLIGATOR

The symbolism of the alligator tattoo will, of course, vary from person to person but the well-known qualities of the animal serve as a general indicator. In the West, the alligator symbolizes aggression, sometimes to the point of killing without feeling. In China, though, the alligator is the inventor of the drum and of singing and may have even inspired the imperial dragon.

ALL-SEEING EYE

The all-seeing eye, a human eye surrounded by radiating beams of light, is found in many cultures and time periods and is designed in many ways in tattoo art. The eye is almost universally taken as a symbol of perception, not just in the physical sense, but in terms of spiritual vision and insight. Most often, the all-seeing eye is a watchful charm to ward off evil, alert but serene. It is also reminiscent of the third-eye concept, such as that on SHIVA'S forehead, where it unifies perception of many different dimensions.

ALPHA AND OMEGA

In a literal sense, the two Greek letters alpha and OMEGA are simply the first and last letters of the Greek alphabet. But when JESUS utters them in reference to himself, they take on a completely different meaning. "I am the Alpha and the Omega, the First and the Last, the Beginning and the End" (Revelation 22:13). In Revelation, the final BOOK of the Bible, prophetic visions of the end of the world and the second coming abound, and it is in these passages where the phrase "Alpha and Omega" is found. More than just an intimation of the eternal nature of Christ, the letters have also come to signify his completeness and promise to return.

ALPHA MU OMEGA

In a wordplay with the symbol of ALPHA AND OMEGA, the addition of the mu changes the three letters into an acronym for three Greek words meaning "yesterday, today, and forever," with an emphasis on the presence of God in the here and now.

AMAZONS

In Greek legend, the Amazons were a race of women warriors with whom various Greek heroes often had violent contact. Typically they were

armed with various weapons such as a bow, **SPEAR**, double **AX**, half-**SHIELD**, and sometimes a helmet. Their modern symbolism is thus a direct referent to their strength, courage, independence, and also their higher aspirations of sisterhood. Not surprisingly, their symbolism has been adopted by lesbians, for all of these reasons. The double ax, or **LABRYS**, is today a popular symbol of the lesbian community.

AMEN

Sometimes said at the end of a prayer or as an expression of approval or agreement, the word "amen" appears in both Greek and Hebrew. But in either context, it carries a sense of solemnity, rather than just affirmation. In a very fundamental and yet nonliteral way, it is ultimately an expression of faith. Typically this tattoo is done with a lettering style that expresses something earnest, although it can be simple and cursive or ornate and Gothic.

AMULET

An amulet can be any type of charm or talisman that is worn for protection from harm (or to bring good fortune) and it has taken many forms throughout time, including the tattoo. From the **VENUS** figurines of Neanderthal man, the **SCARAB** of ancient Egypt, or the **ZUNI FETISH**, to painted and tattooed images of numerous magic symbols, verses of sacred text, or the modern-day lucky **RABBIT**'s foot, amulets take on special meaning to the bearer. They actually become something that embodies the power that they symbolize, whether they are worn in life or death. The immediacy, permanence, and physical closeness of tattooed amulets make them a special class—a symbol that cannot be accidentally lost, a protection that is always present, and power that is constantly in one's possession.

AMUN

Also known as Amon, Amen, or Ammon, this Egyptian god is "The Hidden One," one of the primordial and most ancient of the gods, who was the driving force behind the wind and the air. However, he also became known as the king of the gods, the supreme ruler, during the New Kingdom. Sometimes he is given a **RAM'S** head or is shown as a complete ram.

More familiar, though, is his depiction as a bearded man with a tall, double-plumed headdress. Occasionally his image is painted blue, to show his invisibility. Over the centuries, he came to symbolize knowledge, impartiality, and rulership—the actual physical father of all pharaohs. Indeed, one of the most famous of the pharaohs had his name changed to Tutankhamen (which means "the living image of Amen") in order to show his connection to this symbol of traditional kingship.

ANARCHY

The anarchy movement ranges from groups and individuals who wish to peacefully establish local self-government cooperatives to those who violently lash out at any government. The symbol of a capital "A" inside a CIRCLE is more likely to be used in some type of antigovernment vein than in the infrequent usage it receives from white supremacists. Its origin as a symbol is fairly modern, perhaps going back to its use in the Spanish Civil War (1936–1939). However, the symbol took hold in a much wider community when it was adopted after the 1968 general strike in France. The fact that in many of the world's languages the word for anarchy begins with the letter "A" and the direct and simple appeal of the circle used as a framing element has helped to keep this symbol in use.

ANCHOR

The anchor is one of a handful of symbols in the tattoo world that has remained both popular and true to its origins. The bearer of the anchor is likely a seafarer of some type—traditionally military (Navy, Marines, or Coast Guard) but sometimes recreational or commercial. In maritime lore, the tattooed anchor showed that a seaman had sailed the Atlantic Ocean. In ancient times among Mediterranean seafarers, the anchor symbolized the sea gods. In early Christianity, the anchor (with horizontal tie bar under the ring) was used as a covert symbol by virtue of its resemblance to a cross. Many times the anchor is combined with other symbols that elaborate something more specific—various creatures of the sea, ships, life

preservers, names of ports. In general, though, it guarantees stability and security in the physical world and, by extension, steadfastness, hope, and trust in the spiritual world.

ANCHOR CROSS

The anchor cross, also known as the cross of hope, and the *crux dissimulata* (the disguised or dissimilar cross), was a Christian symbol of hope during the time of persecution under the Roman Empire.
In Rome, during the third century, Christians were persecuted to such an extent that they dared not use the cross as their symbol for fear of exposure. The *crux dissimulata* was created with the intention that a non-Christian would not be able to recognize it as a Christian or church symbol or object of worship. Not surprisingly, Christ himself is seen by these early Christians as the "hope we have as an anchor of the soul, both sincere and steadfast" (Hebrews 6:19). This cross was also the emblem of St. Clement, Bishop of Rome (the first pope to succeed Saint Peter), who, according to lore, was tied to an anchor of iron and tossed into the sea at the order of the emperor Trajan.

ANGEL

An angel, in virtually any culture or time period, represents benevolent spirituality. Angel tattoos sometimes take the form of innocent **CHERUBS** or righteous avengers, but most frequently they are illustrated as gentle guardians, guides, and personal protectors. The word itself comes from the Greek word for "messenger," and angels are most frequently described as intermediaries between the supernatural world and the world of mankind. In some religions, angels are ranked, categorized by specific characteristics, and even personally named (**ARCHANGEL MICHAEL**). But in general, their existence in these religious systems implies a belief in a certain spiritual order—one in which humans have their place.

Indeed, much of what angels do, even in tattoo symbolism, centers around their relationship to humans. While their activities are not unlike ours (such as playing music, as in this example), their actions remain at some sublime level—a level for which mankind longs.

ANGEL OF NO MAN'S LAND

The Angel of No Man's Land, sometimes also known as the "ROSE OF NO MAN'S LAND," is a military field nurse. Originating from the nickname "angel of mercy," the Red Cross nurses of World War I (for example, Florence Nightingale, "the lady with the lamp") were actually memorialized in a song titled "The Rose of No Man's Land." The two images of ROSE and ANGEL are combined in tattoo art that was popular during both World Wars I and II. Soldiers remembered their nurses by getting tattoos that showed these compassionate women wearing a traditional white nurse's cap with red cross, sometimes with a rose as a backdrop and also with American FLAGS or patriotic bunting. At times these nurses risked their lives to tend to wounded men and, at the very least, they offered kindness to soldiers who were far from home.

ANGEL OF THE APOCALYPSE

The Coptic church, which originated and is still based mostly in Egypt, is the principal Christian church in that predominantly Muslim country. In addition, there is a Coptic Orthodox church in Jerusalem, and a few other churches in the Holy Land, built in the nineteenth and twentieth centuries, as well as a Coptic bishopric in Khartoum, Sudan. The Coptic tattoos that come down to us today are those recorded by John Carswell in 1956 in Jerusalem and were principally done for Christian pilgrims to that city, reflecting a centuries-old practice there. This particular design shows the Angel of the Apocalypse or the Angel of Judgment. The winged angel with a ray HALO wears a pleated tunic, belted at the waist,

and pointed boots. He holds the SCALES OF JUSTICE in his right hand and a SWORD in his left. Per Revelation 10:1–10, the ANGEL stands on the earth. Unlike the benevolent angels so prevalent in Western art, this angel is rendering the last judgment of all souls at the end of the world.

ANKH

This ancient Egyptian HIEROGLYPH is an example of a symbol that has completely transcended its culture and yet is uniquely associated with it. It was probably in use as early as 3000 B.C.E., a symbol associated with Imkotep, physician for the pharaoh's family, who later became a god of medicine and healing. Also known as the staff sign, the key of life, the key of the Nile, and the symbol for sexual union and for life, the ankh was associated with the Egyptian goddess Hathor and even with Christ as a symbol of eternal life. Part of its enormous appeal is the expression of opposites in its composition, as well as the active and passive qualities of the loop over the cross. Both the gods and recently dead of ancient Egypt are shown grasping it by the loop, sometimes upside down, using it as a key. In all its basic uses it is fundamentally a sign of life that is unending.

ANNUNCIATION

In the Coptic pilgrimage tradition (see ANGEL OF THE APOCA-LYPSE for more details), the Annunciation tattoo shows the VIRGIN MARY with hands clasped and head bowed and an ANGEL nearby or descending. It depicts the moment when the angel Gabriel announces to Mary that she will conceive a Son of the Holy Spirit (represented by the DOVE with a ray HALO) to be called JESUS (Luke 1:26–38). Although less used today, the Annunciation once had a more important place in early Christian art, largely because it depicts an event that is the prelude to the redemption of the world.

ANT

The ant is associated with industriousness, both in the East and the West, but an industriousness that can be extreme. While in the West the ant is

sometimes seen as selfishly greedy, in Tibetan Buddhism it is excessively attached to the good things of this life. Even a casual observation of this busy insect reveals that, although tiny, it is continuously working and lends itself to symbolize active and diligent engagement in this world, energy, and teamwork.

ANTLERS

While antlers may not ever be seen as a lone design element in any tattoo, they do appear in noteworthy contexts as part of other designs. For example, the **SHAMAN** in many preliterate societies wears a headdress decorated with antlers. In fact, the so-called "Sorcerer" of the Paleolithic cave art of Trois Freres is a famous example (which itself has been used for tattoo art). It is possible that antler headdresses and masks were worn during ritual dances and performances. In most any context, the attachment of antlers is likely a link with wild beasts and a symbol of power.

ANUBIS

Sometimes also referred to as the Egyptian jackal-headed god, Anubis was the god of the dead and of mummification. He presided over the embalming process and the judgment of the dead, monitoring the Scales of Truth to protect them from deception and eternal death. This god of embalming may be associated with the **JACKAL** not only because it was an animal of intelligence but also because it would not have been unusual to have seen the jackal roaming cemetery and tomb areas in Egypt. In worshipping Anubis, Egyptians transformed their desire to keep the bodies of the deceased safe into a desire for the preservation of the body for eternity.

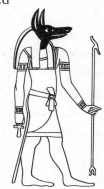

APPLE

In the West, the apple has long been associated with something desirable and yet forbidden. It is the fruit of the Tree of the Knowledge of Good and Evil in the Garden of Eden (and therefore also associated with temptation); it is a source of immortality when Hercules retrieves it from Hesperides; and it is even used by Solomon as the image of the sweetness of

the Word of God. In China, the words for "apple" and "peace" (*p'ing*) sound alike. Even the shape of the apple, with its near spherical symmetry, has been used as a sign for the world rule of emperors and kings as they hold an "imperial apple" along with their scepter. For the Celts, the apple is the fruit of knowledge, but also of magic and prophecy. In the legends of Celtic Britain, Avalon (Appleland) is a symbol for divine joy. Indeed, nearly every Neolithic or Bronze Age paradise of which we know was made of orchards that contained apples.

AQUARIUS

Aquarius (January 20–February 18) is the eleventh sign of the ZODIAC. Symbolized by a pair of undulating or zigzag horizontal lines representing WATER, the image for the astrological sign is also sometimes a man pouring water out of an URN. While all the astrological signs have certain psychological and behavioral associations for people born during their intervals (for example, Aquarians might be characterized as sociable, intelligent, and humanis-

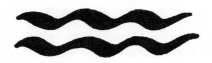

tic to the extremes of superficiality, dissociation, and imitative behavior), the sign of Aquarius has also become a symbol of the New Age movement and humanitarianism. That association might be derived from the water that Aquarius pours over the earth—interpreted as the water of awareness.

ARAI TE URU

Arai Te Uru is the name of the Maori sea god who protected the canoe that brought the ancestors of the modern Maori to *Aotearoa* (New Zealand). It is one of five *taniwha*, a group of mythical monsters or dragons. Although given different forms by various artists, they are generally conceived as serpentlike and sinuous, abstract to the point where they may not resemble an actual animal.

ARCHANGEL

The archangel is one of the many categories of ANGELS in the major Western religions (Judaism, Christianity, and Islam). They are chiefs and even

princes in the heavenly hierarchy. In both the Old and New Test.
the archangels number seven: Uriel, Raphael, Raguel, Michael, ⌐
Gabriel, and Remiel. Frequently in artwork they are depicted as emitung
holy power, wearing more elaborate clothing than ordinary angels, and
sometimes performing their specific roles (see **ARCHANGEL MICHAEL**).

ARCHANGEL MICHAEL

Representations of Michael, one of the seven **ARCHANGELS**, capitalize on
his warrior nature. His holy soldier imagery is derived from Christian sto-
ries where Michael either contends with the **DEVIL** or
where he and his angels fight against a dragon (who
represents the Devil). In the early Christian church,
Michael came to be seen as the helper of the church's
actual armies against the heathens. Probably the most
illustrated of the angels, he is usually shown with a
sword, wearing armor, and in combat with or triumph
over a dragon or Satan (from the story in the Book of
Revelation). Of course his angelic qualities are also em-
phasized with outspread wings and ray **HALOS**. His conquering of the foe is
a powerful symbol of the triumph of good over evil, of right over wrong,
and of our higher natures over our lower.

ARIES

Aries (March 21–April 20) is the first sign of the **ZODIAC** and corresponds to
the ascent of the sun and the emergence of spring in the northern hemi-
sphere. The depiction, which almost looks like
a sprouting weed, also symbolizes the curv-
ing horns of the **RAM**, and it is most defi-
nitely a "positive," or male, sign. Also
associated with the red planet of Mars and
the element of fire, and people born during its
astrological interval are, not surprisingly, given psycho-
logical traits connected with these images. Arians are
seen as courageous, energetic, direct in approach, and
freedom-loving, sometimes to the point of being selfish, quick-tempered,
and impatient.

ARMADILLO

Adopted as the official "small mammal" of the state of Texas in 1995, the armadillo is known for the nine-banded shield of its back, made up of overlapping bony plates. When attacked, it can roll itself up into a ball to protect its vulnerable undersides. It is a desert animal that has come to be associated not only with Texas but with the American Southwest in general, and it represents survival and toughness in that grueling environment.

ARROW

The arrow is one of the oldest, simplest, and most common symbols. Like other fundamental symbols, the range of meanings that it can take is very broad and actually tends to be contradictory at times. It has come to be associated with the male sex, lightning, weapons, swiftness, love, intuition, and sudden death. It is a symbol that has also been usurped by numerous disciplines, signaling an exponent in mathematics and a center of gravity in physics. Its appeal is direct in the sense that it can be used alone or in connection with other symbols to construct more complicated meanings. One well-known tattoo symbol—the **PIERCED HEART**—is a fine example of this type of usage.

ARYAN BROTHERHOOD

The letters "AB" stand for the Aryan Brotherhood, a prison gang that originated in 1967 at San Quentin prison, in California. It is essentially a gang that espouses white supremacist ideology. Tattoos are varied and may include **DAGGERS, HEARTS,** and/or **RIBBONS** that spell out their beliefs such as "white pride," or that identify their state of origin.

ASO

The Dayak are the indigenous people of Borneo, an island that is part of the Malay Archipelago (southwest of the Philippines near Indonesia). As with tattooing techniques found throughout Polynesia, tattooing techniques in Borneo are likely also of great antiquity. The *aso*, a mythical animal that is a hybrid **DOG** and dragon, functioned as a protective image against

malevolent spirits, and it was used not only in tattoos but also on shields, baby carriers, and houses.

ATOMIC RADIATION

The multiple elliptical orbits of this symbol represent electrons revolving around a singular central dot representing the nucleus. Together the orbiting electrons and nucleus depict a scientific conception of one of the smallest parts of matter, the atom. It is also, though, a symbol that stands for nuclear radiation, nuclear research, nuclear power, and nuclear weapons. The curved lines that shadow the main orbits heighten the vibratory and kinetic energy that is implied.

AUREOLE

The aureole, often seen in religious tattoo iconography, is the luminous cloud or circle of light that surrounds the whole figure (not to be confused with the HALO around just the head). It is symbolic of the glory of the divine—shining, bright, and beautiful.

AUTOMOBILE

When used in tattoo art, automobiles (and really vehicles of all types) are typically symbolic of a person's work, pastime, or hobby. Sometimes luxury car or hot rod and sometimes MACK TRUCK or pickup, vehicles are many times shown in motion—in fact, at high speeds. These tattoos, like animal tattoos, sometimes become a metaphor for ourselves or our desires. They can also be associated with "fast living" and a certain recklessness, or "living in the fast lane."

AX

Since the Neolithic (or "New Stone") Age, the ax has been particularly symbolic of both battle and work. All ancient peoples seem to have used stone axes, and their use in creating sparks has perhaps led to their prevalent association with storms and with LIGHTNING, thunder, and rain. For

some people, such as the T'ang Dynasty Chinese, stone axes actually fell from the sky. In tattoo imagery, the ax can stand alone or be integrated into a larger design—perhaps a VIKING scene or a Boris Vallejo painting. Their presence in most contexts, though, will draw upon their use as one of mankind's earliest weapons.

AXIS MUNDI

The "axis of the world" is not a particular symbol but rather a type of symbol that takes many forms. It comes from the worldviews of many ancient peoples describing how they imagined the physical universe to be arranged—with the heavens above, an Underworld below, a central world that we occupy, and a central pole or axis that shoots straight through them all. The TREE OF LIFE is such a symbol, as is the CADUCEUS, both with central poles around which other aspects of the design are arranged in symmetry. Precisely because humans tend to arrange their views of the cosmos along such lines, these types of symbols appeal to us instinctively and appear repeatedly in tattoo imagery and artwork in general.

AZTEC CALENDAR STONE

The calendar stone is a combination of numerous symbols, also known as glyphs. The actual Aztec Calendar Stone was carved during the reign of the sixth Aztec monarch in 1479 and dedicated to the principal Aztec deity Tonatiuh, or the sun, whose face is in the middle. It was uncovered in Mexico City in 1790, measures almost twelve feet in diameter, and weighs some twenty-five tons. Surrounding the Tonatiuh are four square panels honoring previous incarnations of the deity that represent the four previous ages of the world. Circumscribing these are glyphs that represent the twenty days of the Aztec month. The central panel depicts the date "4 *Ollin*" (*Ollin* meaning "movement"), a day on which the Aztecs anticipated that their current world would be destroyed by earthquake. In addition, it holds the dates of previous holocausts: 4 Tiger, 4 Wind, 4 Rain, and 4 Water.

AZTEC EAGLE-KNIGHT

Much of Aztec life revolved around war, the taking of captives, and sacrifices of those captives to the gods in order to achieve the perpetuation of the universe. But the echelons of the Aztec warrior caste were very ex-

plicit and visually, as well as socially, distinguishable. Only when he had captured prisoners could an Aztec warrior wear FEATHER headdresses and leather bracelets. At the end of his career a warrior could attain one of the two upper military orders: that of the "jaguar-knight," whose war costume was a JAGUAR skin; or that of the "eagle-knight," whose helmet was an EAGLE head. In tattoo art, it is the proud eagle-knight warrior that we see depicted most often.

AZTEC SUN

According to the Aztecs, the universe was composed of distinct cosmic eras. They believed that four suns had been created in four previous ages, and that each had died at the end of its era. Tonatiuh was the fifth sun and the present era is still his. His name meant "He Who Goes Forth Shining" because he was the first moving sun. Tonatiuh was responsible for supporting the universe and therefore his weakness could bring the end of the world. Human sacrifices were regularly offered to him in order to nourish him and maintain his strength. Tonatiuh was also in charge of the Aztec heaven called *Tollan*, where only dead warriors and women who died in childbirth could enter.

BACCHUS

Known as Dionysus to the Greeks and Bacchus to the Romans, the god of wine may have even deeper roots in earlier nature religions. He often took on a bestial shape but in early art he was mainly represented as a bearded man. His personal attributes were an ivy wreath and a large two-handled goblet. Unlike the other gods, to his believers Bacchus existed not only outside them but also within. They believed that under the influence of wine, one could feel possessed by a greater power and perform great feats. Although classical imagery is not particularly widespread in tattoo design, it is certainly done, as in the case of Bacchus.

BAD AT HEART

Some tattoo symbols can almost be read, in a literal sense. The word "bad" combined with a red **HEART** obviously represents "Bad at Heart." Oddly enough, the "Bad at Heart" tattoo is usually an attractive one.

BADGER

In the West, with only a couple of exceptions, the badger is predominantly associated with aggression and hostility (as in someone being badgered, for example). For the Japanese, though, the potbellied badger is a symbol of cunning—more like the West's fox, but with the added meanings of prosperity and self-satisfaction.

BAGPIPE

The bagpipe is a wind instrument with at least two pipes that are blown using a bladder (traditionally of animal skin) full of air that is pumped under the arm. Melodies and accompaniment, often described as droning, are played via finger holes on the pipes. There is some evidence that these instruments were known in parts of the world as early as 100 B.C.E. They have been used from Britain to Russia, throughout the Aegean, and even into North Africa and the Arabian Peninsula. Today the pipes are associated primarily with the country of Scotland and are often depicted with a tartan plaid textile bag. However, in Scotland it is not used only as a musical form of entertainment. In the Highlands, bagpipes also accompanied the drum in military use on the battlefield from the eighteenth century. Even today, Scottish military regiments will parade with the bagpipe playing. Although a tattoo of a bagpipe might be the choice of people who can play the instrument, it is also a more general symbol of Scotland as the HARP is for Ireland.

BALL

The ball, drawn in two dimensions or three, had symbolic significance in many older civilizations and was associated with the sun or movement through the heavens. Games with balls are depicted in ancient Mexican art and mentioned in Homer's *Odyssey*. Even in the Christian church in France (before 1538) clerics danced around the monastery, throwing a ball back and forth, to the sound of music. As with other basic symbols in tattoo art, the ball more often occurs in specific contexts—some having to do with sports, some with representations of planets and the EARTH.

BALLOON

Balloons in tattoo art can be associated with celebration, or used as markers of an occasion and even as memorials, much as in Western culture in general. They suggest joyfulness in their varied color and something ethereal in their buoyancy and ability to float. Of relatively modern origin, they are nevertheless connected to older symbols that depict the ability to soar and escape earthly boundaries.

BAMBOO

A plant prevalent in the Orient, bamboo plays an important role in art and symbolism there. A bamboo branch is the attribute of the gentle KANNON, Buddhist goddess of mercy. In Japan it symbolizes youth and strength and it is in Japanese tattoo that it appears most frequently. It is incomparably straight, rising to the sky, with evenly spaced knots, and is also incredibly strong for its weight. Along with the plum and the pine, bamboo is one of the three trees of good omen.

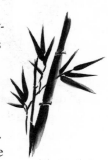

BARBED WIRE

Although originally created as a fencing material used in ranching in the American West in the late 1800s, barbed wire (also known as "barbwire" or "barb wire") has come to symbolize more than just the control of space and land. Because of its use in prison and war camp settings, it also carries a connotation of suffering, confinement, and capture. Its popularity in modern tattoo can be directly attributed to its use in armband styles and similarity to tribal styles, and also the 1996 movie *Barb Wire*, starring Pamela Anderson with her armband barbed wire tattoo.

BAR CODE

The bar code, a means to present product information that can be quickly scanned by an optical computer system, was patented in 1952, but it wasn't until the late seventies that the system really started to take off. Today the bar code is everywhere, speeding up shopping and all manner of commerce. When used in tattoo, it is part of a symbolism that simultaneously emphasizes the need for individuality and the human body as a commodity. Its application on skin is ironic, where it presumably cannot be used for scanning purposes (although real information might be encoded in the tattoo), and pokes fun at the way we see ourselves and our bodies.

BASS CLEF

The bass clef ("clef" being French for "key") is a musical symbol that is placed at the beginning of a staff (the five horizontal lines on which notes

appear) to signal the "key" or refer notes to follow. The bass clef is also clef because the two dots in the symb and below the horizontal line that indicates the note F (below middle C, hence bass, or a lower register and set of tones). Like the treble clef, this is a tattoo that is likely to be worn by people involved with music—particularly musicians and people who read music.

BASTET

The Bastet **CAT**, looking much like a household pet of today, is actually a representation of the Egyptian goddess of the same name, initially worshipped in the form of a lioness. In regions where her worship was particularly popular, large cemeteries of mummified cats with thousands of bronze statuettes of the goddess have been found. At first a goddess of the home, she later became a goddess of war.

BAT

The bat is an animal that is generally associated with negative symbolism in the West and yet is a symbol of good luck and longevity in the Far East. Among the ancient Maya of Central America the bat was revered as a type of guardian god. Today, in the vast majority of tattoo iconography, the bat is synonymous with the dark side of the supernatural—sometimes represented as a winged demon, sometimes as a blood-sucking **VAMPIRE**, sometimes simply associated with **WITCHES** or part of a dark and ominous scene. No doubt that eerie association comes from its dual nature as a nocturnal, winged mammal, active at night and able to make its way in the dark.

BATTLE ROYALE

Classic tattoo design includes an ages-old theme that represents opposing forces locked in combat. The most frequent images used are those of a bird of prey, such as an **EAGLE**, which represents the **SUN**, the **SKY**, and the heavens; and a serpent, such as a **SNAKE**, which represents the earth and

life-giving waters. These two together (although sometimes with other animal additions) represent the forces of creation and fertility and the forces of nature, which are ever in opposition but always in balance.

BATTLESHIP

Today, as in the past, much of maritime tattoo art takes the form of the sailing vessels on which the mariners spend so much of their time. The battleship, as a ship of war, is often drawn bristling with gun turrets, cutting through the WATER, symbol of authority and power, ANCHORS at the prow. But the dominance of the battleship was ended by the advantages of the aircraft carrier (not to mention Pearl Harbor) and construction of them was stopped in 1945 with the end of World War II. Although a battleship tattoo could possibly depict the U.S.S. *Missouri*, decommissioned in 1992, it is more likely a bit of nostalgia and is usually done in the classic style of the era—with dark black outlines and bold colors.

BC

This tattoo is an example of authority's attempts to brand certain people and/or penalize them. During the nineteenth century, soldiers deemed "bad characters" by the British Army had a "BC" tattooed on their wrist.

BEAR

A carnivore and a large animal capable of much ferocity, the bear is a common image in pop culture and tattoo. Not much a subject of Oriental tattoo art, the bear in the West is a symbol of male strength and power, at times associated with authority. Many cultures have myths about bears—from the Greeks and the Celts to the Ainu of northern Japan and the tribes of North America, and also back in time to Neanderthal altars of bear SKULLS in caves. Powerful, dangerous, uncontrolled, and feared, like some primal force, the bear is traditionally the symbol of brutal violence and awesome nature.

BEAR CLAW

The bear claw FOOTPRINT is a symbol of literal and spiritual power in the cosmology of some indigenous peoples in North America. Sometimes as-

sociated with particular clans or organizations, the **BEAR** and its footprint symbol are more generally associated with the power of the animal itself and also the summoning of spiritual power from supernatural realms.

BEAR (HAIDA/KWAKIUTL)

The bear in Pacific Northwestern cultures such as the Haida and the Kwakiutl symbolizes many of the same things that it symbolizes for other cultures worldwide—meanings undoubtedly derived from the nature of the animal itself, no matter where it happens to originate. In Northwestern myth, the bear is a supernatural being of the land that is strong, aggressive, and fearless. In various types of designs, including tattoos, the bear is identified by its massive but short muzzle, rounded and ferocious eyes, and wide, flaring nostrils. Its claws are long and pointed and the teeth and fangs are also usually shown. For the warrior, the bear was also a sign of fierceness.

BEE

Bees have a very long history in symbolism both as individuals and in terms of the hive. Beekeeping has been documented in Egypt as far back as 2600 B.C.E. and beeswax was even used in mummification. In numerous cultures around the world, bees have taken on quite varied associations—from harbingers of death to resuscitators of the dead, from symbols of kingship to bringers of wisdom. In Western styles of tattoo imagery, the bee is a fairly popular insect, sometimes shown by itself but more often in a group. They carry the meanings of being industrious and busy, while working for the group. However, the appearance of a bee on the skin, in reality or in a tattoo, also brings to mind their stinging ability.

BEETHOVEN, LUDWIG VAN

Although many portrait tattoos are actually modern musicians, Ludwig van Beethoven (1770–1827) is also used as a subject. He was one of the foremost and most popular composers and virtuoso pianists of his day and

is still arguably considered by some the greatest composer who ever lived. Tragically, he began to experience deafness as early as 1801 and for the last ten years of his life he was totally deaf. And yet, he composed nearly until the end. Beethoven's story, and thus his symbolism, is one of personal triumph over misfortune in addition to one of supreme musical achievement.

BEETLE

Beetles come in an enormous variety of types, sizes, and colors and these variations are used to great advantage in tattoo art. In fact, it is the deep lustrous quality of their colors that is emphasized in tattoos, sometimes with **WINGS** extended to reveal a differing color beneath. One of the most famous of all Egyptian designs, the **SCARAB**, is a beetle. In Japan, beetles are kept as pets. Prehistoric man of 10,000 to 20,000 years ago had beetle-shaped pendants. Although we may never know what symbolism was intended by early peoples, we know that for some traditional cultures the beetle—capable of flight and of burrowing into the ground—was associated both with food and with shamanism.

BENTEN

Benten (or Benzaiten) is one of the Japanese **SEVEN GODS OF GOOD FORTUNE.** She is the only female deity among the seven and symbolizes eloquence, music, literature, the arts, wisdom, love, and the sea. Sometimes she is shown with the *biwa* (a kind of lute) and sometimes also with a white **SNAKE** or riding a dragon. The Seven Gods of Good Fortune are a popular theme in Japanese tattoo art, most often depicted together as a group, though sometimes individually.

BES

In the ancient Egyptian New Kingdom (1550 B.C.E.), the image of Bes was used as a tattoo. Shown as a bearded, savage-looking yet comical dwarf, he had a large head, pointed ears, a protruding tongue, bowlegs, and some-

times an erect penis. Initially revered as a household deity who guarded against evil spirits and misfortune, over time he came to be seen not only as warding off evil but also as bringing pleasure to merrymakers and as symbolizing sexual potency. Interestingly, Bes is also the earliest-known tattoo that is not an abstract pattern.

BETTIE PAGE

Bettie Page epitomizes a type of tattoo that represents a significant percentage of those acquired by men. Though not particularly symbolic, the art of the pinup girl is intimately connected to the emergence of tattoo in the West. Descending from early mariner tattoos of **MERMAIDS** or **HULA GIRLS**, the pinup girl is a sex symbol, plain and simple, and a modern icon of the male libido. Bettie Page, called the "queen of pinup girls," flourished in the 1950s, although her image was revived in the 1990s. Even while she is transmitting direct sex appeal and is intentionally flirtatious, Bettie also has a look that is unpretentious. In fact, this latter aspect is the real hallmark of the pinup girl.

BETTY BOOP

Oddly enough, the quintessential coy flapper and the first in a long line of sexy cartoon characters, Betty Boop, actually started life as a **DOG**, modeled on a French poodle. But by 1930 she had evolved into the innocent skirt-lifting girl—pulling it down only to have it pop up again—whose trademark line was "boop-boop-a-doop." An icon of pop culture and considered a collectible, Betty Boop has also made her way into tattoo art, as have many cartoon characters. Not surprisingly, she is popular with men because of her pinup girl status, but also with women because of her sexy but safe image.

BETTY GRABLE

Betty Grable is best remembered for her classic WWII pinup showing off her "million-dollar legs." Her famous leggy rearview pose in a swimsuit became an instant sensation and was one of the most widely distributed pin-

ups ever. For the GIs who carried her image overseas, however, she was more than beauty—she was a bit of Americana and reminded them of what they were fighting for back home. Even now, some sixty years later, that photo is the model for tattoo artwork the world over.

BHIMSEN

Among the Newar of Nepal, tattooing is considered an ancient custom. Predominantly Hindu, their artwork still reflects many of the ancient and religious themes that have dominated it. The image of Bhimsen (the god of wealth) is one of the many god figures that are used in tattoo. He typically stands cloaked in a long jacket and pajamalike pants, feet spread apart, bearing a huge club and SHIELD. He also wears a helmet, looking more like a god of defense than of commerce.

BINARY

Binary refers to a number system that uses only two numbers, 0 and 1. Its code has been particularly useful in computer systems to represent bits (very small pieces of information) that are "on" or "off" and "go" or "no-go." A binary symbol tattoo is therefore a string of 0s and 1s that can be used to encode an infinite number of meanings, although its most basic one might simply be a representation of a digital world.

BIND RUNE

RUNES are ancient alphabets used by Germanic peoples in Northern Europe, Britain, Scandinavia, and Iceland from about the third to seventeenth centuries. There are different runic alphabets that are similar but not identical, used at different times by different peoples. The bind rune is essentially a special and customized combination of individual runes that are written one directly on top of another. Even if the bind rune forms a word, the letters are not arranged from left to right as is done in Western languages. Instead, each successive letter is simply placed over the previous, which ultimately creates one dense and complicated rune as a final product. That single image captures, concentrates, and intensifies the meaning of the runes, more so than if the word had simply been written out.

BIOHAZARD SYMBOL

The biohazard warning symbol is a popular tattoo, owing in part to its intricate and interesting pattern, to its resemblance to tribal tattoo art, and to its meaning. It is internationally recognized as "the potential presence of a biohazard" (a biological substance that poses a hazard to humans). The symbol was developed by the Dow Chemicals Biohazards Research and Development team under contract with the National Cancer Institute (NCI), after the NCI decided that a warning symbol to enhance biohazard containment was critically needed. The team that formally developed the symbol, with much testing and redesign, eventually came up with the symbol that we know today, satisfying their initial six requirements for it: that it be striking in form to draw immediate attention, unique and unambiguous, quickly recognizable and easily recalled, easily stenciled, symmetrical in order to appear identical from all angles, and acceptable to groups of varying ethnic backgrounds. Read literally, a biohazard symbol marks the wearer as a hazard to humans. A more likely and average interpretation, though, is one where the tattoo is ironic.

BIOMECHANICAL

The biomechanical type of tattoo is definitely one that gained popularity in the twentieth century, when this type of medical alteration of human bodies became possible. Frequently, the biomechanical tattoo simply overlays that part of the body that is depicted, as if one is seeing into that part of the body with a sort of x-ray vision. But the SKELETON and musculature that might normally be seen are replaced by metal rods, hinges, pulleys, tubes, and other mechanical devices that function in their place. The biomechanical tattoo invokes both a sense of wonder and revulsion and hearkens back to early depictions of the machine in the man and the more recent art of H. R. Giger.

BIRD

In mythology, symbolism, and tattoo, birds traditionally have mostly positive associations. The flight of birds leads them, naturally, to serve as sym-

bols of the link between heaven and earth and to symbolize spiritual and emotional states. However, each bird, real or mythological, carries its own very specific symbolism—the **DOVE** (peace), the **STORK** (newborns), and the **CRANE** (long life) being just a few examples.

BIRDMAN

According to oral tradition, the art of tattoo on Rapa Nui (Easter Island) is ancient and originated with two female spirits and their sons. Tattooing there was first observed and recorded for the West by Captain James Cook in 1774 and was similar to practices observed in other parts of Polynesia. Tattoo motifs varied according to one's position in society but could also be of a more personal nature, such as this particular design, inspired by the legend of the birdman. The birdman cult probably rose to prominence in about C.E. 1500 and was practiced as late as the mid-1800s. The birdman was seen as the earthly representative of the creator god Makemake, and each year men competed for the title.

BIRTH OF VENUS

Because tattoo is fundamentally art, it should come as no surprise that many works of fine art through the ages have inspired tattoo artists and clientele alike. *The Birth of Venus* by Florentine painter Sandro Botticelli (1445–1510) is probably among the most recognizable of these great works. Not actually the depiction of a myth, *The Birth of Venus* actually portrays the birth of love in the world. Standing on a giant clamshell from which she has emerged, Venus attempts to cover herself, partially using her long golden hair. Her nude form, though, is considered one of the most sensuously beautiful figures of the Renaissance. Used today in logos for everything from entertainment to software companies, Botticelli's masterpiece has also found a home on skin. Indeed, it is amazing that artwork that was originally almost life-size can be reduced to work for tattoo. When people use fine art for tattoo, the actual symbolism of it can range from art appreciation to the notion of the birth of love in this case, or to the attraction of something sublimely appealing. Certainly *The Birth of Venus* is all of these.

BISHAMON

Bishamon (Bishamonten) is one of the **SEVEN GODS OF GOOD FORTUNE**, a popular theme in Japanese tattoo art. He is also one of the Four Kings of Heaven in Buddhism and is always shown in full armor, carrying both a **SPEAR** and a miniature **PAGODA**, symbolizing his role as a protector of the righteous. He is more generally known as a patron of warriors and soldiers.

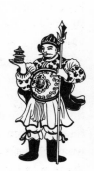

 ## BLACK ROSE

The origins of the symbolism of the black rose are lost in time, and some of its ancient origin is lost in the fairly green mists of time. The Irish song

"Rosin Dubh" or "Little Black Rose" may have originated in the seventeenth century, as the Irish battled the English. The tattoo is a symbol that has been used by many anarchist and anti-authoritarian groups, echoing this embattled history. In this context, the black rose is fundamentally a symbol imbued with sadness, strife, and struggle—tragic in its dark beauty, but not quite the symbol of death and farewell that it has also become in North America, where the color black is frequently associated with death.

BLACK WIDOW

A popular insect image in the world of tattoo, the black widow **SPIDER** is immediately recognizable by its shiny jet-black luster and the small red **HOURGLASS**-shaped design on the underside of the abdomen of the female. The black widow is so named because of the female's practice of killing and eating the male (which is one-fourth her size) after mating. Because all black widows are venomous, the black widow design symbolizes danger, but also feminine energy and creative force.

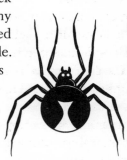

BLIND JUSTICE

The image of blind justice, although derived principally from the Greek goddess Themis, is not solely of Western origin. The Egyptian goddess Maat also used the scales to measure deeds against the weight of a magical FEATHER. Themis symbolizes wisdom and good counsel, and the goddess herself acted as an interpreter of the will of the gods. Typically, blind justice is shown as a somber woman in a Grecian type of tunic or robe, who wears a blindfold to ensure impartiality and carries the SCALES OF JUSTICE and a SWORD to mete out righteous judgment.

BLOOD

Blood is life itself—vitality and procreation—and it is present in tattoo artwork in images that range from the STIGMATA to MOCK WOUNDS and even the BIOMECHANICAL style. The portrayal of blood on skin that is actually whole and unbleeding is both ironic and naturally troubling and may potentially represent something unhealed or hurtful, as in the way of old wounds.

BLUEBIRD

Although SAILOR tattoos are legendary and call to mind a number of stereotypical images, the bluebird is not usually among them. Yet, in years past, when a sailor had traveled 5,000 miles at sea, he got a bluebird on his chest. When he had gone 10,000, he got a second on the other side. History does not record why the bluebird was used to memorialize these sailing milestones. But we do know that the bluebird has sometimes been thought of as a spiritual messenger and associated with happiness.

BLUE MARLIN

Hooking a marlin is one of the ultimate goals of the avid sports fisherman. The FISH has a large dorsal fin and is most notable for the SPEAR on the end of its nose. Found around the world, perhaps the most well known is the swift and sometimes high-flying blue marlin. With a deep blue color but an underside hue of silver with light vertical stripes, the blue marlin may be one of the most picturesque of the large game fish and can reach a weight of 1,000 pounds. A tattoo of a marlin may draw upon the tenacious fight-

ing ability of these giant fish for its symbolism, and it might just as likely serve as a trophy for the fisherman who manages to land one.

BOA

The boa group of SNAKES is made up of several types, one of which is known as the boa constrictor. Contrary to popular belief, boas do in fact bite their prey. They then kill by constricting their large bodies around the victim and either suffocating or crushing it. The boa snake in tattoo is often shown coiled around something, be it a BRANCH, another snake, or even around the arm or torso of the bearer of the tattoo. Boas' skin patterns are typically composed of blotches and diamonds colored green, brown, and yellow. This particular snake perhaps carries fewer historic associations than the viper, but it falls into symbolic line with other predatory animals, being both intimidating and fearsome.

BOAR

Unlike the PIG, the boar has been a companion to the warrior. In the wild, the boar is an aggressive animal and unrelenting in its attack. Norse warriors would use the image of the boar for decorative purposes as well as its actual teeth for various forms of adornment. In ancient Japan the war god himself was sometimes depicted as a boar. It was a sacred animal for the Celts for whom it symbolized military strength and goodness.

BOAT

Naturally, boats and all manner of ships figure hugely in maritime tattoo art. A couple of specific examples are discussed elsewhere but, in general, the boat is a symbol for a voyage or journey, not much different from its literal usage. Boats symbolically become vessels for the transportation of the soul in the afterlife for many cultures, and they also figure in mythological quests and ancestral migration stories. Many boats are christened with names and imbued with personalities and are even referred to by personal pronouns. For sailors they surely held the same meanings, but also represented home and hope.

BOBCAT

The bobcat is a North American wildcat, although a small one, not much bigger than a large house CAT. With tufted and pointy ears their appearance is somewhat reminiscent of a stuffed toy. Like other wildlife in North America, they are symbolic of the spacious and natural beauty that most inhabitants of this continent rarely see or experience today. They are, however, still feline predators, usually solitary, who hunt at night. Frequently part of wildlife scenes, tattoos of bobcats also sometimes include part of their habitat, generally the forest but sometimes the desert as well.

BOMBSHELL

Sometimes paired with the ATOMIC RADIATION symbol, and looking like they came right out of a 1950s B science fiction movie, bombs are naturally representative of explosive, destructive, and killing force. In many instances bombs are used to symbolize war, and the tattoo wearer may combine it with a DOVE, a mushroom cloud, or a SKULL AND CROSSBONES, depending on the specific message the person is communicating. On a deeper level, bombs represent energy itself—disruptive and aggressive.

BOMB WITH FUSE

The bomb with a fuse, unlike the artillery SHELL version, distinctly implies a time-delayed yet inevitable explosion.

BONE

Bones are an essential and primary element of the human being, what we find at the core. Although in most circumstances bones are the last remnants of the body after death, the types of bones that are most typical in tattoo artwork (aside from the SKULL and SKELETON) are realistic portrayals of a person's bones in a type of x-ray vision or even as a broken bone protruding through the skin. At times the bones might have an alien or inhu-

man look to them, something approaching the **BIOMECHANICAL**. In each instance, though, the viewer, seemingly gazing through the skin to see the usually hidden part of a person gets an unexpected and novel view.

BONSAI TREE

The bonsai (Japanese for "tray planted") tree is a symbol of Oriental culture. Highly prized today, their cultivation began in China more than a thousand years ago. The Japanese went to great lengths to refine the art of bonsai and some believe that the finest examples are still being developed in Japan. The bonsai is typically a living dwarf tree (pine, azalea, or maple) grown in a container. They are painstakingly trimmed and trained and take years to grow. It is an art form that has gained in popularity the world over, and its appeal is confirmed by the fact that images of bonsai are used in tattoo. They are nature, as guided by man, and distinctly oriental in their form and presentation.

BOOK

The symbolism of a book tattoo can be literal, referring to reading or lessons, but usually it symbolizes something more. It can symbolize knowledge, learning, wisdom, and sometimes also religion. The closed book is unknown territory or a secret. The **HEART** is sometimes referred to as an open book—exposing thoughts and feelings when it is open.

BOOK OF THE DEAD

HIEROGLYPHS of short sections from the ancient Egyptian *Book of the Dead* are used in many Egyptian tattoo designs. Often colorfully illustrated, papyrus scroll copies of this work have been found in Egyptian tombs. The *Book of the Dead* is but one part of Egyptian funerary literature and it consists mostly of magic spells and formulas used to protect and aid the deceased in the afterlife. It also contains many of the fundamental beliefs incorporated in ancient Egyptian religion. When people use this particular artwork for a tattoo, there is no sense of the morbid. The *Book of the Dead* is a functioning and utilitarian tool with a focus on life.

BORNEO ROSETTE

Borneo, an island that is part of the Malay Archipelago southwest of the Philippines, is one of the few places today where tattooing continues to be practiced in a tradition that may stretch back thousands of years. In this region, home to several native tribes such as the Ibans, Kayans, and Kenyahs, the Borneo Rosette, a Dayak tattoo, tends to receive the most attention. Males in Borneo often received tattoos in honor of achievement, particularly achievement in war and headhunting. The "rosette" found on the fronts and backs of the shoulder region is actually a stylized eye of the ASO (the mythical DOG/dragon associated with protection from malevolent spirits). The name given to the stylized eye today is a Kayan word, *"jalaut,"* for the fruit of a plant recently introduced into the region. Among the Rundum Muruts of Northern Borneo, STARS on the front of the shoulder and above the breast denoted a head having been taken. When the third head had been taken, another star was placed on the throat.

BORN TO RIDE

This slogan tattoo comes from the biker community. Whether outlaw bikers or casual weekend club members, this seems to be a motto that all MO-TORCYCLE enthusiasts adopt. Similar to the slogan "Live to Ride/Ride to Live," both symbolize the devotion that bikers have to their machines and their time on the ROAD with them. These types of slogan tattoos are almost always accompanied by symbols drawn from the biking experience: an engine, a motorcycle, a club logo, a motorcycle logo, or a scene of the winding and open road.

BO TREE

The *bo,* or sometimes *bodhi,* is a tree that can attain great size and age. It is famous for being the tree under which the BUDDHA sat when he attained enlightenment (*bodhi*) at Bodh Gaya. It is held sacred by Buddhists and can be generalized as another form of the TREE OF LI. In early Buddhist art,

the bo tree was used as a symbol for the Buddha since there were no likenesses or statues of him.

BRANCHES

When the flood receded, a **DOVE** brought an **OLIVE BRANCH** to Noah. It symbolized not only dry land but also pardon, peace, and salvation. In Irish, the same word is used for both branch and magic wand. In medieval art, the branch sometimes represents logic, other times chastity or the rebirth of spring. The branch is used effectively in tattoo, sometimes depicted with **FLOWERS** or buds and sometimes without, but it is always evocative of life.

BRICK WALL

The brick wall, although not restricted to prison tattoo, is nevertheless a well-known motif there. Brick walls are a symbol of prison life and incarceration, representing quite literally the function that they serve. In an interesting twist, granite block walls represent time spent in California's Old Folsom Prison.

BRITISH FIGHTING DOG

The Celts of ancient Britain were known for crossbreeding **WOLVES** with hounds to produce a powerful fighting dog for battle. In Ireland there is a legend that tells of a struggle between the hero Cuchulainn and the war goddess **MORRIGAN** in which the hero is attacked by the goddess, who has taken the form of a she-wolf, for daring to spurn her amorous advances. This particular british fighting dog is taken from the *Book of Kells*, probably the best known of the illuminated manuscripts from which so much of Celtic tattoo artwork is drawn today.

BUDDHA

Buddha (literally "awakened one") is actually a title given to the founder of Buddhism, Siddhartha Gautama. Of all the figures in Buddhism, the Bud-

dha himself might be the most popular in tattoo imagery. Symbolic of all that his life and enlightenment represented, he is frequently portrayed in tattoo much as he is in Buddhist art—with a serene and beautiful face, in cross-legged meditative position, and with hands in a meaningful gesture (mudra). In this example, the hands form a mudra that symbolizes turning the DHARMA WHEEL. The Buddha represents an escape from the grasp of worldly concerns, compassion for all others, and wisdom. He was moved by the suffering of others and devoted his life to teaching ways in which that suffering could be confronted and overcome.

BUDDHA, FAT

The figurine of a bare-chested, bareheaded, and smiling fat man is the Chinese *Mi-lo*, an incarnation of BUDDHA. With his bag of presents he is often surrounded by playing children and he is a symbol of carefree bliss. As with so much of Chinese culture, he has a counterpart in Japan called HOTEI, one of the SEVEN GODS OF GOOD FORTUNE, who is believed to bring peace and prosperity.

BUFFALO

While much animal imagery in tattoo draws its inspiration and meaning directly from the attributes of the animal, the American bison (commonly known as the buffalo) is very much associated with the Plains Indians. It was a mainstay of their economy, providing food, clothing, shelter, and TOOLS. However, the bison also symbolizes the intentional destruction of that way of life for the advancement of a dominant and expansionist American culture. Thus, while the buffalo occupied Indian mythology and ritual and is representative of these, it also now represents the legacy of a ruthless white population and a government bent on usurping land and resources.

BUFFALO SKULL

Because the BUFFALO figured so largely in the Plains Indians' way of life and also in their mythology, it is no surprise to find that the buffalo SKULL

played a role in their sacred rituals as well. Tattoo art that uses the buffalo skull frequently capitalizes on these associations by pairing it with other Plains Indians artifacts—beads, **FEATHERS**, strips of leather, red paint. In Plains ritual, the buffalo skull was used as an altar, carried the buffalo's power, and even housed the Buffalo god, depending on the particular Plains group. It is therefore associated with power both physical and supernatural.

BUFFALO SPIRIT

Like the **BUFFALO** and **BUFFALO SKULL**, the buffalo spirit tattoo is representative of the power of the buffalo, as much on a spiritual level as on the physical. This particular way of depicting the buffalo spirit in tattoo form comes from the Cree Indians of the northern Great Plains. For the Cree, much of their ritual and ceremony was aimed at cultivating success in either war or the bison hunt.

BULL

The bull is an animal symbol of great importance, going back to the earliest cave drawings of mankind in the Paleolithic era. Bulls are images and symbols of immense strength and vitality. For the ancient Greeks, bulls represented the unleashing of uncontrolled violence. For the Egyptians, the bull was a creative force. In Jungian analysis, the bull is unchecked power where the allure of bullfighting is really a secret wish to tame the beast within us all.

BULLDOG

The tradition of using an English bulldog as a mascot for the **UNITED STATES MARINE CORPS** is believed to have its roots in World War I. German soldiers referred to the Marines as *teufel hunden*, or "devil dogs," based on their fierce fighting ability. Soon afterward, the bulldog mascot (wearing a helmet with the **EAGLE**, globe, and **ANCHOR** insignia) was depicted in a

Marines recruiting poster chasing a dachshund wearing a spiked helmet and **IRON CROSS**, and the tradition was set.

BULLET

Although some gun and hunting enthusiasts might use a bullet tattoo in a manner similar to other hobby or pastime images, the design has a more violent theme. Since the bullet was essentially designed to harm or kill people, it is fundamentally a symbol of both aggression and hostility, like the weapons with which it is associated.

BULL'S-EYE

The bull's-eye is actually the center of a target, although the term is used loosely to refer to a target itself when it is a series of concentric **CIRCLES**, usually alternating red and white. A bull's-eye tattoo holds a bit of irony since the last thing someone would really want is to be a shooting target. But to be "on target" is another matter, and in this sense the symbol can represent a goal. Visual punning has also been done with this tattoo, since both components of the name ("**BULL**" and "eye") can be represented with their own symbols.

BUTTERFLY

The butterfly is far and away the most-used insect image in all of tattoo. A symbolic creature in many cultures, it sometimes represents beauty itself or metamorphosis and other times the transitory nature of happiness and, indeed, all of life. To the Aztecs, the butterfly symbolized the soul or the breath of life exhaled by the dying. The same is true in classical antiquity, where it was a common belief that the soul left the body in the shape of a butterfly. In Western culture, butterflies are also seen as symbols of freedom. They lend themselves to all manner of colorful and fanciful adaptations in tattoo imagery. Despite their enormous variety with respect to color, shape, and size, their embellishments in tattoo art may well rival those found in nature.

C

CADUCEUS

The caduceus, the staff of the two **SNAKES**, is the staff of the Greek god
Hermes (Mercury to the Romans), who was the mes-
senger of the gods. It is an ancient symbol, present
as early as 2600 B.C.E. in Sumeria. Its resemblance
to the staff of Asclepius, the healer (a staff with
only one serpent), has resulted in a modern confusion
of the two to the point where the caduceus (with **WINGS**
for the swiftness of Hermes) has been adopted as a symbol
for physicians and the healing arts.

CANCER

Cancer (June 22–July 22) is the fourth sign of the **ZODIAC**, expressed sym-
bolically as a pair of spirals in order to convey the
changing direction of the movement of the **SUN**.
Pictorially, Cancer is shown as a **CRAB**. Classified as
a **WATER** and **MOON** sign, those born under its influ-
ence are characterized as sensitive, withdrawn, and
shy, but perseverant.

CANDLE

Candles symbolize light and, by extension, enlightenment or the answer
to a problem. The candle is also used in many different types of religious
rites the world over. The ancient Greeks offered candles to the gods of the

Underworld and the gods of fertility, exploiting some of their phallic symbolism. Flickering and casting a gentle and glowing light, they are also associated with purity and innocence. In tattoo imagery, as in other art forms, the candle is not typically the main subject of a design but rather a part of a larger theme.

CANNON

Military artillery such as the cannon have been used in warfare since the fifteenth century. Tattoos of a cannon might carry very specific meanings such as that of a war memorial or wartime service, but they are also part of the larger group of weapon tattoos of all sorts, which in general are meant to project strength and intimidation.

CAPRICORN

Capricorn (December 21–January 19) is the tenth sign of the ZODIAC and it begins the winter solstice. It is a symbolic representation of a GOAT's body and a FISH's tail and reflects the ambivalent nature of those born under the influence of this sign. In the Far East, it is the first sign of the ZODIAC. The keywords for individuals born under this sign are ambition, realism, hard work, and the ability to find constructive solutions, but also rigidity and pessimism.

CARDS

The playing cards that are used in tattoo imagery are generally either the ace or one of the face cards (the KING OF HEARTS, for example, or the king, queen, or jack of any suit). Many times they are shown in "winning" combinations such as four aces, a royal flush, or a sum of twenty-one. As such, they are symbols of good luck and also fate.

CASTLE

The castle developed around the ninth century in medieval Europe as a stronghold, generally the residence of nobility. In heraldry, it symbolizes both grandeur and solidity. In tattoo art, castles are many times incorpo-

rated into fantasy and Gothic scenes—creating a tone for a larger tattoo piece, setting the scene in some distant time period, or perhaps dominating some fantastic futuristic landscape. Whether under a cloudy but moonlit night or perched high on some sunlit mountain, the castle invites us into a story that is already under way.

CAT

The symbolic meaning of the cat varies wildly across the globe and through time. It has been an ill omen in Japan, a stoic that is unmoved by the death of the **BUDDHA** in Buddhism, the form of a beneficent goddess in Egypt (**BASTET**), a creature distrusted by the Celts, given seven lives by Muslims, a symbol of cunning for the Pawnee of North America, and attributed with clairvoyant behavior in central Africa. Today, cat imagery in tattoo is dominated by depictions of household pets. As pets, we associate them with playfulness, some aloofness, and a great deal of affection. As seen in the animals themselves, their images span the great variety of the species, in both form and color.

CATERPILLAR

Like its other manifestation, the **BUTTERFLY**, the colorful caterpillar lends itself well to a realistic and richly colored type of tattoo. Its symbolic association with transformation is directly linked to its life cycle of larva, chrysalis, and butterfly. And although crawling creatures are sometimes feared and insects sometimes viewed as ugly, the caterpillar offers something both visually and symbolically attractive in terms of life change.

CATERPILLAR WITH HOOKAH

One of the cast of characters from Lewis Carroll's *Alice in Wonderland,* the large blue caterpillar who sits atop a **MUSHROOM** and lazily smokes a hookah pipe is an image that has resonated with tattoo wearers. It symbolizes the utterly relaxed smoking experience of the typical tobacco water pipe on one level, but also hints at the possibility of the pipe containing a narcotic. Add to that the fact that as the caterpillar departs the scene, he tells Alice that if she eats from one side of the mushroom she'll grow smaller and if she eats from the opposite side she'll grow taller, another hint at hallucinatory **DRUGS** (among others sprinkled throughout the book).

CATFISH

Immediately identifiable by their "whiskers," which are actually feelers, catfish vary considerably in size and some can grow quite large. In Japanese artwork, including tattoo, this FISH is mythically linked with earthquakes. Living in a part of the Pacific Rim that is subject to occasionally devastating earthquakes, the Japanese attributed the movement of the earth to *Namazu,* a monstrous catfish that kept the land afloat. When it flipped, it would cause an earthquake. Images of Namazu are not just illustrations of the legend. They are also intended to cheer the survivors of past earthquakes.

CAVE PAINTING

During the Upper Paleolithic period, just before the end of the last ice age in Europe (15,000 to 10,000 B.C.E.), humans lived in small bands, hunting migratory animals and creating some of the most spectacular cave paintings known to exist. Most surviving examples have been found in France and Spain. The simplest figures are only outline drawings, but the majority combine this technique with sophisticated shading and color washes that suggest the differing textures of pelts, horn, and BONE. We may never know exactly why and by whom these ancient images were created, nor their meanings. But they resonate in tattoo imagery as something primal, a connection to a past that, although distant in time, seems vibrantly present in the masterful images that are left to us.

CELTIC BIRD

Created in the Monastery of Lindisfarne, on Holy Island, just off the northeast coast of England, the Lindisfarne Gospels date from about C.E. 698 and they are a rich source of Celtic artwork. Illustrated manuscripts such as this were created by monks who showed their devotion by painstakingly copying and illuminating (decorating with bright color) the Word of God. Celtic tattoo designs borrow heavily from these types of manuscripts and typically feature the ornate and interwoven animals, people, and letters that accompany the text. Celtic KNOTWORK birds such as

those found in the Lindisfarne Gospels show just enough of the animal (head with beak and some FEATHERS) to identify it as a BIRD.

CELTIC CAT

Unlike many other Indo-European cultures (of whom they were one), the Celts did not revere CATS. In mythology, cats serve in archetypal guardian roles as both demons and ANGELS—guarding the gates of the Otherworld, able to shape-shift into a ball of fire and even steal humans.

CELTIC CROSS

The Celtic Cross, sometimes also known as the WHEEL CROSS or the Ring Cross, which began to appear during the fifth century C.E., is a symbol of Christianity today, even though it may have been derived from much earlier pagan wheel symbols for the SUN. Although most commonly used to mark gravestones in Ireland and Scotland, it was once used throughout Scandinavia, where it was erected at sites of violence or accident, as well as in front of farmhouses. It has, unfortunately, been adopted by neo-Nazi and white supremacist movements, including the Ku Klux Klan.

CELTIC DEER

The DEER is a prominent animal in the bestiary of Celtic art and Celtic tattoo art. Considered the oldest creature in existence, the deer is presented in the complex interlocked form typical of Celtic art. It was the principal animal hunted by the Celts for food, and in images it was combined with their gods in both male/stag (Cernunnos) and female/doe (Saba, Flidais) form. In Celtic myth, the appearance of a white stag from the Otherworld signaled that a profound change was about to take place, while a normal stag could lead souls through the dark forests.

CELTIC DOG

Many Celtic myths contain references to DOGS but, like CATS, their roles are ambivalent. Dogs or dog familiars (spirits embodied in an animal and

believed to attend, serve, or guard a person) belonged to the heroic figures and the gods. Their owners would even sometimes engage in wars over these animals. In a more negative characterization, though, animal spirits were also thought to be shape-shifters, able to change form at will.

CELTIC DRAGON

The Celtic dragon represents the often-paired features of both sovereignty and power. It was emblazoned on King Arthur's helmet, and the red dragon is today still an official emblem of Wales. In all instances, the western dragon exemplifies elemental power, especially of the earth, as they typically dwell in dark caves, guarding their treasure hoards. The dragon, like the serpent that it resembles, has also been associated with the DEVIL and sin. When Christian hero knights in shining armor such as ST. GEORGE and St. Michael slew dragons after long and dangerous battles, they were slaying evil. The Celtic or western dragon is usually shown with batlike wings and breathing fire. In tattoo art, dragons take these same characteristics and are representative of mythical power and mystery.

CELTIC SUN

The Celtic sun is actually a combination of two traditions. The circular SUN, with rays, is a universal symbol for cultures all over the earth. The circular PICTISH CIRCLE or Celtic KNOTWORK that occupies the center of the sun is the second tradition. Because tattoos using sun symbolism and Celtic knotwork are both popular, the melding of such symbols in tattoo is a natural progression.

CELTIC TREE OF LIFE

The Celtic Tree of Life is a design that is repeated throughout the great illuminated manuscripts that have made the abstract KNOTWORK art of the Celts famous. Like the more general TREE OF LIFE designs that arise the world over, it is a central axis type of symbol, connecting heaven with earth, and symbolizing both the growth of life and the annual change of the seasons. It is known from the Pictish stones of eighth-century Scotland and also hearkens back to the pre-Christian religions that centered around nature.

CELTIC WEDDING RING

The Celtic wedding ring tattoo is exactly what the name implies. Although not done in ancient times, the popularity of Celtic artwork in tattoo and in jewelry combine in a design for the finger that substitutes for a traditional ring with the same meaning—a symbol of unending love and marriage. The circular shape of the wedding ring is ideally suited to the endless strand of the interwoven KNOTWORK band.

CENTAUR

The centaur is a mythical creature with a HORSE's body and a human torso attached where the horse's neck would be. According to the Greeks, centaurs lived in the mountains and the forests, could not drink wine without getting drunk, and were prone to rape mortal women if they came across them. They are embodiments of discord and tension—the pull between the instinct of nature and the judgment of man. Their legend is believed to have originated as a recollection of the first sightings of nomads on horseback from the steppes of Asia—a frightening sight to the sedentary peoples of the Mediterranean. Centaurs came to symbolize animalism, untamed nature, and lack of self-control.

CENTIPEDE

Like CATERPILLARS and BEETLES, the centipede enjoys a usage in tattoo art that celebrates the vibrant colors and meandering shapes that can be created with them. In some native North American cultures, the centipede could travel between the Underworld, where humans originally came from, and the physical world where we live, and were thus potent sources of power. In the Puebloan Southwest, the Hopi, the Zuni, and the Mimbres regarded the centipede as a symbol of the transition from the world of the living to the world of the dead, and considered it taboo.

CERBERUS

Cerberus is the archetypal hellhound, the three-headed, dragon-tailed DOG of ancient Greece and Scandinavia who stood guard at the gate to the

Underworld, barring entrance to the living and exit to the dead. He was the offspring of the giant Typhon and the half-woman, half-dragon, Echidna. As the "Hound of Hades" he symbolizes the terrors of death and has been generalized as the hell to be found within each individual.

CHAINS

Although a chain is sometimes used in prison tattoo to symbolize incarceration, chains also have a wider symbolism that can relate to slavery and defeat. When broken, though, they symbolize just the opposite—release, be it physical, mental, or both. Unbroken chains are sometimes also linked with subservience in religious matters and are even symbolic of bonds, such as in **FREEMASONRY**.

CHALICE

The chalice has general symbolic meaning as a vessel of plenty. But the majority of chalice symbolism in the West and in tattoo imagery is derived from Christian themes. In one instance, it represents the Holy **GRAIL**, the famous cup that was either used by Christ at the first Eucharist during the Passover celebration just prior to his **CRUCIFIXION**, or in some versions was the vessel used to gather **BLOOD** from the lance wound that he received on the cross. As the Holy Grail, the chalice is symbolic of a higher purpose and sacred quest or journey in search of it. In a combination of the more widespread symbolism of plenty and the Holy Grail legends, drinking from the chalice is said to grant immortality. In the second instance, Christian imagery also uses the chalice to symbolize the Eucharist as it is known today in ritual, with the eating of bread and drinking of wine. In this sense, it is still associated with the blood of Christ but in terms of redemption from sin.

CHEETAH

The cheetah, from the Hindi word "*chita*," for "spotted one," is the fastest land animal in the world, capable of reaching speeds up to 70 mph. Throughout history, as far back as some 5,000 years ago in Sumeria, cheetahs have been considered exotic and beautiful big cats and their hides have symbolized both wealth and kingship. Their use as images in tattoo capitalizes on all these qualities, although cheetahs are usually portrayed at rest in a regal pose.

CHERRY (CHERRIES)

Cherries have been used to symbolize feminine beauty as well as love and even divination. In ancient China they were a symbol of immortality or longevity. In Japan, the cherry was the **SAMURAI**'s symbol. For these warriors, the crushing of the fruit's flesh (to reach the hard pit within) was a symbol of sacrificing human flesh to get to the core of the person. In tattoo artwork, it is not uncommon to see the cherries paired, as they might come in nature. They can appear by themselves or sometimes in the mouth of a classic **SWALLOW**. In these Western contexts, they take on a sexual overtone about virginity (and its loss) that is variously interpreted as "Gone forever" or "Here's mine, Where's yours?"

CHERRY BLOSSOM

While the **CHERRY** fruit was a symbol used to represent the **SAMURAI** warrior caste of shogun-era Japan, it is the blossom of a tree that is quintessentially Japanese and figures prominently in Japanese tattoo art. The brief and beautiful period of flowering and the swift fading and subsequent scattering of petals in the wind symbolize the fragility of human existence and also the perfect death, marked by indifference to the world left behind. Combined with its association with purity, it became the ultimate emblem of *bushido*, the warrior's code. The ideal **SAMURAI**, a combination warrior and sometime poet or artist, was ever ready to meet his death, ever appreciative of the fleeting moment.

CHERUB

Although cherubs (or cherubim) are likely derived from ancient Middle Eastern mythology and iconography, they feature prominently in Islamic as well as Jewish and Christian belief as one of the highest ranking of the classes of angels. In scripture, they are portrayed as awe-inspiring attendants of the Almighty Himself, with multiple sets of **WINGS**. But later Christian art gives us the image that is generally associated with them today, and the one that is used most frequently in tattoo art—that of small

children, who are nevertheless still angels, with wings, and privileged by being in the presence of God. In tattoo art, cherubs oftentimes take on the role of benevolent guardians, sometimes at play, sometimes quietly observing.

CHESHIRE CAT

The Cheshire Cat of Lewis Carroll's famous children's tale *Alice in Wonderland* is known for his grin that is ever present, even when the rest of him becomes invisible. Out of the many characters in Wonderland, he is one of the more popular for several reasons. The fact that he is one of the few friendly characters that Alice encounters on her adventures is one reason. In a deeper sense, though, most people find a smile calming and pleasant, even irresistible. And in this particular case, the smile is also an interesting and unsolved riddle, since the reason for his grin is never revealed.

CHINESE IMPERIAL DRAGON

The Chinese imperial dragon was the emblem of the emperor and represented his power and authority to mediate between heaven and earth. Although dragons had long been considered symbols of rain, fertility, male energy, and happiness, the turquoise dragon was officially adopted by the Han dynasty (206 B.C.E.–C.E. 220) as a representation of the emperor. The "dragon's face" was the emperor's face, the "dragon's pearl" was the perfection of the emperor's thoughts and commands. The imperial dragon was distinguished from lesser dragons by being the only one with five claws (instead of four), said to be derived from the ability of the Dragon King to issue commands by moving in four directions simultaneously while remaining in the center, the fifth direction. The dragon is also the fifth creature of the CHINESE ZODIAC. Persons born in a dragon year are strong willed and usually successful, either marrying young or staying single.

CHOLLO

In prison culture, tattoos are very much divided into ethnic styles. The *chollo* or *pachuco* (a young Mexican-American man who typically wears a

wide-brim hat and a zoot suit) is a tattoo used by Hispanic convicts and gang members to signify membership. The *pachuco* is portrayed either in full figure or simply as a face, with the hat pulled down and a drooping mustache.

CHRISTIAN FISH

One of the earliest symbols for Christ, the **FISH** symbol is derived from a Greek acronym for his name and titles. *"Iesous Christos, Theou Uios,*

Soter" means in English "Jesus Christ, God's Son, Savior." The initials spell *ichthus,* which is Greek for "fish" (*ch* and *th* are each one letter in Greek). Early Christians used the symbol as a covert means of identification in order to escape persecution.

CHRYSANTHEMUM

First exhibited in England in 1795, the chrysanthemum has acquired differing symbolism throughout Europe. The word "chrysanthemum" comes from the Greek words meaning "golden **FLOWER**," but a German legend refers to two white chrysanthemums that materialized in the guise of an old man in front of the home of a poor family who had sheltered the Christ Child. In Italy, their exclusive association with the dead makes chrysanthemums acceptable only for funerals. The numerous ordered petals have also been associated with **SUN** symbolism and so also with longevity. Although chrysanthemums generally denote cheerfulness and rest, individual colors can carry specific messages: red for love, good luck, and best wishes; white for truth; and yellow for slighted love.

CHRYSANTHEMUM (JAPANESE)

Chrysanthemums (sometimes also called mums) were being cultivated in China as many as 2,700 years ago and were brought to Japan by Buddhist monks in C.E. 400. Like the **CHERRY BLOSSOM**, the chrysanthemum figures prominently in Japanese tattoo art. It has long been associated with Japanese royalty, where the emperor sat on a chrysan-

themum throne, and used for medicinal purposes, where a chrysanthe-mum petal placed in the bottom of a wineglass encourages a long and healthy life. In tattoo art it symbolizes steadfastness and determination.

CIGARETTE/CIGAR

The symbolism of the cigarette and the cigar have fluctuated in the same way that their popularity has over time. Originally they were a symbol of daring and forbidden behavior, something of which survives in tattoo art, with a pack of cigarettes accompanying other favorite vices in various designs. As their health consequences were documented and smoking was actively discouraged by the U.S. Surgeon General, they became more a symbol of unwanted addiction. And while their similarity to other phallic symbols is obvious, it was Sigmund Freud who said, "Sometimes a cigar is just a cigar."

CIRCLE

The circle is simply the most important and universal geometric symbol. And like other fundamental and simple symbols, it has radically different meanings and is nearly impossible to interpret when it appears in isolation. Most conventionally, the circle is a solar or lunar symbol. It can symbolize unity and singularity or it can mean inclusiveness. It has been used to represent completeness, but also something without beginning or end. It has been used to symbolize the wheel, as the basis of the MANDALA, in the form of rings and bracelets, as a letter (or part of one) in countless alphabets, and as the number zero. There is no end to the specific uses to which the circle has been applied nor to the meanings that have been ascribed to it.

CLADDAGH

The *claddagh* is an Irish symbol of love and friend-ship. Typically, the *claddagh* consists of two hands, a HEART, and a CROWN. The two hands represent friendship, the crown loy-alty, and the heart, of course, love. The ori-gin of this modern betrothal symbol may actually go back some four hundred years to a small

fishing village of the same name in the Galway Bay region of Ireland. It may have originated as an identifiable marking for the sails of boats there, but it eventually came to be used most regularly as a betrothal ring—invented perhaps in 1689 by a native Galway jeweler who had been captured by pirates but returned safely to his true love after five years away. Alternatively, the *claddagh* ring may have been brought back from the Crusades by a young man who had been captured by the Saracens. While the origin of this symbol is likely lost to time, the meaning is clear. It is a pledge of friendship, loyalty, and love and a message that the bearer is "spoken for."

CLIPPER SHIP

See **FULL-RIGGED SHIP**.

CLOCK

A clock or watch face symbolizes the very thing that it tracks—the passage of time. In the world of prison tattoo, timepieces symbolize sentences being served. An **HOURGLASS** can symbolize prison time being done and clock faces without hands stand for doing time.

CLOTHESLINE

In the world of maritime tattoo, there are numerous esoteric symbols whose origins have become obscured and been lost. According to old school tattooist Doc Webb, sailors got a clothesline tattoo after they had made their second cruise. But it wasn't just any old clothesline—it was hung with men's skivvies that had girls' stockings between them.

CLOUD

Clouds are naturally associated with the sky and also, by extension, with heaven. In paintings depicting Christian conceptions of heaven, clouds form the throne of God. In Islam, the cloud symbolizes the inscrutability of Allah. In several religions clouds bring rain and thus fertility, but they need to be struck by **THUNDERBOLTS** in order to release the water. In ancient China, some clouds were seen as peace symbols. Japanese tattoo imagery draws from the Chinese, using spirals and abstract portrayals, especially in combination with mythical creatures or gods that are associ-

ated with the sky. In Western tattoo art, clouds are often shown realistically, accompanying the **SUN** and **MOON** or sometimes with heavenly inhabitants.

CLOVER

The clover is sometimes thought of as synonymous with the **SHAMROCK**, although the two are not actually the same. Clover is one of a group of plants (*Trifolium*) that are generally three-leafed. Originally, properties of the plant such as being full of life and robust came to be associated with living well and prosperously ("in clover" or "in the clover"). Clover was also planted on graves, probably as a reference to a new life either after death or at the resurrection. The notion that clover was associated with luck is the result of the four-leaf clover, because of its rarity. Thus, a good luck tattoo is generally a four-leaf clover.

CLOWN

The clown, with his big red nose, white makeup, exaggerated **SMILE**, baggy clothes, oversize shoes, and crazy hair, is mostly used as a symbol of playfulness, laughter, and fun in tattoo art. Historically, the clown face can also be a sad one, complete with tears, and most often associated with tragic irony. But in ancient times, the clown stood for the reversal of the norm. He played the fool to the majesty of the king, as he mocked authority, parodied the establishment, and ridiculed that which was accepted, all in the guise of entertainment and inducing laughter.

CLOWN, DEMENTED

Playing on the darker side of the **CLOWN**, and his dual role of fool and **JESTER**, the demented or evil clown substitutes a playful **SMILE** or a downturned mouth with a sinister grin. In works of fiction, the clown has often been changed from an entertaining character to a malevolent one, capitalizing on the unexpected and the reversal of roles to generate fear. Tattoo art probably uses more of these types of clown and jester images than the standard clown, a type familiar from the circus. Although the occasional

clown trapping may be present (extreme makeup, a strange hat, a bulb nose) these clowns are altered to make them more antisocial (say, an **EIGHT BALL** for the bulb nose) with a distorted face under the paint. Here the image is not intended to convey fun or play but rather something to be feared and perhaps treated respectfully from a distance.

CLUBS

Clubs is the suit of lowest value in an ordinary deck of playing cards. However, the three-leaf symbol comes from the fifteenth century, where it was associated with money, wealth, and luck. Used in tattoo art, it is sometimes shown on a playing card in games of chance and sometimes as part of a suite of good luck symbols, especially those associated with gambling.

COAT OF ARMS

Often confused with the family crest, the coat of arms includes the family crest in addition to a **SHIELD**. Both are a means of displaying one's heritage. In England, direct descent is required for an heir to have the legal right to display his ancestor's coat of arms. In other countries it is not uncommon for several different people to share a coat of arms. In essence, the coat of arms is itself a composition of specific parts and symbols, each with its own name and significance, of particular meaning to ancestors and then inherited by their descendants. The use of a coat of arms began in the Middle Ages simply as a means of identi-

fying individuals or families. While the use of personal and family insignia is ancient (it is mentioned by Homer), European heraldry proper is a feudal institution developed by noblemen for seals and shields.

COBRA

Cobra symbolism is essentially **SNAKE** symbolism, with mainly all of the same associations. The cobra, though, is a particularly identifiable species because of its inflatable neck hood. Indian and Egyptian cobras are often the types of snakes displayed by snake charmers. The cobras appear to re-

spond to the music played by the charmer, but, like all snakes, they are deaf and only follow his movements. All cobras, however, are quite venomous and the king cobra is the largest of all venomous snakes. The most famous use of cobra symbolism is that of the royal Egyptian uraeus, worn at the forehead of the pharaoh to represent sovereignty, knowledge, life, and youth.

COD (HAIDA)

Unlike other traditional tattoos of the early Pacific Northwest, the cod is not a mythical or powerful creature. To the Haida, who inhabited this part of North America centuries before the arrival of Europeans, the cod was an important food and it was held in high respect. In order to appease the supernatural beings of the sea and seek success in **WHALE** hunting, offerings of cod (along with grease and tobacco) were made, with the hands held high, and the palms turned out, as in this tattoo design that was noted "on the chest of a Haida chief." (Note how the upward-facing crescents resemble hands and the divided tail might be two arms.)

COLUMN

One might not think that architectural elements would find their way into tattoo imagery, but there is very little that does not. Indeed, some columns are very distinctive—Egyptian columns with papyrus-leaf decorations at the top or fluted Greek columns topped with scrolling spirals. Symbolically, the column is not only a support but also an association with ancient knowledge (as in a library) and is also not unlike an **AXIS MUNDI**, linking different levels of a building or consciousness. And, in keeping with the notion of support, it is not unusual to see columns tattooed on legs and even arms, where the long expanse of available skin is ideal for placement.

COMEDY AND TRAGEDY

The comedy and tragedy masks are symbolic of the theatrical arts. They are derived from the important role that they played in ancient Greek

drama, giving actors the ability to switch from one character to another easily, with the simple change of a mask. In prison tattoo, a laughing face and a crying face are used to symbolize the notion of play now, pay later.

COMET

Throughout recorded history, comets have captured the imagination of humans. They appear unexpectedly, are unlike any other **SKY** phenomena, and disappear mysteriously. The appearance of Halley's comet shortly before the Battle of Hastings in 1066 ended up being a good omen for William the Conqueror. Augustus Caesar used the appearance of a comet to claim that it was the soul of his adopted father Julius Caesar being taken into the heavens and that he and Julius were both, therefore, godly. Today, comets are seen much less mysteriously but their symbolism hearkens back to earlier times. They are used to represent the exceptional and the brilliant, or something particularly insightful or unusual. Along with a host of other astronomical bodies depicted in tattoo art, they lend themselves to vivid and colorful treatments.

COMPASS

Compasses are usually portrayed in tattoo art as they are in classic map art, using the "compass rose," the **CIRCLE** with numerous triangular points, evenly spaced, and radiating outward from the center, with the longest being at the cardinal directions of north, south, east, and west. Occasionally, this artwork hearkens back to more ornately designed antique maps with mythic sea creatures and gods surrounding the compass. Their symbolism in all cases, though, is that of the circle, but with the added specific meaning of direction-finding. Symbolic of journey or adventure, the compass can also take on the more psychological aspects of guidance and the capacity to receive or give it.

CONCENTRATION CAMP NUMBERS

This is not a tattoo symbol that was willingly received and it is not much imitated today, despite widespread knowledge of its existence. In the Nazi concentration camps of Auschwitz, during the Second World War, prison-

ers were tattooed with identification numbers that were used primarily to identify corpses, because the death rate was so high. Begun in 1941 by hospital staffers using indelible ink on the chests of ill prisoners, tattooing became routine when the mass extermination of Soviet prisoners-of-war that year made it difficult to maintain records. Later, Poles and Jews at Auschwitz (the only concentration camp to systematically use tattooing) also received tattoos, typically on the left forearm. Today these tattoos are a testament to the utter brutality and inhumanity of which humans are capable, as well as the resilience and unbreakable spirit of the survivors.

CONFEDERATE BATTLE FLAG

The Confederate Battle Flag, never adopted as the official flag of the Confederacy (which used instead the Stars and Bars and others), was first called for by General Beauregard after much confusion over identity of troops on the battlefield during the battle of Manassas (1861), the first major battle of the American Civil War. It was designed specifically for the purpose of distinguishing it from the Stars and Stripes of the northern troops during battle. It is based on the DIAGONAL CROSS of St. Andrew (as is the UNION JACK). The field is red, the cross or giant "x" in the middle is blue, bordered with white, and the thirteen five-pointed STARS within the cross are white. Today there is much controversy over the use of the Confederate Battle Flag. While for many it symbolizes the "lost cause" and sacrifice of many southern lives, for others it is symbolic of white supremacists (who have adopted it) and the slavery associated with southern plantations.

CONQUERING MESSIAH

The conquering messiah is an interesting cross of both Judaic and later Christian imagery. In Hebrew, "messiah" means "anointed one," someone set apart for a specific purpose. Many times Hebrew holy scripture prophesies a divinely appointed ruler who would one day restore the glory of Israel and protect it. Under the rule of Assyrians, Babylonians, and the Romans, the Israelites prayed and hoped for a messiah who would deliver them from their oppressors. But it is not until the Christian Book of Reve-

lation (Chapter 19) that a physical description of the returning messiah is found: He sits upon a white **HORSE**, his eyes like flames of fire, a sharp **SWORD** issuing from his mouth, wearing a robe dipped in **BLOOD** and inscribed with "King of kings and Lord of lords." Clearly, the conquering messiah symbolizes both physical and allegorical triumph, long awaited.

COPTIC CROSS

The Coptic cross is ornate and patterned, reflecting the cultural influences of Egypt and Ethiopia, where most of the members of the Coptic church reside and practice. The first Coptic church was founded in the sixth century in Egypt as a rebellion against the Orthodox church and even today it claims to practice a more original Christian doctrine than either the Greek Orthodox or Roman Catholic churches.

CORNUCOPIA

The cornucopia, or the horn of plenty, comes from Greek mythology and was a **GOAT** horn that would fill itself with whatever food or drink the owner requested. A gift from the unpredictable gods, the horn of plenty symbolized a sort of windfall, an unexpected profusion of gifts. Today, the horn of plenty is more usually depicted as a basket from which spills the harvest of the autumn season and the symbolism has also changed slightly with additional connotations of hard work and hospitality. The cascading flow of produce from the horn makes it ideal for body placement on the limbs, and colors are largely those of fall with browns and oranges dominating, and some green as well.

COUGAR

Also known as the mountain lion or puma, the cougar is the largest carnivore in North America and can hunt animals three to four times its size. In terms of symbolism, the cougar sometimes functions in a similar way to the **JAGUAR** in Mesoamerican culture: as a totemic animal, an animal that serves as an emblem for a family or clan, or even as a mythic ancestor. These types of powerful animals are also frequent symbols of traditional

SHAMANS. The helper animal may appear in a vision to an initiate and remain a special spiritual companion for the rest of his life.

COWBOY

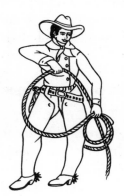

Although no longer a popular style of tattoo, these bits of Americana were a mainstay for tattoo artists at the turn of the last century. Immortalized in history and folklore, the American cowboy stood for rugged individualism. Likewise, the rodeo cowboy symbolized the work hard and play hard ethic that characterized the life of these ropers and riders.

COWGIRL

The cowgirl, like the **COWBOY**, was part of the rural American experience when this type of tattoo was most popular, near the turn of the last century. Although today the cowgirl is most definitely a pinup girl and an American sex symbol, the pretty cowgirl tattoo of times past might have included ringlet curls under a stylish hat, or a short buckskin skirt with boots.

COW SKULL

Sometimes also combined with Native American symbols such as **SHIELDS**, beads, or bird **FEATHERS**, the cow **SKULL** becomes much like the symbol of the **BUFFALO SKULL**, a source of ritual and otherworldly power. A favorite art subject of painter Georgia O'Keeffe, the bleached white cow skull has become a more generic symbol of the American Southwest. Skulls carry more symbolism than other animal **BONES**, possibly because they are more representative or indicative of the animal when it was alive. Bones in general are the last remnants of a body, animal or human, and so also carry a sense of death and the impermanence of life.

COYOTE

Almost universally in Native American mythology, the coyote plays and symbolizes a dual role. Frequently he is considered the creator but also the trickster, and sometimes the source of death being introduced to humankind. Like other Native American imagery, the coyote has been co-opted by modern Southwestern culture and can be seen in many images with the full MOON or perhaps next to a cactus.

CRAB

The crab is a symbol for the ZODIAC sign of CANCER, but it has also been used as a metaphor for negative behavior (owing no doubt to its intimidating appearance) and also as a metaphor for the sea and the abundant life there. In many cultures and time periods, the crab plays various roles in mythology, both major and minor, and is also used in rain ceremonies, since it is a creature of the water. For the Cambodians the crab is good luck, while in China crabs were once thought crafty because of their sideways walk. The variety of species, their brilliant yellow to red tones, and their use in cool blue seascapes have made them well suited to tattoo art, alone or in concert with other sea creatures.

CRANE

The crane is one of the few animals whose symbolism runs very deep in both Eastern and Western cultures. In the West, the crane has long been an object of marvel because of its wingspan and ability to fly long distances. The Egyptians revered the BIRD, which was also known as a killer of SNAKES. Its mating dance provided the model for the "crane dance," celebrated in the Greek world as the sublime expression of the joy of life and love.

CRANE (JAPANESE)

In the Far East, the CRANE has been widely revered as a symbol of longevity, wisdom, good fortune, and fidelity, since these BIRDS mate for life. Many times in Chinese and Japanese art and in Japanese tattoo imagery, the crane is paired with other symbols of longevity such as pine

trees, tortoises, stones, or bamboo. Cranes are also depicted accompanying the SUN, a symbol of social ambition. While the Japanese believed that cranes lived thousands of years, Taoists associated them with immortality. With their pure white body FEATHERS, the black feathers of the neck and the trailing edges of their long WINGS, and a small patch of red feathers on the crown of their heads, much of their beauty in tattoo imagery is derived from the shading of the feathered wings and the judicious juxtaposition of a limited number of colors.

CREATION OF ADAM

"The Creation of Adam" is one of the scenes on the ceiling of the Sistine Chapel of the Vatican, painted by Michelangelo sometime between 1508 and 1512. It shows the languid and reclining form of Adam on the left as he reaches his left hand out toward God. From the right, a white-bearded God the Father, surrounded by ANGELS, his robe and hair flowing in the wind, reaches out his vital hand toward Adam, their index fingers about to touch. Tattoo artists re-create many famous works of art for their customers, some of which are altered in the process. Sometimes this entire scene is rendered and sometimes just the hands. However, in keeping with the ironic and rebellious tradition that tattoo art has in the West, this particular image has been seen with God the Father holding out a beer bottle that Adam is about to grasp. In both tattoo imagery and personal symbolism, nothing is sacred.

CRESCENT MOON

The crescent is one shape that best characterizes the phases of the MOON and is the most frequent symbol for it. Because of the moon's cyclical and changing nature, it in turn is symbolic of the female, of transformation, and of fertility in many cultures and has been associated with such female gods as Artemis. In tattoo art, the crescent moon also juxtaposes nicely with the circular SUN and sometimes both are given facial features to personify them.

CRESCENT MOON WITH STAR

The crescent moon with star is the general symbol for the Islamic faith, representing the waning **MOON** with the **MORNING STAR**. The five points of the **STAR** represent the five pillars of Islam, the Muslim religion founded by the prophet Mohammed: the profession of faith; prayer; giving of a small percentage of one's income to help the poor; fasting in the month of Ramadan; and pilgrimage to the holy city of Mecca. The crescent moon was the symbol of Constantinople (now Istanbul), the capital city of the Eastern Roman Empire, Byzantium. When the Turks conquered Constantinople, they also adopted the city's symbol, appropriating it for the Ottoman-Turkish Empire. Eventually its use spread to the flags of Islamic countries.

CRICKET

Crickets play a large role in myth and superstition, both around the Mediterranean and in the Far East, and are generally equated with good fortune and intelligence. In China, crickets were bred especially for their singing (chirping) and were sometimes kept in little golden cages. In addition, cricket fighting was a sport in China, so they have also become a symbol of fighting spirit.

CRIPS

Despite the rise of Los Angeles gangs such as the Crips as recently as the 1940s, the meaning or origin of the name is unknown. Most sources claim that the name arose from the word "cribs," part of a name for a group that went by "Baby Avenues" or "Avenue Cribs," names themselves taken from an older gang called "The Avenues." The Crips today are spread nationwide. The "Crips" tattoo is a sign of membership done in the gang style—with Old English or Gothic style lettering. Many of these tattoos have only a "C" incorporated into an acronym or part of the design.

CROSSED CROSS

The so-called crossed cross is a symbol of world evangelization. It is essentially four LATIN CROSSES, all touching at their bases, forming a larger cross of equal lengths overall. Here the compass aspect of the cross of equal lengths is exploited, with the small crosses radiating out in the four directions.

CROSSED SWORDS

The symbol of crossed swords is sometimes drawn schematically, where the "SWORDS" are nothing more than stick versions of swords and inverted LATIN CROSSES, but it is nevertheless associated with death. Whether in this schematic form or with more realistic swords, the crossed swords are a symbol for battle and military power. In tattoo imagery, the crossed swords (like the SKULL AND CROSSBONES) are associated with violence and are even reminiscent of maritime tattoos of pirates and their flags.

CROSS GEMMATA

The *crux gemmata* is, quite literally, the gemmed cross and is a Christian, albeit opulent, symbol—studded with gems along both axes. In some forms, the gems number thirteen, representing Christ and the twelve apostles (arranged five across and nine down, sharing one gem).

CROSSHAIRS

Crosshairs refer to the eyepiece of an optical aid on firearms that helps the user aim it accurately. In tattoo imagery, this type of image is typically antisocial in nature, with some object of hate placed in the center of the crosshair (usually shown as a circular field of view with two lines crossing directly in the center).

CROSS OF EQUAL LENGTHS

The cross with arms of equal length (looking exactly like a "+" sign) is probably the oldest form of the cross. In Europe, it is found in prehistoric cave art. In ancient North America, it may be associated with the four directions. In the earliest Chinese writing, it is a sign for perfection. In as-

trology it is a sign for physical matter. Along with the CIRCLE, and many times united with it, the cross of equal lengths is one of the most common of the basic symbols. The capability of these basic symbols to encompass opposite meanings is as true in this case as with the circle. In logic and mathematics, it is a sign that unites. In cartography, it separates. Used to mean "positive" in many cultures, it was also a negative, secret symbol for hobos meaning "here they give nothing." The most ancient example of tattooed skin is that of Otzi, the Bronze Age man of the Swiss Alps. On the inner side of one of his knees, he had a small blue cross of equal lengths (interpreted by some as a medical treatment for arthritis and by others as a sign of group affiliation).

CROSS OF GOLGOTHA

The cross of Golgotha (Hebrew for "SKULL"), also known as Calvary (Latin for "skull"), is named after the place where JESUS was crucified, a hill outside what was then the wall of Jerusalem. The only difference between this cross and the Latin cross is the small, three-tiered pedestal on which the cross stands. The three steps, growing smaller in size at the top, have also been said to symbolize faith, hope, and love. It is a symbol of Christian faith, as are most of the crosses, and it was a favorite in the COAT OF ARMS for crusader KNIGHTS—not surprising in that their campaigns centered on Jerusalem. Although not used much in tattoo imagery per se, its form is reminiscent of the ROCK OF AGES tattoo.

CROSS OF PHILIP

The cross of Philip, one of the twelve apostles, is a LATIN CROSS turned on its side. He was reportedly martyred at Hierapolis of Phrygia on a cross in this position. Again, while this type of cross is not used in tattoo imagery in isolation, it is part of many flag designs, especially in Nordic countries, and finds its way into tattoo symbolism with these sorts of patriotic tattoos. As with the Latin cross, the symbolism is linked directly and overtly to Christianity.

CROSS OF THE ARCHANGELS

The cross of the archangels is almost exactly the same as the CROSS OF GOLGOTHA, with the addition of another cross member, smaller and above the

main crossing member, as though for emphasis or higher rank. This emphasis is symbolic of the higher order of the arch, or "chief," of ANGELS. While ordinary angels protect individual humans, it is the archangels who protect the religion.

CROSS OF THE EVANGELISTS

The cross of the evangelists is an interesting combination of the CROSS OF EQUAL LENGTHS and the CROSS OF GOLGOTHA. It is, in fact, a cross of equal lengths surmounting a four-tiered pedestal. The cross and the pedestal symbolize the four evangelists and the authors of the four gospels— Matthew, Mark, Luke, and John.

CROSS OF THE POPE

The cross of the pope (or the Western triple cross) is a standard Latin cross but with three horizontal beams, each one successively shorter the higher it appears. The three beams represent the pope's triple role as the highest priest, the highest teacher, and the chief shepherd. He is also, as Christ's representative on earth, a coruler of heaven, earth, and hell. The triple nature of this cross (or even the three steps of the CROSS OF GOLGOTHA) hearken back to the divine nature of the number three in most cultures and certainly in Christianity.

CROSS OVER GLOBE

The cross over globe (or orb) is a symbol of both Christian evangelization (the Christian symbol sitting above the world) and for kingly rule. Roman emperors used a globe topped with the goddess of victory. She was replaced with the Christian cross by the Byzantine emperors. In Christian art, the cross will sometimes appear atop a scepter held by Jesus, combining both traditional uses.

CROSS, THREE CROWNS, AND STAR

This Coptic tattoo design, based on a woodblock stamp, combines several symbols into one. The main cross has a bar at the end of each arm, with a similar small cross in each of its quarters (also known as the JERUSALEM CROSS). Above the cross are three CROWNS and above the center

crown is a **STAR**, with its lowest point stretched down-ward. At the bottom of the design are two **BRANCHES** joined with a bow. Unlike many other tattoos that denote pilgrimage to Jerusalem, this design symbolizes a pilgrimage to Bethlehem—the three crowns for the three wise men, the star for the star of Bethlehem.

CROW

Very much like the **RAVEN**, it is not surprising that much of mythology does not usually distinguish between these two black **BIRDS**. Despite more recent associations of the bird with death or bad luck, it was actually associated with good aspects in many parts of the world. In both Japan and the Scandinavian countries, a black bird was the messenger of the gods. In Japan and China, it is also a symbol of family affection. In Ireland, the war goddess took the name of "carrion-crow" and often appeared in this shape, and in ancient Greece the crow was sacred to Athena.

CROWN

The crown often symbolizes that which is royal and above the common man, legitimizing the wearer and associating him or her with higher spheres or authority. Many cultures have used crowns of enormous variety to mark not only their leaders but their gods as well. In tattoo art, the crown is used in patriotic imagery for countries where monarchy survives and it is used with irony as well, worn by fools or pretenders. Sometimes **HEARTS** or luck symbols are crowned, where crowning sets a seal of importance or transcendence upon such symbols.

CROWN OF THORNS

The crown of thorns is a Christian symbol for the humiliation and suffering of **JESUS** in his last hours before **CRUCIFIXION**. Called "King of the Jews" by the Romans, they dressed Jesus in a scarlet robe and placed a staff in his right hand as a form of ridicule (Matthew 27). In tattoo art, not only is a suffering Jesus crowned with thorns, but frequently the **SACRED HEART** is as well. Separate from Jesus, the circled vines of thorns that form a crown still symbolize suffering but also selfless service.

CRUCIFIX

Although many times the words "cross" and "crucifix" are used inter-changeably, they are different. The crucifix is the cross with the figure of Christ crucified upon it. It is thus the principal modern icon of the Christian faith and one of the most popu-lar tattoos in the Western world. In many different countries, the crucifix is the focus of altars, both pub-lic and private. Mariners used to believe that a cross or crucifix tattooed on the back would spare them from pun-ishment with the lash. Many people wear the crucifix tat-too as a symbol and even demonstration of their faith while others use them as talismans, much like other religious symbols. The imagery, like all Christian art, ranges from the minimalist abstract version to the finely detailed and ultra-realistically rendered images of the entire CRUCI-FIXION scene.

CRUCIFIXION

Apart from the individual CRUCIFIX, the crucifixion is an oft-invoked image in Christian tattoo symbolism. From the moment that Christ is first made to carry his cross through the streets of Jerusalem, to the moment of his death between the two thieves on GOLGOTHA, many different tableaux have been captured by artists, including tattooists. Apart from depicting the different significant points of the story, tattoos of the crucifixion are obviously symbols of Christian faith. In order to show a complete scene, tattoos of crucifixion imagery are usually larger in size, as in a back piece.

CRUTCH CROSS

The crutch cross (or St. Anthony's cross, after a crutch or walking stick used by him) was a favorite symbol in Austria and Germany, serving first in the standards of the crusaders and Teutonic KNIGHTS of the thirteenth and fourteenth centuries and later as an anti-Nazi symbol. It is essentially a CROSS OF EQUAL LENGTHS, with small bars at the outer ends.

CRYSTALS

Crystals have held a fascination for humans from the earliest of times, most often associated with spiritual and supernatural powers. A crystal embodies not only the material and the solid, but also the transparent and immaterial, combining the two as little else in nature. They have become symbols of divination and wisdom, and spiritual insight in general. Today crystals figure in New Age spiritualism and are used to promote health and healing, not unlike the shamanistic uses to which they have been put pre-historically in many societies. Tattoos of crystals are almost always in conjunction with other spiritual or religious elements and take on the cooler and more common crystal colors from white to purple. The crystal BALL is another form of these materials, with similar symbolic associations, including fortune-telling or visions of the future.

CUNEIFORM

Cuneiform is the distinct system of ancient writing that was used in the Middle East as far back as 4000 B.C.E. The small but pointy and elongated triangles were likely formed by pressing a small wedge into the small tablets of wet clay that served as a writing surface. Associated mostly with the Sumerians of southern Mesopotamia, it was adapted and used throughout the region. In tattoo art, as with other writing systems, cuneiform can be used to phonetically spell out modern words or it can be copied directly from ancient texts.

CUPID

The Greek god Eros, also known as the Roman god Cupid, is the god of love, in all of its aspects. He is usually portrayed as a naked, winged boy with a bow and arrow, who shoots mortals (and also the gods) in the heart, enticing them to love. Although sometimes mischievous as a matchmaker, even careless, he nevertheless has been viewed in positive ways. It is a sudden and new love that springs forth, merry and without a care, that Cupid particularly represents. In tattoo art, Cupid often appears in flight, with arrow at the ready, sometimes in combination with a HEART or a PIERCED HEART.

DAGGER

Like most weapons, the dagger is part and parcel of violent aggression. But more than other types of weapons, it has also acquired some of its own specific symbolism. Easier to conceal and draw, the dagger became favored over the **SWORD** as a constant companion, and it became the favorite of assassins, coming to symbolize betrayal and treachery. Daggers in some cultures are of very specific shapes and carry special ritual meaning, such as the three-sided Tibetan *phurba*, which symbolizes the submission of demons.

DAGGER AND SKULL

The **DAGGER** and the **SKULL** both have their own symbolic properties when occurring alone, and a tattoo that combines the two images essentially depicts the meanings of both. The dagger was a favorite weapon among assassins and the skull symbolizes death. In prison tattoo, the dagger through the skull is the symbol of a killer.

DAGGER THROUGH ASIAN HEAD

A racist symbol that became popular in early American tattoo art, this tattoo shows an Asian head with a large **DAGGER** plunged through it, top to bottom, with the blade exiting through the mouth. Asian facial features as well as a queue or single braid of hair are reminiscent of American depictions of Chinese people at the turn of the century.

DAIKOKU

Daikoku is one of Japan's **SEVEN GODS OF GOOD FOR-TUNE** (*Shichi-fuku-jin*) and is the god of wealth and the guardian of farmers. Shown as a fat and happy man, he carries a wish-granting mallet in one hand (sometimes used to strike gold from the Earth) and a large bag of treasures slung over his shoulder in the other, as he sits on two bags of rice. Rats sometimes nibble at the rice, further emphasizing the theme of prosperity. In Japanese tattoo art, the Seven Gods of Good Fortune are sometimes shown together as part of a larger piece or they can be integrated into a bodysuit.

DAISY

FLOWERS are a large part of the repertoire of tattoo artwork, and just as each has its own unique look, each also has its own special meanings. The daisy (from the Old English "day's eye") is a Western symbol, native to Europe. It has come to symbolize not only the coming of spring but also youth and innocence. "As fresh as a daisy" is a phrase dating back to medieval times and the flower has been used not only to foretell whether one will be lucky in love (by picking the petals) but it has also been used for medicinal purposes (applied to bruises, for example). In the fifteenth century, the Christian church adopted it as a symbol of the innocence of the Christ Child, less exotic and pretentious than the **LILY**. Daisies, with their large yellow center and white leaves, are popular in tattoo art—sometimes alone, sometimes in a chain, sometimes with petals in the process of being plucked.

DAVID

Many famous pieces of art find their way into tattoo imagery, including sculpture. While not all fine art is overtly symbolic, much of it does allude to great themes and myths. Michelangelo's fully nude *David* is one such masterpiece, reproduced and copied in infinite forms. A tattoo of David may hold particular personal meaning for the bearer that an observer might never know, perhaps marking a trip to Florence or simply admira-

tion of fine art. But for Michelangelo, choosing David as the subject of his work was not a matter of taste or simply to interpret a story from the Bible. The size of the David statue was meant to proclaim the victorious struggle of Florence, where the sculptor's allegiance lay, to become an independent city-state. In keeping with his story, David came to symbolize both freedom and victory over tremendous odds. As a result of the statue and other artwork that plays upon his theme, David has also come to symbolize beautiful youth and heroism.

DEATH BEFORE DISHONOR

The slogan "Death Before Dishonor," frequently written in a SCROLL coiled around a DAGGER, is a perennially popular military tattoo. The saying was used for military units at least as early as ancient Rome (*"morte prima di disonore"*). Not in so many words, it was also advocated in the Japanese *bushido* code of SAMURAI warriors who would rather die than live with the dishonor brought on by surrender. The ermine, because of the myth that it would prefer death rather than soil its pure white coat, became associated with this phrase. This animal appears on COATS OF ARMS as the emblem of knights who would perform any unpleasant deed and suffer any hardship, including death, rather than stain their reputation and conscience.

DEATH'S-HEAD

Figures of death play a large role in tattoo art. While these depictions are sometimes viewed as macabre, death also symbolizes the impermanent aspect of living. It is all the more symbolic when placed "permanently" on the human canvas, a constant reminder of what

eventually awaits us all. The death's-head, or SKULL, is the epitome of death imagery and is present worldwide. Nothing so represents human death as that most identifiable re-

mainder of the body, the skull. Whether it is used in the current logo of the HELL'S ANGELS, or the SS insignia used by the guards at CONCENTRATION CAMPS, the death's-head still inspires some unconscious, or even conscious, level of fear.

DEER

Although modern Western culture may find the deer a somewhat benign, peaceful, and even bland animal, it has been charged with much symbolism in the past. In Mayan HIEROGLYPHS, the deer was a symbol of drought. Among the Aztecs, the mother of the twin heroes was sometimes depicted as a two-headed deer, and deer were also seen carrying the SUN. Among the people of central Asia, the deer was a conductor of souls (also in Celtic culture and among the indigenous people of Colombia). In many cultures, the robes of SHAMANS were made from deerskin and it was not uncommon for shamans to wear ANTLERS on their heads. Tattoos of deer almost always include antlers, which usually occur on the stags, or males, of the species, but not always, depending on the particular type of deer. Western tattoos capitalize on poses that show these animals as representative of wildlife and nature, but also of independence.

DEVIL

The devil, or Satan, comes in a wide variety of forms in tattoo art—with batlike WINGS and a tail; dressed as a fine gentleman in a suit; with cloven hooves; in a grotesque version of a cathedral COLUMN; as a prince—but the most common is a horned, red demon. The devil is the opposite of the divine and the antithesis of God, obviously associated with evil, but more importantly for tattoo, also associated with temptation. His entire purpose is to deprive humans of the grace of God by tempting them into sinful behavior and causing them to give in to their base desires. The tattoo is sometimes also referred to as "hot stuff" (among other names), using the temperature of Satan's residence to make another allusion to the attractiveness of the bearer of the tattoo.

L GIRL

The devil girl in tattoo art can be seen as a specific form of the pinup girl, but the female demon is also known in myth as the "succubus," the female form of the "incubus." The succubus is a demon in the guise of an intimidating and powerful woman, a domineering temptress using her sexual wiles to lure men into having sex. The succubus and incubus are known in many cultures by various names. They represent temptation, sex, and in the case of a tattoo, giving in to that desire, if only enough to have a pinup girl tattoo.

DHARMA WHEEL

The wheel in Buddhism symbolizes many things but perhaps most fundamental is the concept of dharma, the basic principle of cosmic existence and order and its cyclical nature of rebirth into successive reincarnations. Spokes of the dharma wheel sometimes number four, symbolizing the four "moments" in the life of the Buddha, but more typically they appear with eight spokes, symbolizing the Noble Eightfold Path (a doctrine taught by the Buddha). The dharma wheel tattoo borrows from many Buddhist forms and the center of the wheel might be a **LOTUS** or, just as often, a belly button.

DIAGONAL CROSS

The diagonal **CROSS WITH ARMS OF EQUAL LENGTH**, or "X," is an extremely old sign and not generally used alone in tattoo art. It is also known as the cross of St. Andrew (a Galilean fisherman and younger brother of Peter, later to be St. Peter) since he was crucified on a cross of this form. The flag of Scotland (where some of the remains of St. Andrew eventually landed and for whom St. Andrew is the patron saint) displays St. Andrew's cross in white on a field of blue. The **CONFEDERATE BATTLE FLAG** also uses St. Andrew's cross.

DIAGONAL CROSS WITH VERTICAL LINE

The **DIAGONAL CROSS** (or "X") with the vertical line added is seen in Western symbolism not as a cross but rather as a sort of monogram for **JESUS**

Christ. The symbol takes its form from the initials of his name in Greek: I (iota) for Iesous and X (chi) for Christos.

DICE

Tattoos of dice are many times part of lucky gaming designs. In these contexts, the dice are particularly representative of risk-taking behavior, with an uncertain outcome and in which the gambler has a stake. In the game of craps, the number seven (achieved by adding the two die values together) is generally a winning and therefore lucky roll while "snake eyes" (two ones) is almost always a losing combination.

DINOSAUR

Although dinosaurs are just another class of animals that lived about 150 million years ago, they are symbolically the descendants of mythical monsters. Much more often that not, tattoo artwork of dinosaurs depicts the carnivores in the act of having dinner. From small and simple velociraptor images to back pieces of fantastic scenes of dinosaurs in their environment, the prehistoric creatures have certainly captured the imagination of modern man, scientists, and tattoo wearers.

DIVING SYMBOL

The dive flag in tattoo artwork is typically combined with other images of the ocean, like blue WATER or FISH. The white diagonal stripe in a field of red is a flag recognized in the United States meaning "diver down" and is used to warn watercraft and skiers to stay away because divers are in the water. While the diver down flag has a specific nautical meaning, it is generally used as a tattoo symbol to let people know that the bearer is a diver.

DNA

Deoxyribonucleic acid (abbreviated DNA) is the genetic code of life. Its spiraling double-helix structure, which looks like a tall thin twisting ladder, is symbolic of what makes us biologically human and is something that we

all share. Today the graphic representation of DNA is used to symbolize the latest in research, especially with respect to unlocking the human genome, and also the science that underlies our common heritage. Few people in the world have actually made genetic research their profession but a DNA tattoo can also represent the more universal notion of membership in the human species.

DOG

The dog was very likely the first domesticated animal. Then as now, dogs are symbols of companionship, protection, and faithfulness. In the CHI-NESE ZODIAC, people born in the Year of the Dog are considered loyal and honest if also stubborn and selfish. In myth and religion in general, the dog or doglike beast or god is almost universally the guard of the Other- or Underworld. Man's companion in the light of day, the dog moves easily into the role of nighttime guide through the darkness of death. Tattoos of dogs are most often pet memorials, showing not just rough and general characteristics of breeds but the same fine detail of specific dogs seen in human tattoo portraiture.

DOGFISH (HAIDA)

The Haida dogfish is actually a SHARK. In the Pacific Northwest, where the Haida have been traditionally located since before Europeans even ventured into the western hemisphere, many sea animals have entered into the symbolism and mythology of the local people. The dogfish is a species of small shark noted for its huge appetite. It appeared frequently as a family crest in Haida art but it was rarely used by other northwest coast people. In the crest form, there are gills, CIRCLES as nostrils, the mouth is downturned, and the teeth are triangular. However, the dogfish also had a mythical form of existence in the person of Dogfish Woman, a female SHAMAN/magician of great power. Like other designs of this region, the dogfish is highly stylized and abstract. However, its distinguishing characteristics sometimes include rows of triangular teeth and a dorsal fin.

DOLPHIN

The intelligent and friendly dolphin, which is a mammal and not a FISH, has long attracted interest from mariners, perhaps nowhere more so than

in the Mediterranean area. For the ancient Greeks, dolphins were symbols of both the divine and of wisdom. Apollo himself at times took the form of a dolphin. No doubt the occasional interaction that takes place between humans and dolphins contributed to the depiction of men riding dolphins in Greek art. In fact, the Cretans believed that the dead withdrew to the ends of the Earth and that dolphins carried them there. For mariners worldwide, the dolphin was seen as a protector and guide, again likely owing to accounts of dolphins attacking sharks to protect SAILORS who had fallen overboard, plus their tendency to play in the wake of the bow of ships. It is also not uncommon to see dolphin tattoos that repeat, creating arm bands or anklets.

DONKEY

The donkey, or ass, has taken on very different associations for as long as it has been used as a symbol. Even today, in the United States the donkey is a symbol for the Democratic party, although it is synonymous with being ignorant and obstinate. In Christian iconography the humble donkey is present in the manger of the Christ Child and is also ridden by him in his triumphal last entry into Jerusalem. Medieval adulterers in Europe had to ride through the streets on a donkey, but the Greek god Dionysus also rode one. In tattoo art, the donkey tends to be a comical type of character that plays mostly on the modern Western themes of stubbornness.

DOT IN CIRCLE

The DOT in the center of a CIRCLE is a fundamental graphic element and reminiscent of many of the symbols that are used in tattoo, from the BULL'S-EYE to the MANDALA. Like other types of universal symbols, it can have widely divergent meanings. Many of its uses center around SUN or wheel symbolism, and it is even the symbol for gold in terms of alchemy.

DOTS

The dot or, more accurately, dots, are among the oldest of tattoos. Although clay figurines in various parts of the world show dot patterns that are likely tattoos, one of the earliest indisputable pieces of evidence is the

preserved mummy of Amunet, a priestess of the goddess Hathor in Egypt some 4,160 years ago. Her tattoos consist of dots and dashes on the lower abdomen, the thighs, and the arms. One of the most famous tattooed mummies ever discovered, the 2,200-year-old Pazyryk chieftain of Siberia, had tattoos that included a series of dots along the spinal column. This linear arrangement of dots along the spine or near joints is actually a common one, with evidence to suggest that some of these types of tattoos were therapeutic in nature. In an interesting coincidence, locations of modern radiation therapy are also sometimes permanently recorded in the form of very small tattooed dots.

DOVE

The grace and beauty of the dove, combined with its pure white plumage and gentle cooing sound, has made it a favorite symbol of love and tenderness from ancient times to the present. In Judeo-Christian symbolism, the dove brings an **OLIVE BRANCH** to Noah as the flood recedes, and in the New Testament the dove embodies the Holy Spirit. Tattoo art draws on all of these themes, favoring the symbolism of peace and tranquility.

DRAGONFLY

The dragonfly, with its delicate, fine line depictions and gossamer thin yet opalescent **WINGS** and body, is a frequent insect subject of tattoo art, symbolic of swift activity according to some Native American groups. To the Chinese, the dragonfly is a symbol of summer but also of instability. To the Japanese, the dragonfly means quite a bit more. In fact, an old name for Japan, *Akitsu-shimu,* means "Dragonfly Island." There the dragonfly was good luck, a sign of a good harvest, and used as a symbol for warrior clans and emperors alike.

DREAM CATCHER

The dream catcher is a Native American symbol that probably originated in the northern Midwest, eventually spreading into the plains. Based on the story of how the Spider Woman captures the sunrise for people in the

 dew of her web, the dream catcher is in the shape of a CIRCLE to represent how the SUN travels across the sky each day. Usually hung near a cradle board, the dream catcher filters out the bad dreams, allowing only good thoughts to enter through a small hole in the center. With the first rays of sunlight, the bad dreams would perish. The points where the web connects to the hoop often number eight for Spider Woman's eight legs. It is also traditional to put a feather in the center of the dream catcher, symbolizing breath or air, but also meant to be entertaining for a baby to watch. The use of gemstones is not traditional but these are substituted for FEATHERS, which typically would have come from protected BIRDS. Tattoos of dream catchers and variants on them are a very popular part of designs with a Native American theme.

DRUGS

Another vice celebrated in tattoo art (and partially responsible for tattoo's bad-boy image), drug designs and symbolism come in a variety of formats, from syringes to multicolored pills. On one level, they can be symbolic of the substances that they depict, representative of the euphoric state that is their hallmark, and perhaps also of addiction on yet another level. Whether for pleasure, entertainment, or escape, drugs are a longtime component of human experience.

DUCK

Although one of the modern connotations of the duck is with quackery (the pretendings of a charlatan, usually a medical one), other symbolism is more benign. Tattoos and other images of ducks, in both Western and Eastern art, tend to portray the BIRD in realistic fashion. In the East, the duck was a symbol of marital fidelity and affection. In the West, they are both hunting trophy and symbol of wild nature, providing duck hunters with an opportunity for colorful tattoos reflecting the duck's plumage.

EAGLE

The eagle is quite simply the king of the **BIRDS**. In symbolism written or pictorial, it is representative of the mightiest rulers, the highest gods, and the greatest heroes. In surviving texts from ancient Babylon, the deceased king is borne to the heavens by an eagle. In many instances, the eagle embodies lofty aspirations and higher spiritual achievement. In other cases, it symbolizes strength and glory and even substitutes for the **SUN** in Arctic and some Native American mythology. Because they are also birds of prey, eagles have come to be associated with clarity of vision and thus insight as well. Adopted as the national bird of the U.S. in 1782, the American or bald eagle has also become one of the most popular of the patriotic tattoos done in this country. It is impossible to capture the multitude of meanings that eagles have acquired and equally impossible to describe the great range of expression that eagles have inspired in tattoo art.

EAGLE, DOUBLE-HEADED

The double-headed **EAGLE** in the Coptic pilgrimage tattoo repertoire of Jerusalem is likely Byzantine in origin, where it was used as an imperial symbol. Similarly, it has been adopted for use by the clerical hierarchy of the Greek Orthodox and Armenian churches.

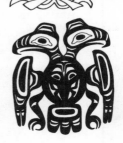

Usually the Haida portrayed the **THUNDERBIRD** or eagle with only one head. This double-headed version

was probably adopted from the imperial Russian czar's double-headed eagle COAT OF ARMS. The Russians had established a presence in the Pacific Northwest by the mid-1700s. The Russians themselves had perhaps adopted the double-headed eagle crest from the Byzantines in 1497.

EAGLE EATING SNAKE

The EAGLE that eats a SNAKE while perched on a nopal cactus appears on the national flag of Mexico. It is derived from the Aztec legend that the capital, Mexico City, was founded according to the command of the sun and war god Huitzilopochtli, who was sometimes represented as an eagle. According to his command, Tenochtitlán, the Aztec capital and antecedent of Mexico City, was founded in C.E. 1325 on a spot where an eagle was seen devouring a snake, ending a long and perilous migration from the Aztec's traditional home of Aztlan to the Valley of Mexico.

EAGLE GRASPING ARROWS

The EAGLE grasping a group of arrows is a patriotic variant of eagle iconography used in the Great Seal of the United States, adopted in 1782. The bald eagle clutches an OLIVE BRANCH (with thirteen leaves and thirteen berries), which stands for peace, and also thirteen arrows, which stand for war and readiness. (Thirteen represents the number of original colonies.) The RIBBON in its beak carries the motto *e pluribus unum*, which means "out of many, one."

EARTH

Tattoos that use images of the earth are not new in the sense that earth symbols have always abounded in all cultures. However, the view of earth from space, with blue OCEANS, tan land masses, and white swirling CLOUDS is a modern icon, and an all-inclusive one. In keeping with other earth im-

ages, it can symbolize universality, caretaker of the earth, fruitfulness, and fertility—even motherhood.

EBISU

Ebisu is one of the Japanese **SEVEN GODS OF GOOD FORTUNE**, a favorite theme in Japanese tattoo art. Ebisu is the patron of the fisherman for this island nation and also the patron of tradesmen. Shown as fat, bearded, and smiling, he often carries a rod in one hand and a red snapper (itself a symbol of good luck) in the other.

EEL

Eels are akin to serpents in their symbolic meaning, but they are also associated with primordial emergence since they are sea creatures. In ancient Egypt they were symbols of the rising **SUN**, while in Celtic lore the war goddess turns herself into an eel and wraps herself around the hero who has spurned her. In parts of Polynesia and ancient Phoenicia, eels were sacred and there is no denying their phallic significance as well. Tattoo art revels in the many exotic colors and coiled positions that eels take in nature.

EIGHT BALL

The eight ball, from the game of pool or billiards, is the black ball that is at the center of the rest. The first seven balls are solid colors while the last seven are striped with white. The phrase "behind the eight ball" means bad luck since if the eight ball is pocketed or misplayed during a game, that player loses. In addition, the eight ball has an association with sodomy in certain contexts, as in the case of some prison tattoos, and also with **DRUG** use, as slang for an eighth of an ounce of cocaine.

EK ONKAR

Translated loosely, *ek Onkar* means "one (ek) God (Onkar)," derived from the Sanskrit **OM**. Sikhism, a religion centered in India that combines teachings of Hinduism and Islamic Sufism, was

founded in the late 1400s and early 1500s by the first Sikh guru, a mystic named Nanak. The most significant words used in Sikh teachings, ek Onkar emphasizes the oneness of God, a basic tenet of Sikhism.

ELEPHANT

Like other animal symbols, the elephant differs radically in the East from West in terms of its symbolism. In the West, the elephant can be the very epitome of obesity, although it is also associated with having a good memory. In the East, kings rode elephants as symbols of stability, heavenly intervention, and blessing. In tattoo art, elephants are sometimes part of wild nature scenes from the African savanna, representing distant wildlife, and are sometimes crowned as in Asian art. Of all elephant symbols, the Hindu god GANESHA is probably the most famous and recognized.

ELF

The elf, a small, airy creature both enchanting and mischievous, is Norse in origin. Although later incorporated into works of fiction as ethereal, beautiful, and benevolent, elves would originally dance in meadows at night in order to woo mortals to their deaths. As such they can symbolize powers of darkness and any desire that inhibits judgment and self-control.

EMPEROR

Images taken from TAROT cards—and sometimes simply the wholesale use of the cards themselves as images—are not uncommon in tattoo. Their appeal lies in the archetypal persons and subjects that they depict, of interest to us all, especially if they could actually work to foretell the future and explain the present. In the emperor card, the fourth tarot, what is symbolized is what is generally shown—empire, power, success, and supremacy. There is much in the emperor's depiction that suggests these meanings, from the EAGLE on his SHIELD to his crossed leg position on the throne as a defense against evil.

EMPRESS

The empress is the third TAROT and she is resplendent power incarnate with her EAGLE shield, CROWN, and scepter. But there are two sides to the

empress, one that emphasizes the use of power to satisfy her vanity, and the other that uses power to rule justly. She symbolizes female nature in its entirety—idealism, gentleness, persuasiveness, but also weakness.

E. M.T.

Emergency medical technicians, dispatched to the scenes of medical emergencies, use a symbol that is similar to the **CADUCEUS** of medical doctors in some respects. Like the caduceus, its central motif is a serpent coiled around a staff. But where the modern caduceus is produced from a confusion of symbols from the staffs of Asclepius and Hermes, the E.M.T. "Star of Life" remains true to form, using a staff with only one serpent that resembles the staff of Asclepius, who was the son of Apollo and a healer. The six-barred cross that appears as a background to the serpent and staff stands for the six-system function of emergency medicine: response, on-scene care, care in transit, transfer to definitive care, dedication, and reporting. E.M.T.s are clearly proud of their profession and the role that they play in saving lives, when they choose this symbol for a tattoo.

ENNEAGRAM

The enneagram, or nine-pointed **STAR**, is used and viewed in many ways. In Christian symbolism it stands for the nine gifts of the spirit: love, happiness, peace, patience, leniency, benevolence, loyalty, humbleness, and temperance. In kabalistic (Jewish mystic) symbolism, it represents the very essence of being.

EVE

Eve, the second of God's human creations and the first woman in Judeo-Christian and Islamic tradition, is certainly a symbol of womanhood and motherhood, as she is mother to the human race. But owing to her role in the introduction of sin into the world (succumbing to the enticements of the serpent and doing likewise for Adam), she also represents temptation and the fall from grace.

EVIL SPIRIT (HAIDA)

Not much is known about the evil spirit of Haida mythology except that it is half man and half **BIRD** and lives in the mountains, feeding off humans

and **WHALES**. It is an image not often used in traditional arts of the Pacific Northwest but was documented as a tattoo in historic times. Although the design is essentially schematic line art, it clearly shows a human torso, human arm, and a human leg, as well as a head with a beak, a **WING**, claws for hands and feet, and sometimes also tail **FEATHERS**.

EXCLAMATION MARK

Even punctuation marks have appeared in tattoos. The exclamation mark of Western alphabets, a **DOT** with vertical line above it, makes a fitting end to any series of symbols, adding emphasis and serving to focus our attention. The symbol is actually used by itself in some contexts to express surprise or something unusual.

EYE OF HORUS

In ancient Egypt, the eye of **HORUS** (also called the *udjat* or *utchat* or "sound eye") was a powerful symbol and protective amulet. During his battle with **SETH**, Horus's eye was plucked out and torn apart. But **THOTH** was able to piece it back together, adding a little bit of magic to it to make up for a tiny piece that was missing. As the regenerated eye of the **FALCON** god Horus, this talisman was worn as a sacred symbol to ensure good health. Among modern tattoos that use ancient Egyptian motifs, the eye of Horus ranks near the top, along with the **ANKH**.

FAIRY

Fairies in tattoo art are sometimes akin to the pinup girl, but more often they appear as the mystical and ephemeral winged creatures of the magical world that they symbolize. In some sense, all these types of fantastical and mythical creatures represent our power as thinking beings to imagine, create, or embellish for a myriad of purposes.

FAITH AND LUST

SWALLOWS, one of blue and one of red, one with a **HALO** and one with horns, have been a time-honored and popular motif in tattoo art, often accompanied by words such as "love" and "hate," "faith" and "lust," or "bitter" and "sweet." Usually appearing as two separate tattoos, these **BIRD** images are obviously meant to be interpreted as one, even when the two swallows appear on separate arms or legs. When choosing this type of tattoo, people are hearkening back to an earlier era of tattooing and also touching upon the union of opposites that acknowledges that all of life is composed of two sides, no matter the particulars of the subject.

FALCON

The falcon, a predatory **BIRD**, has been noted in many cultures for its strength and swiftness, but also for its beauty. The Peruvian Inca used the shape of a falcon as a solar emblem, where it corresponded to the male,

brightness, and ascension. The Egyptians in particular were impressed with the identifying mark under its eye, an eye of acute vision, and created an entire story of symbolism based on the EYE OF HORUS symbol.

FAN

The folding fan, reportedly invented by the Japanese in the seventh century, was carried by both men and women in Far Eastern society. A multitude of different categories of fans existed, each with its appropriate use or user—such as those carried by SAMURAI or those used on the stage during performance. Owners could express their individual tastes through the decoration of the fan (CHERRY BLOSSOMS in this example) and a great deal of attention and effort was expended in their embellishment. Occasionally the Japanese may have also used them as screens against evil, but they are perhaps better known today as the accoutrement of a flirtatious GEISHA.

FATHER TIME

Long-bearded, robed, and carrying a scythe, Father Time is ushered out with the end of every new year and replaced by a baby. Most likely, he is a symbolic descendant of the god SATURN, whom the Greeks called Chronos, meaning "time." He carried the scythe or SICKLE not as the GRIM REAPER might, to harvest human souls, but rather in honor of farmers, for he was also the god of agriculture. Today, Father Time personifies the knowledge that all of us are subject to the same inescapable laws of nature.

FEATHER

The feather chiefly symbolizes lightness, or what lifts birds into the SKY, and so it is also associated with the ascent to heaven and supernatural divination. The Egyptian goddess Ma'at wore a single ostrich feather headdress and used a single feather to weigh against the heart of the recently deceased who wished to gain entrance to the afterlife. Among the Zuni though, feathers are used on prayer sticks that are planted in the ground

but that eventually carry their requests to the gods above. In the head-dresses of the native inhabitants of the North American prairies, a feather recalled an act of bravery by the wearer. While most tattoo art encom-passes the motifs noted above, there is also the occasional lone **PEACOCK** feather, as well as those to be found in **DREAM CATCHERS** and attached to **MEDICINE SHIELDS**.

FEMALE SYMBOL

The modern sign for the female sex is also an an-cient sign for the planet Venus, which in turn was associated with the Greek goddesses Aphrodite and Athena. Venus is the planet that has been called the **MORNING STAR** (though it is no star at all), appear-ing alone or with the waning **MOON**. It is also called the evening star, seeming to appear in the sky a second time, alone or with the crescent of a new moon. Linked with the moon and stars and their cy-cles, the planet Venus was worshipped by nearly all peoples and cultures of antiquity as the goddess of fertility and war, beauty, and love. In this example, the starkness of the symbol is combined with a **ROSE**, a traditional symbol of feminine beauty.

FEMINISM

The symbol for feminism is, not surprisingly, drawn almost completely from the **FEMALE SIGN**. The only change is the addition of a fist within the circle.

FIG, SIGN OF

The sign of the fig is a symbolic gesture believed to ward off the evil eye and offer protection against malevolent spirits or forces. It is created by making a **FIST** with the thumb protruding between the index and mid-dle fingers, also considered an obscene gesture of contempt and symbolic of sexual intercourse. Why the sign of the fig should be protective is un-clear, although it may be linked to the notion that spirits are sexless and frightened of any allusions to it. In many regions a red coral amulet

depicting the sign of the fig is popular even today on watch chains and necklaces.

FINGERPRINT

A fingerprint provides an infallible way to identify an individual. Its use in tattoo imagery, both life-size and larger, can be representative of this individuality, as well as humanity in general, as are the HANDPRINT and FOOT-PRINT. It may also represent the trace evidence left behind from someone's touch, as is the case in so many fingerprinting investigations.

FIREFIGHTER

Many firefighter tattoos, whether the central image is a fire hydrant, a well-muscled Dalmatian, or the unique domed hat, use the "firefighter's cross" as a backdrop. In essence, this curved and roselike form is another version of the MALTESE CROSS. The association between the Maltese cross and fire fighting can be traced to a story wherein Saracen defenders of the city of Jerusalem used firebombs filled with naphtha (a flammable liquid), inflicting injuries and heavy losses on the crusaders, who eventually retreated to the island of Malta. The brave efforts of the KNIGHTS to rescue their brothers from the enemy fires created a lasting association between their symbol, the Maltese cross, and fire fighting.

FIREWORKS

Fireworks are associated with celebration, particularly public celebrations of important events. Although they were originally developed as military rockets by the ancient Chinese, fireworks are now part of the celebrations that mark not just victory but also peace. Today, a multitude of different chemicals and packaging mechanisms are used to achieve effects of heightened brilliance and drama. Tattoo artwork capitalizes on these types of displays, using colors in combination and arrangement that suggest the same jubilant atmosphere.

FISH

The symbolism and subject of fish is a broad one and their representations in tattoo imagery are effectively as infinite as the variety of fish. Fish are,

of course, symbols of WATER, evocative of the sea, rivers, and lakes. They have been sacred symbols in some cultures and also fertility symbols, owing partly to the vast numbers of eggs that they lay. Despite many variants in both legend and ritual practice, fish were often considered ambiguous creatures, silent, mysterious, and hidden, yet glistening.

FIST

The fist has been used as a symbol of power and antagonism by many groups. The black power salute was a raised fist used by African Americans as a gesture of pride and solidarity. Ironically, it has been co-opted by white supremacist and Aryan groups as a hate symbol.

FIVE FORCES OF NATURE

According to ancient eastern Indian thought, the universe was composed of five basic elements or forces of nature known as the Pancha-Mahabhootas. The depiction appears as a column of separate symbols that represent each of these elements. At the base is a square, which represents the EARTH, then a CIRCLE for WATER, a TRIANGLE for fire, an upturned and open crescent for air, and a DOT suspended above the crescent for ether or the SKY. It is identical in form to the graphic representation of the STUPA.

FIVE GREAT BLESSINGS

In Chinese, the word for BAT is similar to the word for happiness, *"fu."* Where one bat symbolizes happiness and two bats sketched on the wrapping of a gift convey best wishes and good fortune, five bats (*wu fu*) stand for the five great blessings: long life, wealth, health, love of virtue, and a natural death. Sometimes the bats circle a stylized glyph known as the prosperity symbol, implying that a person's prosperity is the result of a virtuous life.

FLAG

Flags are definitely a part of the repertoire of tattoo imagery, be they patriotic and nationalistic, maritime signals, or emblems of particular special groups. The historic use of flags was at first primarily strategic—visual aids

that made it easier to observe groups at a distance. Over time they became symbols with which people could identify, and this is the role that they play in tattoo art as well.

FLAMES

Considered one of the fundamental elements of nature in many cultures, fire has conflicting symbolic associations, as one might expect for something that can warm and illuminate, as well as destroy and consume. The Judeo-Christian tradition contains many examples of holy fire, from the burning bush of Moses to Pentecost. For the Hindus, fire comes in many distinct forms, including lightning and the SUN. It has also been used as a symbol of purification and renewal from the Americas to Japan. Many of these symbolic meanings are exploited in tattoo art where fire and flames add more passion, brilliancy, and ardor to everything from "hot" rods to the SACRED HEART.

FLEUR-DE-LIS

The fleur-de-lis ("LILY flower" in French) was historically the symbol of the monarchy of France, first popularized during the twelfth century by Louis VI. Its broad appeal owes to its use of the holy number THREE and its symmetric though curved design of three leaves banded together near the bottom. The fleur-de-lis was also associated with Joan of Arc and so also with freedom from oppression.

FLOWERS

The category of flowers, like animals, is a huge part of tattoo symbolism. The tattoo world abounds with images of flowers, stylized or realistic, real or fantastic. While many have their own special significance and symbolism with endless shades of meaning, some flower tattoos are done with combinations that are more generally representative of a pleasing aesthetic effect, drawing on their common characteristics of beauty and growth.

FLYING MONKEY

Although **HANUMAN**, the Hindu **MONKEY** god, was capable of flight and the Wicked Witch of the West was able to send an army of them against Dorothy in *The Wizard of Oz*, most references to a flying monkey (in a tattoo or otherwise) use it as an example of something that could never happen, or perhaps shouldn't have.

FLYING SAUCER

Although an **ALIEN** is a more popular symbol than the flying saucer, they both are used in tattoos to represent something otherworldly. Also called **UFOS** or unidentified flying objects, some groups have made them the focus of virtual cult status, believing them to contain beings of advanced intelligence from other planets who are visiting ours for various purposes, depending on the group. Flying saucers have even become symbolic of government conspiracy to prevent the populace from learning about visitors from other planets or secret government projects.

FOO DOG

The Foo (or Fu) dog is also known as the "lion of Buddha," and indeed it is a **LION** and not a **DOG**. Used extensively in Asian art and tattoo, the lions of **BUDDHA** (frequently occurring in pairs) were his divine and noble companions, protectors of the truth. Originally symbols used in Buddhism, they were adopted by the Chinese royal family as protective symbols, and also to represent imperial strength. Placed at entrances, the typical seated yet ready position of the stone statues suggests a resemblance to dogs, especially with their upraised ears and curly but subdued manes. It is not unusual to see them in male/female pairs—the male with one foot on a sphere, often carved as an open lattice, which represents the totality of Buddhist law, or heaven, and the female with her foot on a cub, often depicted upside down or crawling up her leg, which represents the **EARTH**.

FOOL

The fool, unlike the other major arcana of the **TAROT**, has no number. He exists beyond the bounds of the normal human group, and is therefore an outsider. He wears the **JESTER**'s cap but also carries a traveling pouch, which is empty since he pays no heed to possessions. With his walking staff, he is in motion, even as a **DOG** tugs at his pants. Tattoo art, like tarot art, portrays the fool in myriad ways but these basic accoutrements seem to always accompany him.

FOOTPRINTS

In prehistoric times, footprints were an important symbol of the presence of other humans. While not nearly as widespread as the use of the **HAND-PRINT**, the footprint carries its own set of symbolism. It is suggestive of travel and tracking when on the landscape. But to be "under someone's foot" is to be subordinate to him or her. Some cultures possess a ritual washing of feet, and a bare foot sometimes represents humility or even overt sexuality. Unlike the **FINGERPRINT** or **HANDPRINT**, the footprint symbol is almost always paired, left and right, or set in a series of steps. In surfing, "hang ten" is synonymous with putting ten toes over the edge of the board. Two bare feet are used on surfing products, echoing the mode of dress and the surfing position.

FOREIGN LEGION

Although the hollow-center grenade, represented by an open **CIRCLE**, topped by a group of seven flames (the outward two curling downward), is the symbol of the famous French Foreign Legion, the tattoos that a legionnaire might wear can be more campaign-specific and memorial in nature. For example, the tattoo commemorating Operation Epervier (Sparrowhawk), which was initiated in 1986 in Chad, includes the familiar tattoo art themes of the **SWORD** in fist and the wing of a **HAWK**, a **BIRD** of prey, combined for a very specific effect and meaning.

FORGIVEN

A tattoo of the word "forgiven" may seem easy enough to read and understand but it also symbolizes the larger belief system of Christianity, whose central belief, as articulated by JESUS Christ, in the New Testament Book of Matthew (26:28) is "This is my blood of the covenant, which is poured out for many for the forgiveness of sins."

FOUR-TWENTY (4:20)

The numeral 420, also written as 4:20, is an allusion to MARIJUANA. Although legend has it that the number refers to a California criminal code, there is no such code. Instead, it may have originated as 4:20 p.m.—the time of day reserved for getting together and smoking pot amongst high school students in San Rafael, California, in the early 1970s.

FOX

The fox, like the coyote, is many times not only the trickster but also a hero in different cultures. "Crazy like a fox" (meaning inventive but destructive, alert but careless); advocate of man and yet his mortal enemy; synonymous with a good-looking woman in the United States; associated with seduction in ancient China—all of these have characterized the fox. Perhaps because its perceived contradictory behavior so reminds us of ourselves, the fox takes on many of the aspects of human consciousness and behavior.

FRATERNITY

The Greek-letter societies of the United States that are the best known are the fraternities (for men) and sororities (for women) of college campuses. The society "house" is the center of social activities and is typically the main purpose of such societies—to furnish communal and cost-effective living. Their popularity at different campuses varies and their ranks rise and fall over time but they remain a long-standing tradition. One of the leading honorary societies today is Phi Beta Kappa (ΦBK), but it actually began as a social fraternity at William and Mary College (Williamsburg, Virginia) in 1776. Many fraternity and sorority members will mark their membership and group identity with a tattoo of one or more of the Greek

letters. Still others will use branding—burning the letters into the flesh—as a variant in the body modification rites.

FREEMASONRY

The **COMPASS, SQUARE**, and the letter "G" are the most common of the symbols for Freemasons, a secret fraternal order that originally sprang from the guilds of stoneworkers (masons) of the Middle Ages in the British Isles. Considerable speculation regarding their activities and motives exists and, indeed, there are many branches and variants of freemasonry worldwide, such that it is difficult to describe them in general terms. However, one can probably say that they espouse morality, charity, obedience to the law of the land, and belief in a Supreme Being and in the immortality of the soul. The basic symbols of compass and square are borrowed from the builder's or mason's craft. The "G" has been ascribed different meanings such as *gnosis* (knowledge), God, geometry, and generation. Today the themes of working raw stone into a finished product are applied to human beings rather than lithic material. The freemasonry symbol is typically restricted to use as a signal of membership.

FRIGATE BIRD

The frigate bird design of Rapa Nui (Easter Island), a very schematic and minimalist design, is not unlike other Polynesian tattoos that use seabirds as a motif. On Rapa Nui, the frigate bird may have achieved cult status. In ecological terms, it is an important symbol. As the island became deforested, perhaps affected by larger changes in climate as well as exploitation by the human population, the bird population dropped and some species were completely eliminated. The frigate bird motif may also be related to the **BIRDMAN** deity. In general, in the Pacific, this tattoo has also represented the proximity of land to the seafaring voyagers of the islands.

FROG

The frog is currently an extremely popular animal image in the world of tattoo and is often selected from a seemingly infinite number of potential

types. Much of the popularity of any tattoo design is, quite simply, not symbolic but rather aesthetic. In this regard the frog is an ideal choice for many reasons since it can be incredibly and vividly colorful, with texture or wetly gleaming, by itself or in its watery environment. Frogs are a benign and unthreatening choice and are visually appealing at the same time. When symbolism does enter into a consideration of a frog design, however, there is a vast and incredibly rich history behind its use. From the Romans to the Aztecs and from India to Japan, these small but vocal creatures have come to symbolize all manner of emotional and spiritual aspects, drawn mostly from their natural behavior. Two common threads that seem to run strong, though, are their symbolism of fertility and also of magic. In the west, we don't have to look far for those meanings when it comes to fairy tales of enchanted princes.

FROG (HAIDA)

The **FROG** symbol, in the Pacific Northwest art of the Haida, is a crest of the **EAGLE** moiety. It is also thought to bring good luck. Frogs were gutted and the flesh pounded and rolled into balls that were boiled. When eaten, they were thought to bring wealth as well.

F.T.W.

The letters "F.T.W." are an abbreviation for "fuck the world," an oft-used acronym and motto among bikers that has appeared regularly in their tattoos since the 1960s, as well as on people from all walks of life today. But a deeper interpretation sees the motto as a symbol of dissatisfaction with "the world" or with mainstream culture—something that the bikers of the sixties utterly rejected in favor of making their own rules and transforming their time on **MOTORCYCLES** into a life on the road.

FUDO MYO-O

In the Buddhist mythology of Japan, Fudo is one of the fierce protective gods (Myo-o), a form of **BUDDHA**, who are ferocious in appearance in order to frighten away evil spirits and to destroy ignorance and ugly passions.

Fudo Myo-o, usually shown with blue skin, bears a **SWORD** in one hand and a rope (a noose or lasso) in the other to symbolize cutting through all delusion, the destruction of obstacles, tying up evil creatures, or even catching and leading believers toward enlightenment. He sits or stands upon a diamond-hard rock, a symbol of resoluteness. Behind him is a **HALO** of flames, symbolic of purification. One of his eyes looks up and the other looks down, as he guards both heaven and earth. Fudo Myo-o is a popular motif in Japanese tattoo, frequently appearing as a back piece, a central and dominating figure of protection.

FUKUROKUJU

One of the **SEVEN GODS OF GOOD FORTUNE**, Fukurokuju is the god of longevity and wisdom. Typically he is depicted with a very high-domed, bald head, mustache, and beard and occasionally shown with an animal that also symbolizes longevity in Japanese culture, like the **CRANE**, **DEER**, or tortoise. The Seven Gods are not usually shown in isolation but instead are incorporated together into larger tattoo designs.

FULL MOON

Many names have been given to the full moon, that large and fully lit **CIRCLE** of light in the night **SKY**, such as harvest **MOON** (the moon closest to the autumnal equinox) or blue moon (the second full moon in a single month). In fullness, the moon is the completion of the lunar cycle and it is also a complete circle, with all of the attendant symbolism of that form—particularly that of wholeness and cyclical, unending time.

FULL-RIGGED SHIP

Maritime tattoo and the full-rigged sailing ship have been found together since tattooing first entered modern Western culture with early **SAILORS** in the South Pacific. While many maritime tattoo designs will use a ship for

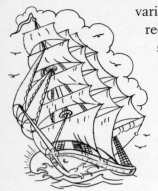

various reasons, there was also a specific reason for receiving a tattoo of a full-rigged ship—having sailed around Cape Horn. Alternatively, it has been noted that a sailor who sails around the Cape is entitled to a small blue five-pointed **STAR** tattoo on the left ear. Five times around the Horn earned one on the right ear as well. Two red marks on the forehead meant that the sailor was a mighty voyager, having rounded the Cape ten or more times.

GANESHA

Ganesha (also Ganesh) has become more popular in the last century, especially in the West. He is the Hindu god with an **ELEPHANT** head known as the remover of obstacles. It is difficult to think of a more apt figure for overcoming obstacles since his elephant head came about as a result of an early accidental death at the hands of his father, **SHIVA**, who, realizing his mistake, took the head of a passing elephant and breathed life back into the boy. Like many images in Hindu or Buddhist art, almost every feature of Ganesha has some symbolic content and meaning. The number of arms that he has may vary from one portrait to another, but typically one hand is held in a pose of protection and refuge, the second holds a sweet food symbolic of the sweetness of the realized inner self, the third holds an elephant goad with which to prod man to the path of righteousness, and the fourth holds a noose to represent worldly attachments and desires. His potbelly symbolizes the bounty of nature and also the idea that Ganesha swallows the sorrows of the universe and protects the world. Tattoos of Ganesha are many times as ornate as the religious artwork on which they are based (portraits or statues), although occasionally they can also be simple blackwork.

GARGOYLE

Gargoyles were originally architectural elements. They began as waterspouts, designed to funnel rain away from a building by spouting it out the

mouth of a forward projecting carved creature. Made famous in the European Middle Ages on the exterior of lofty cathedrals, these mythic animals were usually grotesque **BIRDS** or beasts, and were thought to ward off evil. Tattoo artwork today will occasionally allude to the functional origins of the gargoyle, using finely shaded blackwork that simulates the look of carved stone.

GARLAND

A garland combines the symbolism of both **FLOWERS** and the **CIRCLE**. They are used in tattoos to encircle arms, wrists, ankles, and even navels. Although certain flowers have definite symbolic associations, a garland generally stands for such positive aspects as good luck and fertility and even the union of this world and the next.

GAS MASK

The gas mask, a device worn over the face and head to protect the wearer against harmful substances in the air, came about at the same time as, and hand in hand with, the introduction of chemical weapons in World War I. It has since become a symbol of the threat of both biological and chemical weapons, the destruction of the environment, and the extreme measures to which humans will go in warfare. Typically done in shades of green and yellow, the tattoo can also represent danger due to the presence of a toxic substance (in the same vein as the **BIOHAZARD** tattoo) and be a warning to whoever might see it.

GAY LOVE

The two **MALE SYMBOLS** joined together is just what it appears to be—a representation of gay love as well as the gay movement.

GEARS

Gears, cogs, and wheels at one time symbolized the industrial age and mechanization. In the form of a tattoo, though, it might represent a person's hobby or line of work. In addition, it also carries somewhat the

sense of the **BIOMECHANICAL** style of tattoo and the human role in an age of machines.

GECKO

Gecko **LIZARDS** appear in virtually all warm areas of the globe and so are part of the symbolism of many cultures. Almost unanimously, the gecko is a symbol of good luck—from Guam to the American Southwest. Perhaps owing to their nonpoisonous nature, the chirping sound that most gecko species make, or the typical lizard tail that grows back when broken, they are sometimes also symbolic of the ability of life to regenerate.

GEISHA

Contrary to popular Western notions, the Japanese geisha is not generally a woman of ill repute, although this aspect is not always true. The word literally means "art person," and a geisha is a highly trained professional woman whose traditional occupation is to entertain men. Singing, dancing, playing music, knowledge of history and current events, and the ability to make conversation and to create an atmosphere of relaxation and entertainment are the essential skills of the geisha. They are usually immaculately dressed in ornate and expensive kimonos and wear traditional thick white makeup. In Japan, geishas have been transformed into symbols of traditional values. In the West, the geisha holding her **FAN** has become a symbol of the exotic grace and beauty of the East.

GEMINI

Gemini, the twins, the third sign of the **ZODIAC** (May 21–June 20), is generally the symbol of duality and also human contact. Some zodiacs employ the image of two children holding hands while others use a man and a woman or, as in the case of a Coptic zodiac, a pair of lovers. Positive traits ascribed to those born under this sign traditionally include intelligence and skill at communication, with negative traits including inconsistency and a tendency toward gossip.

GENIE IN THE BOTTLE

The genie in the bottle or lamp (or the ring) is a famous part of the tales in the collection known as the *Thousand and One Nights*. The genie is based on the Arabic *Jinn* (*Jinni* is the plural), a supernatural being on par with ANGELS and DEVILS. They are able to dwell within all manner of inanimate objects and can punish humans for any harm done them, intentionally or unintentionally, but will also serve humans who know the proper magical procedure. Tattoos of genies who have been summoned vary from giant, well-muscled male genies surrounded by smoke to diminutive females in Persian attire waiting in their jeweled bottles. An interesting cross of good luck sign and protective symbol, genies summon and represent something magical.

GHOST OF TOMOMORI

General Taira no Tomomori is a ghostly figure taken from a legend of feudal Japan who is sometimes used in traditional Japanese tattoo artwork. Rather than suffer defeat in a battle at sea, he committed suicide by jumping overboard in full armor, taking with him the royal entourage, followed by his vassals. His ghost and those of his legions were thought to rise up in storms at sea in order to exact revenge upon the rival clan that defeated them.

GIBSON GIRL

Irene Gibson was the ideal in American female beauty and fashion at the turn of the century, helped in no small part by her husband, artist Charles Dana Gibson. With her long hair piled high and left trailing in a few tresses, she became one of the first glamour girls, admired by women and coveted by men. Her image, albeit generic, became a staple in the flash (posters of tattoo image samples for prospective customers) of tattoo shops of the period—the woman with dark, flowing hair and rosy red cheeks.

GIRAFFE

The giraffe, though the tallest animal in the world (as tall as eighteen feet), symbolized peace and gentleness to the Chinese and also to the Arabs, who exported the animal to China from its native Africa via India. A gift of

a giraffe became a sign of peace and friendliness between rulers. Up until the eighteenth century, the giraffe was only known in Europe from travelers' accounts of Greece and Rome. Like other animals of Africa that are used in tattoo art, giraffes have become symbols of all wildlife there and an attempt to preserve the environment.

GNOME

Likely originating in the *genii* of the Middle East, the legend of gnomes traveled to Scandinavia where it was embellished, and from where we derive most of our conceptions of them. Short, sometimes hunchbacked, living underground, and possessing great treasures, the gnome is only visible to clairvoyants. Generally perceived as kindly, especially to miners, the male is sometimes shown wearing a red cap, and the female a green cap, until she is married.

GOAT

Like the **RAM** and the **BULL**, the goat has often symbolized the powers of procreation. It has been regarded by some societies as a god and yet by others as a **DEVIL**, and the ancient Greeks were taking part in an already ages-old tradition when they used it for sacrifices to the gods. Interestingly, in Hawaii, where the goat was introduced by Captain Cook, it became a popular tattoo motif, possibly because of the goat's novelty and rarity.

GOBAN TADANOBU

Although many of the warrior-heroes of Japanese history and legend have made their appearance in Japanese tattoo, Goban Tadanobu is one of the more famous and also one of the most easily identified. Together with his master, Sato Tadanobu, he was caught in a great struggle between warring clans. He is a tragic hero whom the Japanese have always held in the highest esteem: bold, single-minded, utterly loyal, betrayed by circumstance, and dying without complaint in the face of hopeless odds. In one fight scene, he resorted to using a *go* board as a weapon (hence his nickname). The board is essentially a low, thick wooden table with a grid for placing the small, circular black and white tokens of the game. His

..scular form and the *go* board are the trademark symbols for this famous **SAMURAI.**

GOBLIN

In French folklore, the goblin (or hobgoblin) is a mischievous little spirit that likes to attach itself to households. Temperamental and ugly, goblins perform all sorts of pranks—banging pots and pans, rapping on walls, pulling the covers off the sleeping—but might also perform a household task. They are particularly fond of pretty children and wine. In artwork and tattoo imagery, they are sometimes indistinguishable from **GNOMES.** However, gnomes are generally kindly and goblins are generally not.

GODZILLA

Godzilla is the fictional dinosaurlike creature created by Toho Co., Ltd., Studios of Japan in 1954. A rampaging, nearly unstoppable giant monster, it is a **DINOSAUR** (most nearly resembling Tyrannosaurus rex) that has survived into modern times but has been mutated by atomic radiation. His image changed radically over the course of a multifilm career. An icon of terror that smashed through Tokyo buildings on a regular basis, he also served as a warning about the unforeseen consequences of modern science. Eventually he even became an unlikely hero and champion of mankind against other giant creatures. People who wear a Godzilla tattoo, perhaps like those with an actual dinosaur tattoo, may be projecting something primal and ferocious. But there is also a sense of fondness for the B sci-fi movie era and even a bit of '50s kitsch when it comes to this now classic character.

GOLGOTHA

The scene of Christ's **CRUCIFIXION** is a popular theme in Christian tattoo iconography, rendered in many different ways. For some, it may be as simple as three small **LATIN CROSSES** on an inverted crescent. For others, it is a large portrait-style image, replete with Roman soldiers, bleak landscape, and dark foreboding clouds. Still another type is one that capitalizes on the name of the site of the crucifixion, Golgotha. Aramaic for the word **"SKULL,"** Golgotha is a skull-shaped hill outside the city walls of Jerusalem. In allegorically and symbolically laden images, some tattoos will place the

three crosses atop a skull, combining those two popular images in tattoo design.

GOOD SHEPHERD

Christian and Coptic tattoo images alike touch upon many different aspects of Christianity, including the image of Christ as the good shepherd to which he himself alluded. In tattoo artwork and otherwise, this type of image most frequently takes the form of JESUS carrying a LAMB or a shepherd's staff. In these images, it is caring and compassion that are primarily symbolized.

GORILLA

The gorilla is the largest of the manlike apes, a forest dweller of equatorial Africa. Although seen for many years as a ferocious and deadly animal, research has actually shown the gorilla to be largely unaggressive, even shy. Tattoo artwork ranges from tiny silhouettes of the creature to full-blown back pieces in a jungle setting. They are surely associated with strength, but because of their threatened status they have also become living symbols for wildlife conservation and protection of their native habitats.

GOSPELS

Each of the gospels of the New Testament has an associated symbol, based on the evangelist who wrote it and influenced by the vision of the Old Testament prophet Ezekiel, who saw four creatures supporting the throne of God. The symbol of Matthew is a winged man, since his gospel emphasizes the humanity of Christ. The winged LION represents Mark because his gospel stresses power and miracles. Luke is symbolized by a winged OX, since his gospel makes many references to the sacrificial death of Christ. The EAGLE is used as a symbol for John, since his gospel emphasizes the deity of Christ.

GRAIL

The grail, also known as the Holy Grail, is the subject of much legend and speculation. It is essentially the CHALICE used by Christ at the LAST SUPPER, shortly before his CRUCIFIXION and death. In the traditions of the KNIGHTS

of the Roundtable, it had the power of providing food, light, and invincibility. The quest to find the grail was an outward way of symbolizing the spiritual risks of seeking enlightenment and also an attempt to fundamentally transform the **HEART** and soul to attain it. Jung sums this up by saying that the grail represented "the inner wholeness for which men have always been searching." Tattoos of the Holy Grail are emblematic of all these aspects and attempt to capture the radiance around what might otherwise be an ordinary cup.

GRAPEVINE

Entwined in a wreath, all manner of plants represent a victory over death, especially the grapevine. The fruit-laden grapevine is a symbol of the Greek god of wine, Dionysus, and the cultivation of grapes for wine is probably nearly as old as civilization. The grapevine in tattoo is done both with or without grapes, with blackwork or color, thus sometimes suggesting wine but more generally symbolizing life.

GRASSHOPPER

In the Old Testament, grasshoppers were a euphemism for huge numbers of people and were also considered a blight on the land. In Japan, both crickets and grasshoppers were kept as pets in beautifully crafted cages and admired for their singing ability. Among the Chinese, the grasshopper came to symbolize flourishing descendants and hence abundance as well. Tattoos of grasshoppers are sometimes ultrarealistic, showing the grasshopper in much more detail than could be seen with the unaided eye. Other times they are shown in vivid and unreal color, among **LEAVES** and grass and even in the process of rubbing their legs to create their chirping sound.

GREAT OMI

The image of the Great Omi, a famous sideshow attraction also known as the "Zebra Man" from the bold black stripes over much of his body (including his head and face), has itself been used as tattoo artwork. He was born Horace Ridler, to a wealthy English family in 1892, and served in the British Army, leaving the military after the First World War. In 1922, at

the age of thirty, he began the work of transforming himself into a tattoo attraction. But it was not until 1927, with the tattoo work of George Burchett in London, that his distinct black zebra stripes took their final bold shape (partly meant to cover up previous tattoos). His place in several famous circuses and even in *Ripley's Believe It or Not* was assured from that time onward. Although he passed away in 1969, his image is still famous in the tattoo industry.

GREAT WHITE SHARK

The great white SHARK is a particularly large and aggressive species of shark and one that is considered especially dangerous to humans. They are present the world over, wherever the temperature of the WATER is warm enough to support them. Tattoos of white sharks are notable for their depictions of the animal with mouth open in attack. Indeed, these sharks are most known for this very feature since they will make unprovoked attacks on virtually anything, even small BOATS. Their coloring is typically gray or blue with a white belly and they will easily grow to lengths over thirty feet. In maritime and naval tattoos, the sharks sometimes also wear uniforms or spout periscopes.

GREEK-RUSSIAN ORTHODOX CROSS

The Greek-Russian Orthodox cross (also known as the Russian cross) was first used by Byzantine artists. The bar above the main crossing member represents the abbreviated inscription placed by the Roman governor Pilate, which read INRI (*Iesus Nazarenus Rex Iudaeorum*, Latin for "JESUS of Nazareth, King of the Jews"). The origin of the small diagonal beam at the bottom may be lost to time but several explanations have been put forth: it is a footrest and Jesus's legs were of different lengths; it is a footrest and the earthquake that occurred after his death dislodged it; it represents the robber on his right side who ascended with him to heaven; it symbolizes the main saint of Russia, St. Andrew, who was crucified on a torture rack of diagonally crossed beams, which is the most likely explanation.

GREEN MAN

Earliest known examples of the foliate head (as it was known prior to 1939 when it was dubbed the Green Man) date back to classical Rome, although its spread across Europe accompanied the Christian church. Although we do not know the meaning of the foliate head in its first uses, we can speculate that, as with most things green, it symbolized rebirth and regeneration, eventually linked to the Christian belief in resurrection. The Green Man is found carved at pagan temples and graves, and also at medieval churches and cathedrals, and was used as a Victorian architectural motif, across an area stretching from Ireland in the West to Russia in the East.

GRIFFIN

The griffin is a fabulous mythical beast combining two of the most potent of animal symbols, the **EAGLE** and the **LION**. It has the hindquarters of a lion and the head and wings of an eagle. Ancient Greeks identified them as guardians of various treasures.

As guardians they symbolized strength and vigilance, as well as the obstacles to be overcome in reaching a goal. In ancient Persia, the griffin was a frequently used motif and was also associated with the state religion, Zoroastrianism (the teaching of the Magi, based upon the fundamental principles of Good and Evil). Later, Christianity used the griffin to symbolize the twofold nature of Christ, both human and divine.

GRIM REAPER

The grim reaper is, quite simply, a symbol of death itself. Generally depicted as a hooded and caped skeleton wielding a giant scythe, he comes to "harvest" human souls with his tool. He is the personification of death as it approaches and a reminder that no one escapes him in the end.

GRIZZLY BEAR

The grizzly **BEAR**, so called because its hair is silver- or pale-tipped, giving it a grizzled effect, is undoubtedly a symbol of strength. Although today it has come to represent wildness and wilderness, especially in its native North America, in the past many Native American legends included the bear as a person. Similarly, Pomo Indian initiates (in Northern California) were ritually killed by a grizzly bear impersonator. In addition, **SHAMANS** called upon them as animal affiliates or dream helpers.

Grizzly bears are the world's largest terrestrial carnivores. The most revered animal hunted by the Tlingit of the Pacific Northwest, the large brown grizzly bear was looked on with great regard, not only as a dangerous antagonist, but because of its connection with man in the legendary past. The grizzly bear is both powerful and fearsome.

GUEVARA, CHE

Although the world of tattoo is populated with literally an infinite number of portrait images, few have transcended their particular individualistic symbolism in the way that the image of Che Guevara has. Theoretician and tactician of guerilla warfare and a prominent figure in the Cuban Revolution, Guevara's death at age thirty-nine, which happened while he was fighting for Communism in Bolivia in 1967, helped to ensure his lasting fame. A photograph taken on March 5, 1960, by photojournalist Diaz Gutierrez, of Guevara wearing a black beret with a star and an uplifted but somber gaze has become the one of the best-known portraits in the world. It has become synonymous with Communism, as well as violent revolution.

GUITAR

Like other musical instruments that are used in tattoo art, the bearer generally plays one. However, the guitar does not only represent musical ac-

tivity. The electric guitar has become a modern symbol of rock and roll and the culture that goes along with it, not unlike the giant guitars mounted outside the Hard Rock Café restaurants. In tattoo art, it is not unusual to see specific electric guitars, such as Fender Stratocasters, accompanied by **FLAMES**. Alternatively, an acoustic folk guitar (especially in the dreadnought body style) might be accompanied by **FLOWERS**, all depending on the style of music and the particular instrument that the bearer plays.

GUN

In prison tattoo, a gun is a symbol for an armed robber. In general, for the wider world of tattoo, a gun can take on several meanings, depending on the specific context. While in some cases tattoos of guns are on a level with those that represent hobbies or sports, most people who sport a gun tattoo are probably saying something more. It is fundamentally a weapon and, on this level, it symbolizes not just violence but also aggression.

GUNTOWER

The guntower is a prison tattoo, representative of the life where guards always occupy these two-story structures in order to monitor the actions of inmates. They symbolize prison life and incarceration.

HAGOROMO

Hagoromo is a beautiful goddess of Japanese myth and sometimes a subject of Japanese tattoo art. The story of the mortal who stole an ANGEL's cloak and so prevented her return to heaven is widely spread across the globe, as is the story of an angel or NYMPH who flies down to earth and arouses the love of a mortal. In the case of Hagoromo, she visits a poverty-stricken farmer and ends up granting him everlasting abundance when he takes pity on her and returns her sheer veil, covered with STARS, after seeing her weep. She may be less holy than KANNON, but she has a sexy side to her, and is usually depicted as being better-looking than he is.

HALLOWEEN

Holidays are rarely the subject of tattoo symbolism but Halloween is a notable exception. Scenes including JACK-O'-LANTERNS, a scary house at night, and BATS or WITCHES against a full MOON are part of the celebration of a night that used to be known as All Hallows' Eve. Begun in ancient Britain to mark various points in the year for the different peoples of the region, it served as the recognized end of summer and also the start of a new year. It was a time of renewal but also a time of looking backward, as the souls of the dead were believed to pay a visit on this evening. Eventually all manner of ghosts, witches, GOBLINS, black CATS, and demons were thought to be roaming about making trouble for the living. In the modern day, it is a holiday mostly celebrated by and for children but with costumes and parties that recall something of the mischief and mystery that were originally part of the celebration.

HALO

The halo is a symbol of holiness, a representation of an enlightened spirit using a ring of light. Usually it is displayed as a radiance around the head and sometimes as a MANDORLA around the whole body, as is common with the VIRGIN OF GUADALUPE tattoo. Apart from saints and images of JESUS, the most common form of the halo in tattoo art is a brilliantly radiant gold ring suspended over any number of people or things. In these images it conveys less a sense of the sacred and more the center of spiritual energy or the presence of something uniquely important and special. Halos also convey the notion that a person, or pet, is deceased but still very much alive to the bearer of the tattoo, at least in a spiritual way.

HAMMER

Suggesting might, activity, and brute force, the hammer is used in symbolism that centers around power. It was the tool of the Norse god THOR and the Japanese god DAIKOKU. First the symbol of the blacksmith, who turned raw metals into TOOLS, it was not a far step for it then to be associated with creation. Hammers were also occasionally used on the battlefield as weapons. More recently, it has been paired with the SICKLE in communist iconography as tools of the worker and peasant, whose cause this political system is meant to champion.

HAMMER AND SICKLE

The sledgehammer grasped by a well-muscled arm is the standard artwork symbol both for various labor and communist movements; however, the design was most famously employed by Soviet artists. Sometimes called "Soviet Realism" or "Socialist Realism," the saturated colors, heavy black outlines, bold typography, and a use of photomontage compositions are all combined to produce a look that is overtly monumental and heroic, especially in poster art adapted for tattoo images. Intended as a glorification of the new society that was being forged in the early 1900s, these images have today come to symbolize not only the communist movement but the propaganda techniques and cultural flavor of the time. The HAMMER, SICKLE, and a field of red (sometimes specifically replaced by a red STAR) are also the symbols of the former Soviet Union.

HAMMERHEAD SHARK

The hammerhead **SHARK**, like the **GREAT WHITE**, is a particular species of shark that has found some popularity in tattoo designs. Like the great white, it has been known to attack humans without provocation. With a gray-brown coloring on top and an off-white underside, the most striking thing about this species is, of course, the head. It is almost rectangular in shape, resembling a "T," with the eyes set at the ends. The largest, and most dangerous, type of hammerhead shark typically reaches a length of about fifteen feet.

HAN

The Han, or name chop, is a type of signature seal that was developed in China and used since the Shang dynasty (1766–1122 B.C.E.). It was a precursor to printing but used the same principle of a hand-carved block of jade or another type of attractive stone pressed into a red ink paste made of cinnabar and stamped onto a painting or document. For business purposes it served as a signature. The most frequent use of it in tattoo artwork comes either in the form of Japanese tattoo or re-creations of Chinese artwork as a signature of the artist, almost always done in a **SQUARE** of red, in either Chinese or Japanese characters.

HANDCUFFS

Handcuffs, used by the police on prisoners under arrest, are widely recognized as a means of manacling the hands. In an interesting twist, handcuffs in tattoo art are often not used to represent imprisonment or confinement. Instead, they can depict someone just having escaped, open instead of closed. In this way, they are used to symbolize newfound freedom and release from shackles, whatever those shackles might have been.

HAND OF FATIMA

Khamsa, the number five in Arabic, is another name for the hand of Fatima, the Prophet Mohammed's favorite

daughter. Known throughout the Mediterranean region and the Islamic world as a sign of good fortune, it is specifically used to avert the evil eye and has also been used to symbolize the support group, even the **BLOOD** revenge group (of the closest male relatives).

HANDPRINT

The hand may be the part of the body most frequently appearing in symbolism. Handprints, and their silhouettes, have been part of human artwork since the **CAVE PAINTINGS** of the Paleolithic era. While all manner of symbols use hands in various positions, the handprint, like the **FINGERPRINT**, is a uniquely human symbol, as well as being unique to each human.

HANUMAN

In Hindu mythology, Hanuman is the divine **MONKEY** chief and the ultimate devotee of Lord Rama. He is shown as a human except that his body is covered with white hair and he has the face and tail of a monkey. A hero in spirit and in many deeds, Hanuman symbolizes qualities of selfless devotion and unshakable belief. In one of the most famous stories of this devotion, he was presented with a **PEARL** necklace from Sita, the wife of his Lord, on the occasion of Rama's coronation. But, after receiving it with much humility, he proceeded to break each pearl with his teeth. When Sita inquired in astonishment as to the purpose of his actions he replied that he was trying to discover if any of the pearls contained his beloved Lord Rama, since he did not keep anything that was devoid of him. Sita then asked whether Hanuman kept Lord Rama within himself. At this, Hanuman opened his chest and showed those assembled that both Lord Rama and Sita were indeed there.

HARLEY-DAVIDSON

The Harley-Davidson **MOTORCYCLE** and the company's bar-and-**SHIELD** logo have become American icons for free-spiritedness and independence. Far from being strictly a biker tattoo, the bar-and-shield, sometimes with an **EAGLE** and even the Stars and Stripes, has come to be synonymous

with Harley riders of every sort the world over, but especially in the United States. When the company was formed in 1903, simple block lettering on the sides of gas tanks sufficed for product branding. Today, through a well-developed set of designs that capitalize on generic and familiar American emblems, the bar-and-shield may be the most frequently used logo in tattoo imagery.

HARP

When harps are used alone in tattoo imagery, they are virtually all of the Celtic variety. From the evidence of Pictish engraved stones from the eighth century, we can see that the Picts possessed a form of the instrument with which we are familiar today, the triangular *clarsach*. It has been used as a national symbol, inscribed on Irish coins, and even played on the front lines of battlefields. English invaders unsuccessfully attempted to eradicate harp-playing, giving the harp the added symbolism of resistance.

HARPY

Harpies are the evil spirits of classical Greek mythology. They are winged monsters who have the bodies of BIRDS and the heads of women, sharp claws, and a rank, disgusting odor. Their name means "snatchers"—apt since they carried souls to the Underworld and inflicted punishments on them there. Their symbolism is one of vicious lust and obsession, yet coupled with guilt once they have been satisfied.

HAWAIIAN BIRD MOTIF

The Hawaiian BIRD motif, so reminiscent of the types of seabirds prevalent there, unfortunately has no known name or meaning that survives. As is the case with much, though not all, of traditional Hawaiian tattoo designs, the cultural information connected to them was lost as a result of early Christian missionary efforts to stop the practice of tattooing and incorporate Western culture into native.

HAWK

The hawk, a BIRD of prey, is a favorite in tattoo imagery and in symbolism in general. It is the source in nature of the famous Egyptian symbol of the

EYE OF HORUS and in Greek mythology it was the messenger of Apollo. Frequently having to do with the SKY or the SUN, the hawk has come to be associated with royalty as well. Falconry, or the sport of hunting with hawks, has long been a pastime of the rich and privileged. It is not uncommon in tattoo art for the hawk to be perched on a leather glove or in the process of hunting.

HEAD OF ST. JOHN THE BAPTIST

The theme of the beheading of John the Baptist is one that has been used widely in Christian art including Coptic tattoo art, the type of tattoo art used in pilgrimage images in Jerusalem, especially in the earlier part of this century. The story is one of desire and spite. SALOME was the stepdaughter of Herod, who had imprisoned John the Baptist because he had dared to criticize his marriage (to the former wife of his half-brother and Salome's mother). When Salome's dance delighted Herod, he promised her anything. Prompted by her mother, she asked for the head of John the Baptist—a request she was granted. The bearded head is shown tilted on its side, with a CHALICE below.

HEART

The depiction of the heart as an actual organ in the human body, in a naturalistic way, is not its most common depiction in tattoo art. Reminiscent of the x-ray style of rock art in western Arnhem Land in Australia, it is depicted as though one could look through the skin and see into the chest. Such a depiction is also akin to the BIOMECHANICAL style or the portrayal of WOUNDS. In some instances these types of tattoos have been used by heart patients, symbolizing the surgery or other treatment they have received and perhaps also their recovery.

HEART SYMBOL

The HEART, in one form or another, may be the most used symbol in all of tattoo imagery. Its most obvious symbolic meaning is one of love and affection. However, many different variations on this theme can be found. Frequently the heart is shown in combination with other types of symbols,

some of which are specific, as in the **SACRED HEART** or the **PIERCED HEART**. Many times, though, the heart can be seen with a banner across it, or underneath it, that spells out the meaning of the heart for the bearer, usually the name of a beloved person. Sometimes hearts are portrayed as if jaggedly cut down the middle, representing a broken heart and sometimes representing two people who "share" one heart when half the tattoo is on one person and half on the other.

HEART WITH CROSS

The **HEART** with a cross is a fundamentally Christian symbol while also being a variant of the simple **HEART SYMBOL** tattoo. Many times in tattoos, the cross and heart are depicted in 3-D, with the cross sitting atop the heart. The cross symbolizes Christ and in this context is particularly reminiscent of the sacrificial nature of his death, as the two images together relate to the act of sacrifice and the love it requires, as well as the love engendered by sacrifice.

HEART WITH DAGGER

The **HEART** pierced by a **DAGGER** is a recurrent image in tattoo art, uniting two favorite symbols for the skin. Although likely never used by practitioners of voodoo for tattoos, the heart pierced by a dagger is the symbol of Erzulie Dantor, the dark aspect of Erzulie, a spirit of cruel vengeance and jealousy. In just the opposite sense, the heart pierced with a dagger has been taken as a variation of the **SACRED HEART** tattoo by some Christians. More often than not, though, in tattoo imagery the meaning is more literal—it is the heart as the center of emotion, being, and love that is in pain, damaged or wounded.

HEART WITH FLAMES

The **HEART** with flames is a "heart on fire" for somebody. Although **FLAMES** can be used for a multitude of different meanings and are combined with all types of other symbols, they are a symbol of passion and energy when combined with the heart.

HEART WITH MOM

This tattoo is ever present in Western culture, to the point where it has become synonymous with "the typical tattoo." It is a type of tattoo where a flowing banner is placed across the front of a heart with a personal or familial name such as "Mom" or "Dad" written in it. Sometimes intended as a memorial or a pledge of unending love, the "Heart with Mom" tattoo is usually done in a traditional or "old-time" tattoo style, using primary color schemes, perhaps a little three-dimensional shading, but always a white banner that folds behind itself with scripted letters.

HEI TIKI

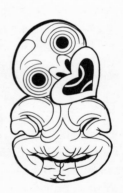

The *hei tiki* is an AMULET used by the Maori of New Zealand that has been used as a more general TIKI god symbol for Polynesia. The Maori pendant resembles a human fetus, with head bent to one side, and it is typically carved from shiny green stone. Typically worn by women, these amulets are believed to possess magical protective powers.

HELL'S ANGELS

The Hell's Angels were likely the first MOTORCYCLE club, but they did not start out on motorcycles—they started in airplanes. In 1941, before the United States had entered World War II, the Flying Tigers, an air combat unit of Americans, volunteered to fight for the Chinese. One squadron was called the "Hell's Angels" and commander Arvid Olsen had the name painted on all his fighter planes. Olsen returned to Southern California and took up motorcycle riding with other veterans, wearing their familiar wartime clothing of leather bomber jackets, heavy boots, and helmets and goggles. Today, the Hell's Angels tattoo shows the familiar horned SKULL in profile with an ANGEL wing flaring out behind it, somewhat similar to the DEATH'S-HEAD.

HERMES WING

Hermes was the fleet-footed messenger of the ancient Greek gods and he also had duties that involved conducting the dead to Hades. He carried the CADUCEUS and wore winged sandals that allowed him to fly rapidly from place to place. The tattoo that recollects him and his speed involves small WINGS tattooed near the ankle, on the outside of the leg, in the approximate spot where the wings on his boots would have been.

HEXAGRAM

The hexagram is the six-pointed STAR composed of two overlapping triangles, one pointing up and one pointing down. The most famous hexagram is the STAR OF DAVID, but there are many other types of symbolism that have been associated with it over time, dating back to at least 600 B.C.E. Alchemists of the Middle Ages used it as a general symbol representing the art of alchemy and also as a sign for the combination of WATER and fire. In Indian tradition it stands for the marriage of SHIVA and Shakti. In terms of Jungian psychology, it is the union of opposites.

HIEROGLYPHS

Hieroglyphs have been a design choice for tattoos since the time of the ancient Egyptians. There are statues of Egyptian kings of the New Kingdom that show what is very likely hieroglyph tattooing. Hieroglyphs are a system of pictorial writing and while the word "hieroglyph" was originally used to refer to ancient Egyptian writing, it has come to be applied to pictorial writing systems in other parts of the world as well, including the Maya of Central America. Many specific Egyptian hieroglyphs are used in tattoo such as the ANKH or the EYE OF HORUS, and some are more extensive, spelling out names or even whole phrases, such as blessings.

HIPPOPOTAMUS

Because the hippopotamus devoured and trampled their crops along the Nile, the ancient Egyptians saw this creature as a force of destruction and a follower of SETH, the god of chaos, and hunted it from BOATS with harpoons. Eventually, though, it also came to symbolize fertility and childbirth because of its great rounded belly. Elsewhere in Africa, a folktale told

how the hippopotamus was created by God to "cut the grass." Because of the heat, the hippopotamus asked if it could stay in the water by day and cut grass at night. Although God was afraid that the hippo would eat the FISH in the river, he agreed. The hippopotamus, however, was true to its word and only ate the vegetation.

HIV POSITIVE

HIV stands for "human immunodeficiency virus," which can cause AIDS, or "acquired immunodeficiency syndrome." HIV damages the body's ability to fight infection, preventing the immune system from creating a defense against viral or bacterial attack. The letters HIV tattooed with a " + " sign stand for "HIV positive," meaning that the wearer is voluntarily displaying the fact that he or she has tested positive for the presence of the virus. Initially most cases of HIV in the United States were diagnosed in homosexual men but today heterosexual intercourse is the main mode of transmission, accounting for 70 percent of all HIV infections worldwide.

HOAKA

Many of the tattoos of Polynesia consist of geometric and linear motifs, rows of TRIANGLES, for example. The *hoaka*, a common design in Hawaiian art, tattoo, and otherwise, is a series of crescent arches. It has been suggested that, like much of Polynesian tattooing, there may be some genealogical significance to the tattoo. It may represent human beings who are joined together in a lineal descent, a genealogical relationship where they can trace their origin back to even the gods. Such a design would carry much symbolic significance for an individual, serving to underscore one's high position in society and likely authority in that society as well.

HOBBIT

Tattoos of hobbits, the peaceful and amiable race of little humanlike creatures that lived in Middle Earth, are a part of fantasy art tattoo. Created by J.R.R. Tolkien, the hobbit enjoys an especially warm place in the hearts of the readers of his books *The Hobbit* (1937) and *The Lord of the Rings* (1954–55). Creating an entirely believable world and telling a tale of the heroic struggle between good and evil, Tolkien created vivid images that

today inspire all manner of other creations, including cartoons, movies, and a multitude of tattoos.

HOLD FAST

An old maritime tattoo, the letters "H," "O," "L," and "D," one each tattooed on the knuckles of one hand, and the letters "F," "A," "S," and "T" on the knuckles of the other hand were said to help seamen hold on to the riggings better.

HOLY LAMB

The theme of portraying Christ as a LAMB (instead of the GOOD SHEPHERD) is another popular one in Christian art and Coptic tattoo work. In the Old Testament, as elsewhere in the world, lambs were offered in sacrifice as atonement for sin. In the New Testament, JESUS replaces the lamb, and John the Baptist says of him, "Behold the Lamb of God, who takes away the sins of the world" (John 1:29). The lamb is also regarded as a reflection of the gentle nature of Christ. The holy lamb tattoo generally shows a haloed lamb, sometimes accompanied by a staff flying a banner of white cloth with a red cross (hearkening back to the CRUCIFIXION).

HOLY TRINITY

The number THREE is considered to be a sacred or divine number in most cultures. In Christian imagery, the three intersecting CIRCLES that form an equilateral TRIANGLE are used as a symbol for the Holy Trinity.

HOMEWARD BOUND

Homeward bound (yet seaward drawn) is one of the "old school" maritime tattoo designs. It is usually depicted with a clipper ship, fully under sail, WATER splitting at the prow, almost heading directly at the viewer, with a banner or two that proclaims "Homeward Bound." Occasionally other nautical items were substituted, like an ANCHOR or the steering wheel, but the clipper ship is the traditional image, most authentically re-

alized with the black outlines, heavy shading, and bright colors typical of tattoo artwork of the day.

HORSE

In a symbolic tradition that easily stretches back to the vibrant horse paintings in the cave art of the last ice age, wild horses were the embodiment of power. Not until thousands of years had passed would the horse be tamed for human use. In the CHINESE ZODIAC, people born in the Year of the Horse are considered cheerful and perceptive, although they may talk too much. Numerous characters have mounted horses, including the Four Horsemen of the Apocalypse (representing death, war, pestilence, and famine) from the Book of Revelation, the goddess KANNON of Japan, ST. GEORGE as he slays the dragon, and the Valkyrie of Norse legend on winged versions, to name but a few. Horses express an instinctual and unbridled energy and dynamism and yet are also intelligent and even noble.

HORSESHOE

The horseshoe might be the best known lucky charm or AMULET in the West. Among the ancient Romans—who invented the horseshoe—the "U" shape was believed to ward off evil. Indeed, the shape itself was also associated with a CRESCENT MOON and hence fertility. According to more recent tradition, horseshoes hung over doorways protected a home's occupants, sometimes pointing down (to drain off bad luck), sometimes pointing up (to hold good luck). In tattoo artwork, they generally point up, are sometimes accompanied by a banner that says "Lucky," and frequently are accompanied by other symbols of luck such as DICE or SHAMROCKS.

HORUS

Horus is the falcon-headed god of ancient Egypt who symbolized keen-eyed justice from which no one could hide. Also frequently represented by the EYE OF HORUS, his depiction in full body form ranged from a man with a FALCON head to a pure BIRD form with WINGS outstretched and the disk of the SUN suspended above his head. In his legendary battle with SETH, he was cut to pieces and had an eye torn out, but was reconstructed and reanimated by THOTH. He stood as a symbol for the constant battle to preserve cosmic balance and to bring about the victory of the forces of

light. Tattoos of Horus draw from the complete repertoire of vibrant Egyptian imagery and can be both ultracolorful or done in blackwork.

HOT AIR BALLOON

The hot air balloon, invented in France in 1873, has captured the imagination of people ranging from science and fantasy writers such as Jules Verne to modern-day adventurers and aeronauts still looking to set world records in them. Colorful and made in special shapes, these "lighter-than-air" craft ride on the winds and so came to be associated with freedom and adventure, and also with a higher vantage point and higher or positive thought.

HOTEI

In Japanese mythology, and so in Japanese tattoo, Hotei is probably the most identifiable of the **SEVEN GODS OF GOOD FORTUNE**. He is the famous "laughing **BUDDHA**," the god of happiness and prosperity, with his giant potbelly and his round smiling face. In tattoo artwork, the Seven Gods are generally all present in a large piece that may cover quite a bit of the body. A humorous placement of the big-bellied Hotei is sometimes on the belly itself.

HOURGLASS

The hourglass has been a symbol of the passage of time and the transitory nature of human experience, in that way implying *memento mori*, a reminder of our mortality. But because it can also be turned upside down and started over, the hourglass has been associated with the notion of symmetric cycles and reversals. In prison tattoo, the hourglass and the clock are specific reminders of "time" served.

A slight modification of the hourglass by adding **WINGS**—probably a more common tattoo than the hourglass alone—creates a visual pun. It is not that the hourglass is suddenly endowed with **BIRD** characteristics or the capability of flight; instead, the message is that "time flies."

HULA GIRL

The dancing hula girl tattoo is embedded in the legend and lore of tattoo imagery and has many associations. Because tattoo in the West was popular early on with mariners, the hula girl tattoo meant that a **SAILOR** had been to Hawaii. At the same time, whether she is wearing the typical hula outfit or in the buff, she is also a type of pinup girl.

HUMMINGBIRD

Most notable for its ability to seemingly hover in midair (due to the very rapid flapping of its **WINGS**), the hummingbird is a New World animal and its ancient symbolism therefore draws from the cultures that flourished there. The Aztecs believed that the souls of dead warriors came back to **EARTH** as hummingbirds or **BUTTERFLIES**. The Hopi have a story about a hummingbird hero who saved mankind from starvation. In tattoo art, the hummingbird is sometimes shown along with the colorful **FLOWERS** that attract it, frozen in a moment in time with wings flung backward. Like the food they eat, there is something sweet in their diminutive size and their uncanny, even zany, flying antics.

HYDRA

The Hydra is a mythic serpent-headed monster of Greek legend. If one head was cut off, two grew in its place. Eventually defeated by Hercules with fire, the **BLOOD** of the slain beast was used to tip arrows, making them poisonous. The Hydra heads represent the many vices to which humans are prone. Despite valiant attempts to escape those rampant desires, they grow again even if severed. Contact with vice, like the poisonous arrows, can be corrupting.

IBIS

For the ancient Egyptians, this tall, thin, water-wading **BIRD** with the pointed and downward-curving beak was a creature of great symbolic significance, considered the incarnation of the god **THOTH**. Numerous mummified ibises accompanied burials. Much like Thoth, the ibis was associated with the intellect, knowledge, and wisdom. In Judaism, the ibis was credited with foreknowledge, heralding the flood of the Nile, but it was also considered unclean. In early Christian bestiaries, the ibis was believed to feed off the carcasses of dead **FISH** (because it could not swim) and would feed the same to its young, propagating sinful behavior.

ICARUS

Icarus is the symbol of rash and uncontrolled youth that disregards parental warnings to earn its death. In Greek mythology, he and his father, the inventor Daedalus, are imprisoned after falling out of favor with King Minos of Crete. In order to escape the island, Daedalus creates **WINGS** of wax and **FEATHERS** for the two of them so that they can fly to Sicily. Despite cautions 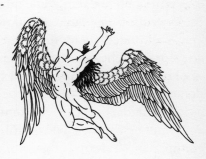 from his father to fly the middle course, Icarus flew ever higher and closer to the sun. When the wax melted, he fell into the sea and drowned.

IGUANA

The iguana is a large (up to six feet long) lizard of the Western hemisphere that, perhaps because of its beautiful green color scheme or its status as a pet, is popular in tattoo art. Among New World groups, iguanas were important to the Maya of Central America, where they were sacred animals. Their distinctive, powerful legs, large body, and equally large head, combined with a long tail, make them ideal tattoos for longer parts of the body. Sometimes, despite their potential for vibrantly colored designs, black TRIBAL versions are also done.

IHS

In more recent times, the letters "IHS" have served as an acronym for various words relating to Christ—"I Have Suffered" in English; *"Jesus hominum Salvator"* in Latin, meaning "Jesus the Savior of men"; and even *"Jesus, Heiland, Seligmacher"* in German, meaning "Jesus, Lord, Savior." But the origin of these letters is not of an acronym at all, but of an abbreviation. The letters "IHC" had been used in Christian symbolism as the abbreviation for Jesus's name, based upon the spelling of JESUS using the Greek alphabet. When translated to Latin equivalents, the first three letters (iota-eta-sigma) would appear "I-H-C" or sometimes "I-H-S," where the letter "S" rather than "C" replaces sigma.

ILLUMINATI

The illuminati (meaning "enlightened ones") symbol of the eye within a pyramid or TRIANGLE is one whose origin is shrouded in mystery but whose presence is widespread. The eye itself is sometimes called the ALL-SEEING EYE, the third eye, or the eye of providence, and has most generally been interpreted as a reminder of the constant presence or watchfulness of an all-powerful being, as was common in Western cultural iconography of the seventeenth and eighteenth centuries. The triangle or pyramid is likely an adjunct based on the Christian trinity. In tattoo artwork, the illuminati takes on a seemingly infinite number of forms that range from winged ver-

sions with **HALOS** to re-creations of the Great Seal of the United States, as seen on the dollar bill.

INDIANS

Tattoos of Indians (indigenous peoples of the New World) tend to focus on bust portraiture of various Plains Indians groups, notable for their **FEATHER** headdresses. Whether these images draw on well-known Western art images (such as James Fraser's famous statue *End of the Trail*, with the emaciated **HORSE** mounted by an exhausted Indian brave, both with heads drooping low) or are generic representations of "American Indians," they are romanticized attempts to depict the heroic and tragic struggle of these indigenous peoples to maintain their cultures and even just to survive. They are often intended as poignant and patriotic symbols, and it is ironic that these indigenous peoples did not use portraiture in their own tattoo artwork. Instead their images have been co-opted and incorporated into an Americana of which they were not necessarily willing participants.

INFINITY

The figure eight lying on its side is the mathematical symbol for infinity, meaning something very great in number, essentially unending or uncountable. It is similar to the **OUROBOROS**, or **SNAKE** that eats its own tail, but here there is a double looping and returning motion, a double endlessness.

IN MEMORIAM

Tattoos of in memoriam (Latin for "in memory of") are likely a very ancient joining of ink with skin. From the use of these actual words, in English or Latin, followed by the initials, name, or perhaps some other more symbolic reminder of the deceased, these tattoos are more than an expression of grief, although they are certainly that. The people memorialized become a physical presence, quite literally, and a lasting part of the tattoo bearer. In many ways tattoos have been and continue to be a transformative process for people. The in memoriam tattoo is yet one more way for us to cope with loss and express our desire for remembrance. Placement on

the skin of these innermost feelings and bringing them "to the surface" is also an apt analogy.

INRI

The letters "INRI" are seen in Christian CRUCIFIXION scenes and also frequently in tattoo imagery involving Christ on the cross. The Roman governor Pilate ordered that an inscription be placed on the cross, written in Aramaic, Greek, and Latin. The letters "INRI" are an acronym for the Latin version—"*Iesus Nazarenus Rex Iudaeorum*"—JESUS of Nazareth, the King of the Jews (John 19:19).

INTERLOCKED ARMBAND

The flowing and intricate scroll patterns in the illuminated manuscripts that have made Celtic artwork famous (such as in the *Book of Kells*) are not particularly symbolic but rather serve a decorative purpose. But delving a bit deeper, the single thread that reconnects with itself, no matter how complicated the pattern, has often been used to symbolize eternity.

INTERLOCKED BEARD PULLERS

Surprisingly, the motif of beard pullers, whether interlocked as in a design from the *Book of Kells* or simply standing, is not an isolated instance of Celtic KNOT WORK. The beard pullers motif has ancient historical roots in Islamic art, where beards were associated with men and beard pullers with dispute and conflict. When Christian and Islamic societies and cultures began to meet, a direct borrowing of images sometimes took place, although the meanings associated with them weren't so easily absorbed or even understood. In Islamic art there may also have been an entertainment aspect, as in the performances of professional wrestlers or mock fighters of the time period.

However, after entering Christian iconography, the beard pullers came to symbolize the vice of discord and a moral exhortation against aggressive struggle.

ISIS

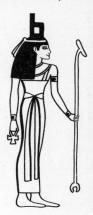

Isis is easily the most important and illustrious of the ancient Egyptian goddesses and the most popular in modern tattoo imagery. Shown frequently with long, outstretched WINGS with which she protected the dead, and standing in the pantheon, she was the wife of OSIRIS and the mother of HORUS. Eventually her worship spread beyond Egypt and she became an all-powerful and universal goddess throughout the Mediterranean.

IVY

An evergreen, climbing, and clinging vine, ivy has come to represent not only love and friendship but also immortality. For the Greeks, it was also thought to cool the brow and balance the heating power of wine. For the Egyptians, it was associated with OSIRIS, resurrected from the dead. Medieval Christians extended the meaning of the symbol to include eternal life. Its circuitous and wandering path allows for numerous types of placement on the body in tattoo art, all of which have probably been exploited, shown sometimes in the lustrous shades of green that are natural to it and other times in blackwork, with its distinctive five-pointed leaf.

IWO JIMA FLAG-RAISING

Although many types of tattoos are used by military men to memorialize their wartime actions, some images have transcended individual experience to capture the imagination of a generation. The raising of the American FLAG on Mt. Suribachi, on February 23, 1945, was photographed by Joe Rosenthal of the Associated Press. It shows the flag on a pole that is not yet upright, and six helmeted men have taken up positions surrounding the pole, either planting it in the ground, hoisting it just above their shoulders, or with hands upstretched helping to right it. The image became emblematic of not just the battle for the Pacific that took place on numerous small islands like Iwo Jima, nor just for the greater World War, but it also symbolized heroism in the face of harrowing conditions, the sacrifice of American lives, and victory. This picture was widely reprinted, and statues, paintings, a U.S. postage stamp, and even tattoos, have been based upon it.

JACKAL

The jackal is a beast of ill omen and death in areas of the world that it occupies—namely parts of Eastern Europe, North Africa, and Southeast Asia—because it feeds on corpses and frequents graveyards. **ANUBIS**, the ancient Egyptian god of the dead, was portrayed with the head of a jackal, with a distinctive long muzzle and large pointed ears. In some Hindu iconography, this relatively small animal (15–25 pounds) is associated with violent feelings and emotions.

JACK-IN-THE-BOX

The jack-in-the-box is a musical box toy with a handle crank on the side. As the crank is wound, music is played, and tension increases in the handle. The crank becomes more difficult to turn until the clown or jack springs out of the top of the box from beneath the lid.

In tattoo artwork, the jack-in-the-box is shown sprung. But what comes out of the box is anybody's guess— rarely is the little emerging puppet a simple clown in tattoo imagery. Sometimes it is a **SKULL** or any other numerous types of heads. A common head to pop out might be the evil **CLOWN** with wacky hair, makeup, and bulbous nose, but also a sneer and wicked look about the face. This is not far from the actual purpose of the toy, which is to give a bit of a start or scare as the jack pops out, and these more malevolent versions capitalize on the scary and surprising aspect of this play-

thing—a bit of an unexpected and bad surprise, even if you're familiar with the toy.

JACK-O'-LANTERN

The jack-o'-lantern, or the pumpkin carved with a face and lit from within by a candle, is a symbol of HALLOWEEN. Many of the customs of Halloween are shrouded in the history of ancient Britain, including the origin of the jack-o'-lantern. Some legends attribute it to a night watchman and others to a scoundrel who managed to trick the DEVIL and needed a lamp to navigate from hell back to EARTH. Originally, though, in either version, a CANDLE was placed in a turnip. When the legend was transplanted to the United States, the turnip was replaced by the native pumpkin.

JACOB'S LADDER

Jacob's Ladder comes from a story in the Judeo-Christian tradition (Genesis 28:12) where Jacob dreams he sees a ladder on which ANGELS go up and down, between heaven and EARTH. Ladders in general are a symbol of ascension and the ladder that connects the heavenly and mortal realms is one of connection as well as ascension. It is a bridge and an expression of communication between God and humanity.

JAGUAR

The jaguar, the largest of all cat species in the Western hemisphere, plays a decidedly Underworld role in the cultures of Central and South America, where the animal is found. The Maya regarded the jaguar as an incarnation of the internal powers of the EARTH, sometimes escorting souls after death. Depictions of evening sometimes showed the jaws of a jaguar (the earth) swallowing the SUN. Glyphs that use the jaguar or its skin are associated with dreaming, spirits, and shamanic activity. Tattoo imagery uses the jaguar in similar ways, sometimes depicting it in a naturalistic state with its leopardlike two-tone spots. Other images use Mayan glyphs, typically the head with a canine tooth showing in profile.

JANUS

Janus was one of the most ancient of the Roman gods, with roots in an Indo-European deity. The god with two faces, one on each side of the

head, was originally the creator, but over time he became the god of change and transition, the god of the gate. His two faces meant that he watched entrances as well as exits, saw the internal and the external worlds, looked left and right, above and below, could see before and after, and be for and against. Janus (for whom the month January is named) was the god of beginnings and the protector of portals.

JAPANESE DRAGON

In Oriental myth, the dragon could not be more opposite to its Western counterpart. Dragons in Oriental art do not have WINGS nor do they necessarily breathe fire, although FLAMES erupt from their limbs. They are not creatures of EARTH, but rather combine elements of the air and WATER and are equally at home in the OCEAN or the CLOUDS. Although strength and power are represented, the dragon above all is a reconciliation of opposites, a combination of YIN AND YANG. Also unlike the Western dragon, the Oriental dragon is not a cunningly malevolent beast. Instead it is strength combined with wisdom and is benevolent. It is also not unusual to see a dragon clutching a BALL, a PEARL, or a jewel in one of its claws. This item is essentially the closed-lotus form seen in various Buddhist designs including those in temples and on grave markers. It represents the spiritual essence of the universe, by which the dragon controls the winds, rains, and even the movement of the planets, and he protects it from those who might usurp those powers. Like other Japanese tattoos, the choice of a dragon is an aspiration to these same qualities of wholeness and wisdom. It is one of the more popular of Japanese-style tattoos and they are depicted with great variety in terms of body position, degree of hostility in aggressive or passive position of the claws and jaws, and in their environment.

JELLYFISH

The jellyfish has not often been the subject of legend or lore, although it does occur occasionally. In tattoo art, though, the jellyfish is not an un-

common image when it comes to tattoos with an **OCEAN** or sea theme. In these designs, the beautiful and gossamer grace of the jellyfish is emphasized as it seems to float in the breeze of an unseen current. They seem naturally mysterious to us and are potentially dangerous at times, but they remain visually delightful.

JERUSALEM CROSS

The symbol of the Jerusalem cross has a long history in the world of Christendom and the world of tattoo. The central form has been interpreted as four tau crosses joined together to represent the Old Testament law. The four smaller Greek crosses represent the fulfill-

ment of the law in the four **GOSPELS**. Godfrey of Bouillon, who participated in the first Crusade (C.E. 1096) and became the first Latin ruler of Jerusalem, used it in his **COAT OF ARMS**. Pilgrims to the holy city have used it ever since that time in order to commemorate their journeys—even pilgrims such as King Edward VII of England and King Frederick IX of Denmark.

JESTER

The jester or court **FOOL** is an interesting figure in tattoo imagery, depicted in the typical "jester's motley" as an entertaining fool and just as often as an evil character. The jester's motley evolved over the ages into the form that is associated with it today—wearing of the brightly decorated, patchwork clothing hung with bells, including the drooping pointed hats. Jesters were often people of some wit and originality. The malevolent version sometimes seen in tattoo art uses the same accoutrements, including the small puppet version of the jesters that they would sometimes carry, but the faces of these evil characters have narrower eyes, or fangs, or even pointed ears—in short, something a bit maniacal and frightening.

JESUS

People who want to make a public statement about their private beliefs will sometimes use tattoos to do it. Unlike the names of spouses or friends,

whose relationship to a person might change, religion often is seen as more lasting and therefore more appropriate for tattoo. Other than a cross, there is probably no other symbol more evocative of Christianity than its founder, Jesus Christ, also called Jesus of Galilee or Jesus of Nazareth. Although no actual portraits of him survive, nor are any purported to have existed, many great artists have rendered him over the centuries. Naturally, details vary widely, but expressions that convey compassion, suffering, and holiness are universal.

JIGGS

Cartoon characters are an exceedingly popular part of tattoo art and include everything from the Tasmanian Devil to the Cat in the Hat. But cartoon characters in tattoos are not new and while some have incredible staying power (**BETTY BOOP**, for example), others have faded away. Jiggs is an example of the latter. A cartoon that debuted in 1913, *Maggie and Jiggs* (or *Bringing Up Father*) was about a rags-to-riches pair of Irish immigrants who never quite escaped their lowly upbringing despite their windfall wealth. The nearly bald Jiggs, with his short **CIGAR**, diminutive mustache, and "Orphan Annie" eyes, was a character in tattoo art that spoke of something lucky and wealthy, and yet yearning for the simple life, even at the cost of being harassed by his social-climbing wife.

JOHN 13:35

This biblical citation of **BOOK**, chapter, and verse is a sort of "shorthand" in Christian symbolism that crosses over well to tattoo art. Where the entire verse might seem too long for a tattoo, or too much text to be attractive, the citation gets the message across to people in the know. It might even inspire a question to be asked. And in answer to that question: John 13:35 reads "By this all men will know that you are my disciples, if you love one another."

JOHN 3:16

As in the previous example, this biblical citation is a shorthand way of conveying the message of the verse. This citation is probably the most

popular of its type. John 3:16 states that "For God so loved the world that He gave His one and only Son, that whoever believes in Him shall not perish but have eternal life."

JOKER

The joker is like symbols such as the CLOWN, the JESTER, and the FOOL. The joker is, of course, also associated with a deck of playing CARDS, with two jokers in a deck. Their appearance resembles that of the court jester but their function resembles more that of the FOOL of TAROT CARDS. The jokers stand outside the main deck of fifty-two cards. They are sometimes used in card play, and sometimes not. When used in a game, they generally have special properties not granted to any of the other cards. It is also not unusual for the joker card to be used as a sort of visual pun to indicate that the tattoo wearer might be something of a "joker" him or herself.

JUROJIN

Jurojin is one of the SEVEN GODS OF GOOD FORTUNE in Japanese mythology and a popular symbol in Japanese tattoo art, though he is usually shown with his companions, the other six gods. Jurojin is the god of longevity, shown as an ancient bearded man, sometimes confused with FUKUROKUJU, who is also associated with longevity but also wisdom and sometimes wealth. Jurojin generally carries a tall staff to which is attached a SCROLL, or he might also wear a scholar's headdress and is sometimes accompanied by a STAG, a symbol of longevity in both Japan and China.

KABUKI

Although it is not typically used in traditional Japanese tattooing, the kabuki face is used in Western tattoos to evoke an Oriental feel. Kabuki is the traditional form of theater in Japan, where the actors blend music, song, dance, and mime with elaborate costuming and makeup to serve up an extravagant performance. The kabuki face is based upon the exaggerated makeup used by the actors, where the face is first painted completely white and then given the distinguishing marks of heroes or villains, with particular attention paid to the eyes. The kabuki face in tattoo artwork is a link to traditional forms of popular Japanese entertainment, is representative of that culture, and it is also an opportunity to incorporate a stark piece of artwork into a design.

KACHINA

The Pueblo Indian kachina can actually be one of three things: the ancestral spirits of their religion, the masked dancers who perform at ceremonials, or the small carved dolls sometimes given to children. The dancers and dolls represent the spirits—beings that can be unique to each Pueblo group and of which there may be several hundred, each with its own purpose and costume. Tattoo artwork that incorporates kachinas shows them in any of their three manifestations, often using a combination of the earthy browns, reds, blacks, yellows, and turquoises popular in the artwork of the region.

KALACHAKRA

Kalachakra is Sanskrit for "time" *(kala)* "wheel" (chakra or *cakra*) and it is taken more broadly to mean cycles of time in Tibetan Buddhism. The complex symbol for this esoteric component of Buddhist teaching is based upon Sanskrit letters that spell the main *Kalachakra* mantra (incantation). The stylized syllables appear on the left side of the logo, with vertical lines connecting them to the right side. From bottom to top, there is the black YA, the red RA, the white VA, the yellow LA, multicolored MA, green KSHA, and blue HAM (which also includes the top horizontal bar). Above the horizontal bar at the top are the white or red CRESCENT MOON, the red, yellow, or white SUN disk, and the little blue, green, or black FLAME on top. Beyond the main symbol there is usually a kind of frame made of flames, which corresponds to the outermost "CIRCLE of wisdom" of the MANDALA.

KALI

In Hinduism, Kali is the destructive version of Devi, the supreme goddess. Where Devi is peaceful and kind, Kali is terrifying, with her four arms holding a SWORD, a severed head, a strangling noose, and sometimes one arm is held in the gesture of assurance (the *abhaya*, or protection from fear, hand position). Colored black, with fangs, smeared with BLOOD, and tongue protruding, she represents the vicious and yet ever-present side of existence, fierce and devouring, sometimes even destroying demons.

KANJI

Kanji is one of the systems of Japanese writing. It is based on characters adapted from Chinese, and to the untrained eye the two look quite similar. Many tattoos in both the East and West will use these types of symbols to spell out special or important words, such as "love" (depicted).

KANNON

In Japanese Buddhism, Kannon (the Chinese Kuan-Yin) is the embodiment of compassion. Committed to enlightening humankind and relieving suffering by postponing his own entrance to nirvana, he is a bodhisattva, a **BUDDHA**-to-be. But "he" is not always a "he." Over time, Kannon acquired the nature of mother-goddess as well, and was able to meld and change genders, combining all aspects of life. In Japanese tattoo work, Kannon is female in appearance, with long flowing robes and beautifully coifed hair, sometimes riding a dragon, sometimes a carp. The essence of merciful compassion and protection, she is among the most favored of all Buddhist deities and her long form is not unusual in large tattoos, especially back pieces.

KILLER WHALE (HAIDA)

Among the peoples of the Pacific Northwest, the killer **WHALE** was easily the most feared of the sea creatures, said sometimes to be part of the mountains themselves because it could be seen so close to the mainland. The whale is depicted again and again in various art forms, including tattoos, often in a fierce form with teeth showing. The most distinctive features are the upright dorsal fin and the bifurcated tail. A character in mythic tales and also an important figure in family crests, no other sea creature was more symbolic of awe-inspiring power and strength to the seafaring peoples of the region.

KING OF HEARTS

The highest ranking of the face cards in a fifty-two-card deck, the king can be a powerful card in many games. When the king card is used in tattoo artwork, it is sometimes used with other cards in a winning hand of a gambling game, signifying luck. However, this particular suit and rank combination also has a literal meaning when used alone, where the bearer of tattoo is taken as the king of hearts, in essence a royal but kindly ruler of emotions, especially love.

KINTARO

The popular Japanese legend of Kintaro, based in part on an actual historical military hero of the tenth century, is symbolically linked with the image of the **KOI**, or Japanese carp, and both are part of the yearly celebration of Boys' Day. Even as a child, Kintaro was gifted with enormous strength, managing to subdue a giant koi, another symbol of strength. Frequently shown in tattoo art in the act of wrestling the koi, he is given a healthy and ruddy complexion and bulging muscles. On Boys' Day in Japan, families with sons fly the koi **FLAGS** and renew wishes for their boys to be like Kintaro—strong, courageous, but perhaps most of all, persevering. Together, he and the koi are the ultimate symbol of ideal manliness.

KNIGHT

A title of honor that is still bestowed on a number of individuals for various reasons, the knight was originally a professional cavalry soldier in the European Middle Ages. Tattoos of knights range from the fantastic, where they might be mounted on **UNICORNS**, to those more firmly rooted in history such as **ST. GEORGE**. Over time, especially during the Crusades, knights came to symbolize chivalry, loyalty, courage, and a code of personal honor.

KNOTWORK

Knotwork is a constant motif in Celtic art, especially in Irish manuscript illumination, but also in tattoo. Symbolically, it is much the same as the **OUROBOROS**, the **SNAKE** that eats its own tail, usually shown as a complete circle. It is a symbol of constant motion—the developing, coiling, and intertwining of human and cosmos, in a never-ending cycle. Most Celtic tattoo artwork turns to knotwork not only for immediate identification with the Celtic region but also for the intricate and beautiful designs that can be created with that technique alone.

KOA'E KEA

From the 1899 account of Augustin Kramer, a German ethnographer and member of the German South Seas expedition that visited Hawaii, we know that one particular repeating motif represents the *koa'e kea*, a white-tailed tropical bird of the South Pacific often seen soaring in Kilauea Crater in Hawaii. Much of the meaning of Hawaiian tattoo has been lost over time due in large measure to the harsh repression practiced by early Christian missionaries. It is interesting to note that Kramer observed these tattoos on the chest of a man who also had the name of his recently deceased wife tattooed on his chest, in English lettering. Together the two designs formed a giant "V" on the man's chest, his wife's name descending from upper left to bottom center and the *koa'e kea* ascending from bottom center to upper right.

KOALA

This tree-dwelling marsupial, sometimes also called a koala BEAR, is a favorite in the stuffed animal toy market since the real creature is already rather toylike and cuddly in appearance. Feeding on eucalyptus leaves and carrying their young on their backs, koalas are slow-moving, even sleepy looking, with large black noses, white underbellies, gray-brown fur coats, and fairly large fluffy ears. They are native only to Australia and their image can be used to symbolize this nation, but they are more known internationally as a symbol for kindness, caring, and of endangered species worldwide.

KOI

Probably surprising to many Westerners is the large amount of myth surrounding this beautiful FISH. It is known outside Japan as the brightly colored white, golden, orange, and even calico fish that fascinates private collectors but that can also be found in public ponds. The Japanese carp or koi is one of the more popular and beautiful of Japanese tattoo symbols—a beauty that belies its symbolic meaning. Although Chinese in origin, the carp is celebrated for its manly qualities in Japan. It is said to

climb waterfalls bravely, and, if caught, it lies upon the cutting board awaiting the knife without a quiver, not unlike a **SAMURAI** facing a **SWORD**. This theme dates back to ancient China, where a legend tells of how any koi that succeeded in climbing the falls at a point called Dragon Gate (on the Yellow River) would be transformed into a dragon. Thus the fish became a symbol of worldly aspiration and advancement. Eventually, the stoic fish came to be associated with so many masculine and positive qualities that it was appropriated for the annual Boys' Day festival in Japan, when colorful, streaming koi **FLAGS** are traditionally displayed for each son in the family. In tattoo imagery, especially in combination with flowing **WATER**, it symbolizes much the same—courage, the ability to attain high goals, and overcoming life's difficulties.

KOKOPELLI

This popular symbol associated with the Southwest is actually taken from petroglyphs (rock art) of the Pueblo Indian regions of the southwestern United States. The hunchbacked flute player is typically shown in a dance pose, playing a flute, holding it with two bent stick-figure arms. He is known by different names among the different groups who have used his image in everything from rock art to ceremonial room walls, and even on pottery. His meaning and his character in the different groups, of course, varies. But, almost universally, he is considered in some way a symbol of fertility and a harbinger of good. As befits a symbol of fertility, he sometimes is shown with male genitalia of exaggerated size.

KORU

An incredible amount has been written regarding the Maori (New Zealand) tradition of tattooing—from historical observations by early Western observers right up to the current revival of the tradition as part of cultural pride and activism. While much of the specific symbolism is difficult to interpret, there are elements signaling familial descent as well as personal achievement that are woven together in the complex blackwork designs, most noteworthy in designs covering the entire face. One of the basic elements in these symmetric, balanced, and dense compositions is

the *koru*—the folded, coiled, and looped scroll most often thought of as an unfolding tree frond or a curling wave.

KRISHNA

Because Krishna is one of the most beloved and popular of the Hindu deities, it follows that he is a frequent subject of Hindu tattoo art. Often shown as a beautiful young man with flowing black hair and blue-black skin, playing a flute, he is an avatar or incarnation of the great protector god vishnu but is thought of as a god himself. There are numerous tales of his life and exploits from varied sources, but chief and perhaps most notable of his characteristics is his ability to reveal divine love in human love. In folklore, his earthly relationships with women are seen as the same type of loving relationship that exists between God and humans. His very person comes to embody the ideal relationship between the soul and God.

KRISHNA AND RADHA

In his youth, krishna was a *gopa* (cowherd), renowned as a lover and able to play his flute to attract nearby *gopis* (the wives and daughters of other cowherds) to him in the forest. Among them all, it was Radha who was his most beloved. Their relationship came to symbolize, as did Krishna himself, the perfect love between the divine and godly essence (Krishna) and the human soul (Radha). Typically, they are shown standing, facing forward, with arms around one another in embrace.

KU KLUX KLAN

While the number 311 (three elevens, since "k" is the eleventh letter of the alphabet) and the initials "KKK" are both used to refer to the Ku Klux Klan, the group's symbol is equally well known from the patches on their white robes, pins, and tattoos. Because the original Ku Klux Klan, which was formed by Confederate veterans after the Civil War, purportedly took its name from the Greek word *kyklos*, meaning circle, one of the main elements in its emblem is the red circular field. This field serves as a backdrop to a white cross of equal lengths (sometimes also made into a wheel cross) with a red drop of blood at the center of the cross, said to symbolize the blood shed by Christ for the white race only.

KYUMONRYU SHISHIN

The most popular hero of the illustrated Japanese novella **SUIKODEN**, of the early 1700s, was Kyumonryu Shishin, who had tattoos of nine dragons. Because the image of a dragon was thought to summon **WATER**, it became a popular tattoo among *Edo* (modern-day Tokyo) firemen of the period, a city prone to fire. Kuniyoshi's illustrations of the 108 Suikoden heroes had an enormous impact on tattoo designs, which continues to this day. It is not uncommon to see the tattoos worn by the fictional heroes (such as a **DRAGON**) as well as tattoos of the heroes themselves.

LABARUM

The labarum is also known as the chi rho since these are the Greek letters that make up the symbol. Used in the early Christian church, the labarum was actually one of two different symbols: the chi rho, standing for the first two letters of Christos, or the letters "i" and "x," the initials of *Iesous Christos* (**JESUS** Christ).

LABRYS

The double **AX**, simply as a **TOOL** form, has been known throughout the Anatolian and Aegean regions for thousands of years, but is especially famous for its presence in the late Bronze Age (ca. 1600–1450 B.C.E.) shaft graves of Mycenae. Loosely associated with both the legendary Greek **AMAZONS** and Indo-European goddess cults, the double ax or labrys has today become a symbol used by lesbians, adopted by the rights movement in the 1970s.

LADYBUG

The ladybug, also called the lady bird **BEETLE** and even the maiden's beetle, came to be associated with the **VIRGIN MARY** at some point in the Middle Ages because of its good works in ridding plants of pests—hence the use of the word "lady." It is more than likely that tattoos of ladybugs are not representative of religious belief, since there are numerous tattoo images that relate much more directly to Mary. Instead, the ladybug appears

sometimes as part of garden scenes or among other colorful and benign insects. It is not unusual to see a ladybug tattoo in isolation as well, likely due to its symmetric, brightly colored, and buttonlike body.

LADY LUCK

Perhaps most famous for her depiction in the nose art of World War II bombers—a risky profession where lady luck was no doubt courted—she has actually been a part of gambling enterprises and assumed the role of casting fortunes in life in general since the Greek and Roman eras. In tattoo images, as in bomber nose artwork, Lady Luck is usually scantily clad and accompanied by the tools of her trade, such as **DICE**, **CARDS**, or a **HORSESHOE**.

LAKSHMI

In the Hindu pantheon, Lakshmi (also Laksmi or Sri Laksmi) is the divine and compassionate mother, the wife of **VISHNU**, one of the primary gods and the protector of the world. The **LOTUS** is nearly always shown either as her seat, her pedestal, or in her hand, reminiscent of how she appeared when she was born from a milky **OCEAN**. She is invoked by those desiring physical well-being or harmony, partly symbolized by her right-hand gesture (mudra), which bestows blessing. The lotus, planted firmly in the mud beneath the **WATER** on which it floats, is symbolic of a transcendent and pure state. Lakshmi stands or sits on the lotus as a symbol of spiritual perfection and authority.

LAMB

In almost all areas of the globe where **SHEEP** were raised as livestock, the first lamb born in the new year's litter was a signal of spring. It was the fate of the most perfect of these first lambs to then be used as an offering to ensure continued life. While these customs have long ago fallen into disuse, the lamb remains a symbol of sacrifice, purity, meek gentleness, and innocence.

LAMBDA

Lambda, λ, is the eleventh letter of the Greek alphabet, which in lower-case form (the form most used for symbols) looks quite a bit like an upside-down "y." It is used in the sciences as a symbol for a multitude of concepts, from elementary particles to wavelength. In tattoo symbolism, though, the lambda is more apt to be a symbol of the gay and lesbian rights movement than of a mathematical concept. It was adopted by the Gay Activists Alliance in the early 1970s, which suggested that it was associated with energy. More than other gay or lesbian symbols, it carries a somewhat militant connotation.

LAST SUPPER

This Coptic tattoo design, part of the repertoire of pilgrimage tattoos done in Jerusalem in the early 1900s, is a schematic scene of what is known as either the Lord's Supper or the Last Supper. In it, JESUS meets with his twelve disciples for Passover, just prior to his execution. The symbolism in this image has many layers and reflects many of the basic tenets of Christianity but particularly expresses the institution of the sacrament. It is a ritual where believers consume the body and BLOOD of Jesus in the form of bread and wine, expressing their communion and unity with him.

LATIN CROSS

Of all the symbols in the Western world, the simple Latin cross is preeminent. Its use in history predates Christ, and its simple and fundamental crossing of lines of unequal length has been used for many purposes, with all manner of meanings attached, in many cultures. However, its use as a symbol for the CRUCIFIXION of Jesus Christ, and so for Christianity in general, is the meaning that it nearly always takes since Christians appropriated it in the early centuries of the last millennium. In that incarnation it has come to symbolize specific Christian tenets such as death, sin, and guilt, but also resurrection, salvation, and eternal life. Of all religious tat-

de, the cross is undoubtedly the most prevalent and well-recognized

LAVA LAMP

Wacky but groovy and now retro and cool, the lava lamp is an icon of the psychedelic 1960s, when it first became popular. It was actually called the Astro Lamp when it was invented by Edward Craven, an Englishman. These colorful and conical glass lamps have globular and flowing shapes that slowly rise and fall within the liquid of the lamp, lit from within. They were a decorating accessory that remained popular into the early 1970s, making a comeback in the late 1990s. Tattoos of the lava lamp are ideal for the ultra-color-saturated look of the new-school style of tattoo and are both a campy reminder of the era and reminiscent of the lamps' hypnotic effect.

LEAF

The simple leaf is many times part and parcel of floral tattoo designs, without its own specific meaning. But, when taken as a symbol itself, its meaning is generically that of growth and life. In the East, a bunch of leaves is seen as a single entity, with a common purpose, and a harbinger of good fortune and prosperity. The MAPLE LEAF, in Japanese tattoo, is part of an autumn motif that is frequently carried through an entire bodysuit. The red maple leaf is also known as a symbol of Canada.

LEO

Leo (July 23–August 22) is the fifth sign of the ZODIAC. Sometimes symbolized by an oval with a rising and downward-curving "tail" reminiscent of some sun symbols, the pictorial symbol for the astrological sign is typically a LION. Leo is associated with summer in the Northern hemisphere and with fire, heat, and light. People born during this astrological interval are, not surprisingly, thought to possess psychological traits associated with these images. Leos are seen as high powered and strong willed, with ambition and a flair for life, although in extreme cases, to the point of being aggressive, intolerant, and opinionated.

LEOPARD

Like the JAGUAR and COUGAR, the leopard is the animal companion of SHAMANS in both the Western and Eastern hemispheres, and like the CHEE- TAH, another spotted great CAT, the leopard was a symbol of aggressive war- rior and kingly castes. Although leopardskin was worn by the priests of ancient Egypt to ward off evil spirits, it is more often the simple wild ani- mal nature that permeates the images of this creature in tattoo. Some- times set in jungle scenes and in the company of other wild animals, tattoo art capitalizes on the colorful nature of these images.

LEOPARD SPOTS

Some of the most unusual tattoo artwork involves LEOPARD spots that do not appear on the form of that animal. In recent times, people have cov- ered a large portion of their body with leopard coloring and spots. Cer- tainly there is notoriety involved and perhaps a form of performance art when people attempt large or complete coverage with a single pattern. Why leopard spots are selected over the distinctive skin patterns and col- ors of other animals (such as reptiles, FISH, or BIRDS) is particular to the per- son, although the effect is visually striking.

LEPRECHAUN

The leprechaun is an impish little character of Irish origin. Although his occupation is shoemaker, he is most known for having a hidden pot of gold. If he can be located by the sound of his ham- mering and captured, he may reveal the location of his hoard. But he is usually tricky and feisty enough to elude his captor, who has only to look away for an instant. A tattoo of the leprechaun, with his red hair, green coat, cocked hat, and possibly a pipe, is a symbol for people of Irish descent, particu- larly the more plucky of these. It is also not unusual to see him paired with other Irish symbols such as the SHAMROCK. This famous example, the logo of the University of Notre Dame, was created by Ted Drake in 1964 and adopted by the home of the "Fighting Irish" in 1965.

LESBIAN LOVE

The modern ideogram for love between women, or lesbian love, is simply the interlocked combination of two FEMALE SYMBOLS, where the CIRCLE of each sign overlaps the other.

LIBRA

Libra (September 23–October 23) is the seventh sign of the ZODIAC, beginning at the midpoint of the astronomical year as the SUN passes from the Northern to the Southern hemisphere. Symbolically it is shown as two horizontal lines with the top line arching into a curve in the middle before returning to a straight line. Pictorially, the SCALES are used to represent this sign. For those born under the influence of the align-

ment of STARS and planets during this period, positive traits that are assigned include fairness and diplomacy, while the negative include being indecisive and changeable.

LIGHTBULB

The lightbulb, like older symbols involving light, is also a symbol of enlightenment, although not particularly in a spiritual sense. Instead, the lightbulb has come to represent a "bright" idea, in a sort of literal reading of the image. In a more generic sense, it can also be mental energy or the process of thinking.

LIGHTHOUSE

Although the lighthouse is a maritime safeguard and undoubtedly a welcome sight for SAILORS, it has come to mean more than just a beacon for warning ships of shoreline hazards and pointing the way toward shore. Light, in any context, is heavily imbued with symbolism and suggestive of higher concepts, such as the SKY, the SUN, and the heavens. It is illumination not only of an outward nature, but also an inward one. The lighthouse captures that light in a tower, focusing it and projecting it outward, providing direction and guidance.

LIGHTNING

Whether a quick flash in a dark and cloudy sky or a bolt from the hand of Zeus, lightning has long been viewed as a combination of the force of life along with its destroyer. From ancient Babylon to ancient Peru, cultures have viewed lightning in close conjunction with rain, which sometimes produces it, and also with the sun, which is sometimes confused with it. It was thus a potent symbol for the generation of life and fertility. At the same time, lightning's destructive and dangerous capacity was known and its control was almost always in the hands of sky gods. In tattoo art, both the stylized bolt as well as more realistic portrayals with inclement weather can be found. While the bolt might also be representative of electricity, both electricity and lightning are in turn representative of energy and power.

LILITH

Lilith is the counterpart of eve, derived from Hebrew folklore and likely descended from earlier Mesopotamian or Assyrian demons. She is even sometimes referred to as the first wife of Adam. Rather than being the nurturing mother of humanity, Lilith is a destructive demon, a vampirelike creature who attacks men and children at night. She is a symbol of sensual lust and also the negative aspect of the mother symbol, who withholds normal caring and love.

LILY

A favorite motif in the decorative images of the ancient Egyptians and the Greeks of Mycenae, Minos, and Crete, the lily entered into Christian imagery with the Sermon on the Mount, where lilies were extolled for their faith and the fact that they "do not toil." Perhaps among the oldest cultivated plants, they have long been symbols of chastity, owing to the large white petals that form an almost trumpet-shaped flower. In time, the lily also came to symbolize, among other things, a pure life, pallid death, Christ himself, and the promise of the resurrection and immortality.

LINCOLN, ABRAHAM

Portrait tattoos make up a surprisingly significant part of the tattoo repertoire and the people portrayed can come from all walks of life—some pub-

lic, some private. In American history, few images evoke as many emotional connotations as that of President Abraham Lincoln (1809–1865). Seemingly etched into the deep lines of his face, we read his struggle to unite a divided country, his decision to abolish slavery, and his early death at the hands of an assassin. In more modern times he has become associated with slain civil rights leaders and the fight for freedom in general.

LION

The lion is frequently referred to as the "King of Beasts" and the title is an apt one for its role in symbolism as well. The lion design projects many of the same symbolic qualities as the animal does in nature—power, vitality, energy, and courage. A favorite symbol of sovereigns and also of gods, the lion has been used as a metaphor for nearly every type of ruler, including **JESUS, BUDDHA**, and **KRISHNA**. In tattoo art, the lion is very often depicted quite naturally, sometimes portrayed simply with its distinctive head and mane or shown in its African savanna environment.

LION (CHINESE)

See **FOO DOG**.

LION RAMPANT

The lion rampant was used in European heraldry as early as the 1100s. The **LION** has an ancient association with rulers and kings and has been used in many forms in the heraldry of monarchs and their vassals worldwide. The lion rampant, though, frequently done in red, came to be associated particularly with the Christian **KNIGHTS** of France, most notably the count of Flanders, Philip of Alsace, who went to Crusade in 1177. The lion rampant tattoo might thus be a form of either heraldy, a portion of a family **COAT OF ARMS**, or a symbol of the Christian soldier.

LION WITH SWORD

The **LION** with **SWORD** combines two symbols that have long histories in the Persian empire and in Islam, both symbols of power and royalty (along with the **SUN**, with which they are often

paired). Interestingly, it was the son-in-law of the prophet Mohammed, whose name was Ali, who was known as the Lion of Allah. In Persian tattoo flash (posters of tattoo image samples for prospective customers), the lion with sword is a common motif.

LIPS

Red lipstick–colored lips imprinted on a page have long been used to symbolize a kiss, usually given in absentia on a letter or note. The same is true in tattoo as well, in an almost direct translation. As is often the case with tattoo, though, placement on the body can greatly influence the meaning attached to the kiss. In some cases, tattoos of lips are done like real lips instead of a lipstick stamp, to appear as a kind of second mouth. In other instances, a placement of lips on the buttocks is a visual way of saying "kiss my ass."

LIZARD

Although known worldwide in mythology, the lizard appears most frequently in Polynesian culture, from Hawaii to New Zealand, sometimes as a creator of the human race and other times as a powerful ancestor. The lizard in tattoo art seems to draw from all types of artistic motifs, from that of the Pueblo Southwest (like that of the popular GECKO) to decorative images from Africa. The lizard is sometimes seen symbolically as akin to the SNAKE and there are certainly similarities, such as the shedding of skin, underground dwelling, and hibernation—all symbolic of renewed life.

LOBSTER

Generally, when lobsters are used for tattoo imagery, they are part of the wider symbolism of OCEAN life and sea creatures. Occasionally, though, they appear to be on the attack, with the large front pincers open. Because they do scavenge dead carcasses for food, they have been used to represent the forces of regeneration, as in TAROT symbolism. In Chinese art, they are sometimes used as the feet of Kuan-Yin (Japanese KANNON) to symbolize wealth and marital harmony. Most tattoo art shows the lobster as red—a color that does not occur for the lobster naturally. When alive,

lobsters are essentially blue-green in color. The shell only turns a bright red when it is cooked.

LOTUS

Like the **ROSE** in the West, the lotus of the East is probably the most important of the **FLOWER** symbols and laden with meaning. It springs forth from the muddy and murky **WATERS**, floating on top, opening in the morning and closing in the evening. For the Egyptians, it was the first flower and from it sprang the first gods. Many of the pillars of the monumental architecture there are actually designed as bunches of lotus. In Hinduism, the lotus blossom is the most important symbol for both spirituality and art. Brahma, the creator of the world, was born from a lotus blossom that grew from the navel of **VISHNU**, who was sleeping on the water. It is equally important from the Buddhist point of view, symbolizing the **BUDDHA**'s nature, pure and ascendant, and part of the most famous of Buddhist mantras—"**OM MANE PADME HUM**"—"Hail to the Jewel in the Lotus." In tattoo art, the lotus is frequently paired with the symbol for **OM** (as in this case), or with an image of Buddha, or even a jewel. Its colors, as in nature, vary from white to pink as well as blue.

LOVE AND HATE

The love/hate tattoo is simply composed of the letters that spell out the two words. In one technique, each letter is placed on a finger such that when the fingers are held together or in a **FIST**, they spell out the two words. In the West, the right side or right hand is considered the good or just side and in many examples of the tattoo, the word "love" is on the right hand. Although not symbolic in a pictorial sense, these two words are often found together (much like "good and evil"). This type of pairing of opposites has been interpreted as representing totality, not unlike the **YIN-YANG**.

LUCKENBOOTH

The Scottish luckenbooth brooch is not unlike the Irish **CLADDAGH** ring. Its name is taken from the "locked booths" of jewelers along the Royal

Mile near St. Giles Cathedral in Edinburgh, where they were sold in the sixteenth and seventeenth centuries. There are many variations of the design, but often two hearts are intertwined and topped with a single CROWN. In some examples the HEARTS are formed from a stylized letter "m" (from the royal monogram of Mary, Queen of Scots). A luckenbooth brooch is used as a love token and it was also pinned to a baby's blanket to protect it from evil spirits.

LUTHERAN CROSS

The Lutheran cross is related to the Lutheran church, named after the reformer Martin Luther. It is essentially a plain or LATIN CROSS on a small pedestal but with the three ends of the cross (top, left, and right) ending in TREFOILS, to further emphasize the Trinity, or three-personed god.

M

MACK TRUCK

Unlike the **HARLEY-DAVIDSON** logo for bikers, truckers don't generally sport just a logo in their tattoos. Instead, the actual truck itself is the main element of the design. It might be interpreted as a work-related tattoo but the dramatic scenes and settings for these truck images and the detail given to their individual characteristics likely imply something more. Big and powerful, polished to the brightness of the **SUN** itself, these trucks and their tattoo images seem more an extension of the self than simply a picture of a work vehicle.

MADONNA

Madonna ("my lady") is a name given to the **VIRGIN MARY** when she is portrayed in a devotional and portraitlike way, as opposed to illustrations of her at historical points in her life (the annunciation, the birth of Christ, etc.). Although there are many types of Madonna images, especially the **MADONNA AND CHILD** and the **PIETÀ**, many Madonnas in tattoo art depict her standing alone, in long flowing robes, with her gaze cast downward and arms spread open in protection and blessing. Surrounded by a **HALO** and rays of light, she is beautiful yet regal, perhaps sad herself but still comforting and always serene.

MADONNA AND CHILD

In Coptic Christian tattoo art, the **MADONNA** and Child is a very popular image, as it is in most Christian

art. In her long flowing robes, she carries the infant JESUS in the crook of her arm and they both wear crowns. This type of image became more popular after her title "Mother of God" became prevalent in the early centuries of Christianity.

MAKAH SEA WOLF

The Makah are a Native American group who live on the northwestern tip of the Olympic Peninsula in Washington state. According to the mythology of these ocean-faring people, KILLER WHALES are actually WOLVES that have gone into the sea, hunting gray whales in packs, as wolves would. The image was one that resonated with the Makah, skillful whale hunters themselves, and it was given representation in various different art forms, including tattoos.

MALA

The Buddhist *mala* (Sanskrit for "rose" or "garland"), like the Catholic ROSARY, is a string of beads used to count recitations. And, like the rosary, it is sometimes seen as a tattoo, worn about the neck. The purpose of the mala is for the counting of mantra or prayer repetitions. The long mala worn about the neck or wrapped around the wrist many times is 108 beads long, related astrologically to the twelve houses, multiplied by the nine planets of the solar system. Sometimes a slightly larger 109th bead, called a guru bead, is added to terminate the count, accompanied by a tassel.

MALE SYMBOL

The symbol for the male sex is taken from the astrological symbol for the planet Mars, which is in turn associated with the Roman god of the same name, whom the Greeks knew as Ares. Mars was second in importance only to Jupiter himself, the chief of all Roman gods, and he represented the spirit of battle and was essentially the god of war.

MALTESE CROSS

The Maltese cross, also known as the "cross of promise," takes its name from the Malta Supreme Military Hospital Order, an organization akin to

the Red Cross. The eight points are said to symbolize the eight qualities of a **KNIGHT**: loyalty, piety, generosity, courage, honor and glory, contempt for death, helpfulness, and reverence for the church. This cross is also used by the Order of Knight Templars (founded by eight knights in C.E. 1118) and used for some of the highest medals given in some countries (such as the German Iron Cross).

MANDALA

Mandala is the Sanskrit word for **"CIRCLE,"** which is generally the shape that these symbols take. Used in both Hinduism and Buddhism, they are

complex representations, varying combinations of brightly colored circles, rectangles, or seemingly mazelike paths that depict the world-order (physical, mental, and spiritual) and frequently serve as a meditative focus. Tattoo mandalas, although small, are very detailed and reflect the same myriad choices in terms of color and internal structure that their larger counterparts do.

MANDELBROT

Benoit Mandelbrot is a Polish-born mathematician who has lent his name to an interesting group of geometric shapes that have been used in all manner of decoration, including tattoo. Mandelbrots are also known as fractals, complex shapes that are irregular and yet repetitive and that, when generated by computers, seem to grow like ice crystals, forming patterns of great beauty that can curve and spiral seemingly infinitely.

MANDORLA

Italian for "almond," the *mandorla* is the almond-shaped **HALO** of light that surrounds the whole body of sacred figures. Like a halo, it represents power and spirituality and is found in the artwork of various religions. Perhaps one of its most famous uses in tattoo is with the **VIRGIN OF GUADALUPE** design.

MANEKI NEKO

There are many stories that tell of the origin of the lucky beckoning **CAT** of Japan. Its tricolored fur alone makes it rare and hence a lucky occurrence if one of these types of kittens is present in the litter. There is also the story of a feudal lord who saw a cat beckon to him from the doorway of a temple as he passed by. He followed it into the temple and a lightning bolt instantly struck the place where he had been standing. Today, the *maneki neko* not only is thought to bring luck but many times also holds a coin and beckons customers to patronize a business. A *maneki neko* tattoo is sometimes a combination cute kitty and good luck symbol.

MAN'S RUIN

Man's ruin is a classic and very popular tattoo design with a great deal of tradition behind it. It typically includes four main elements: a scantily clad or nude woman who is reclining in a stemmed glass (champagne in some cases, martini in others), some type of alcohol nearby, and some symbol related to gambling (**DICE**, **CARDS**, money, or all three). These, then, are the paths that can, individually and together, lead to a man's ruin.

MANTUAN CROSS

The Mantuan cross is similar to the **MALTESE CROSS** but with ends that are flat, though flared. Like the Maltese Cross, the Mantuan design was also used for the German iron cross (of which there were several forms). But the Mantuan cross was also used during the First World War on German planes and tanks. It was later adopted as a fascist symbol in France and Portugal.

MAPLE LEAF

The coming of winter and the end of summer are a natural part of the symbolism of this floral design in the West. Done in typical fall colors like those of the Japanese maple **LEAF**, and sometimes shown carried on the wind, the

tattoos that use these leaves are also conveying a sense of time passing, the approach of winter, and the temporary death of green plants. When done strictly in red, the maple leaf is also a symbol for Canada.

The Japanese maple leaf, along with the **CHERRY BLOSSOM**, is one of the most popular of the Japanese floral tattoo motifs. Long prized in Japan for their magnificent colors of red and greenish-yellow, maple trees have been cultivated there for over three hundred years. In tattoo art there, they are likewise evocative of the autumn and the change of the seasons and correspond to a symbolism that is linked with the passage of time and aging.

MARIJUANA

A tattoo of the marijuana plant means precisely what one might expect— it identifies the wearer as a user or dealer of *Cannabis sativa,* or the Indian hemp plant. Usually dried, crushed, and put into pipes or formed into **CIGARETTES**, the leaves can also be added to foods and beverages. The intoxicating and medicinal uses of this drug have been known for thousands of years, inducing states that range from mild euphoria all the way to paranoia and psychosis in extreme cases. In prison tattoo art, the number 13, which stands for the thirteenth letter of the alphabet (m), is sometimes used instead of the jagged-edged palmate leaves.

MARITIME DRAGON

According to maritime tattoo tradition, a dragon tattoo (generally of the Oriental style) showed that a **SAILOR** had served on a Chinese station. A golden dragon showed that he had crossed the international date line. The association of a dragon with China is not unexpected, where the symbol is prevalent and positive. The reason for the association with the international date line is lost to time. It is interesting to speculate, however, about the connection between distant **OCEAN** places and the edge of the known world, and fantastic beasts such as dragons. On the Lenox Globe (manufactured around C.E. 1500) the words *"hic sunt dracones"* or "here are dragons" appear on the eastern coast of Asia.

MARITIME PIG

According to maritime lore, a **PIG** tattooed on the left foot and/or a **ROOSTER** on the right would keep a sailor from drowning. Since neither of these animals can swim, they would have a vested interest in getting the seaman back to shore quickly.

MARITIME ROPE

A tattoo that is rarely seen today, early seamen who were dockhands had a rope tattooed around the wrist to show their profession.

MATHEMATICAL EQUATION

A combination of individual symbols that each have their own meaning, the equation is a formula whose main ingredient is typically an equal sign. The symbols on either side of the equal sign are thus equivalent to each other and one can be substituted for the other. The mathematical equation is thus a type of shorthand that expresses a relationship between various quantities that are represented by the individual symbols (**PI**, a plus sign, the Greek letter sigma standing for summation, etc.). In the well-known equation derived by Einstein, $e = mc^2$, energy (e) is equal to mass (m) times the speed of light (c), squared (to the power of 2). As with tattoos of **MUSICAL NOTATIONS**, these specialized symbols will appeal most to people who understand them. Indeed, some equations or mathematical expressions are commonly referred to as elegant or symmetric. Whether they embody fundamental physical concepts or numerical truisms, the math symbols themselves often have a stylized representation that is attractive in itself.

MAYAN VISION SERPENT

The Mayan vision serpent is the symbol of the path of communication between the sacred world and the human world, between the world of the gods and ancestors and our own. For the Maya, it was also a profound symbol of kingship. The vision serpent rears up from the coiling smoke of burned paper offerings that are spotted with **BLOOD**, located in a bowl at the bot-

tom of the image. Typically called forth by a descendent, an important ancestor (such as the founder of the lineage) is shown emerging from the gaping and very stylized mouth of the serpent. The appearance of the ancestor, presiding over whatever occasion has made his or her presence necessary, confers a sense of auspicious importance and even approval and power to the invoker. More than likely, the person who actually induced this hallucinatory vision has also performed the bloodletting that produced the burning offerings.

MAZE

The maze, in both physical and symbolic form, has been present in many cultures, stretching back into prehistory, perhaps the most famous being that of the **MINOTAUR** of Crete. Essentially, a maze is a complex and intentionally confusing group of paths, some of which dead-end. It has been used as a type of military defense and also to depict religious pilgrimage on cathedral floors. To successfully travel the maze in any of these instances is to attain something of worth, something hidden, and also secret. In the end, the navigation of the maze is representative of transformation and emblematic of overcoming difficulty.

MEASURE OF MAN

Leonardo da Vinci's sketch *The Measure of Man* (originally called the *The Vitruvian Man*) is an example of a famous piece of art that has become ubiquitous in modern culture and thus a type of symbol—and one that is used in tattoo art, despite its complexity. In a large **CIRCLE**, combined with a large rectangle, a nude man stands with arms and legs symmetrically spread out. However, he is shown in two positions by using two sets of arms and legs, both of which touch either the circle or the rectangle. More than a convenient unit of measure, it suggested to the people of the Renaissance that geometry and beauty were linked and, furthermore, that the human mind had discovered this relationship. The sketch not only established man as the measure of all things, centrally located, but also the

purpose of the inquisitive mind in determining the answers to many other questions of the physical world.

MEDICINE SHIELD

The Native Americans of the Plains region carried **SHIELDS** into battle that were dual in purpose. Less used for their practical and protective function, they were believed to be imbued with magic or medicinal power. Each shield, frequently circular in form and made of leather, was decorated with designs and attachments specific to the particular religious experience of its owner. Shields could be used to manipulate the weather for battle advantage and even vanquish an enemy if the opposing warriors but saw it. Frequently the design of these shields was taken from vision quests that were undertaken as a passage into adulthood. Attachments such as bird feathers might be linked to animal dream helpers in these quests but may also have been protective talismans or symbols in and of themselves. Today, tattoos of medicine shields express the same individuality, with tokens of protection and power that only their wearers can interpret for us.

MEDUSA

Medusa, one of the three Gorgons (literally "the terrible ones"), had snakes for hair and a gaze that could turn whoever looked at her into stone. Symbolically, she has been seen as a threat and a hideous monstrosity to be feared, though she was eventually beheaded by Perseus, who used his shield as a mirror, forcing her to see her own reflection. In tattoo art, she is particularly colorful (due to her hair) and generally looking directly back at the viewer as if to frighten him or her.

MENORAH

The menorah is a candelabra with seven or nine branches that is associated with the Jewish faith, and thus it symbolizes Judaism. It is most

closely associated with the Festival of Lights, also known as Chanukah, celebrating the dedication of the new altar in the Temple at Jerusalem in 165 B.C.E. According to tradition, the festival occurs near the time of the winter solstice, as does Christmas, and lasts for eight days. On each day an additional **CANDLE** is lit—one on the first evening, two on the second, and so on.

MERMAID

The mermaid represents an ages-old story of feminine power, emerging from the water sometimes to lure men to their deaths and other times to act as their rescuers. Half-woman, half-**FISH**, these popular images have been used by mariners as symbols of temptation while others are variations of the pinup girl tattoo, and still others represent the call of the sea.

MERMAN

The merman is, of course, the masculine form of the **MERMAID**, and just as ancient a mythological creature. Not often seen in tattoo, but appearing occasionally, the merman is a tempter and a seducer who could also be a danger, luring **SAILORS** to drown. To see one on a voyage was sometimes an omen of an impending shipwreck.

MESSAGE IN A BOTTLE

Although not a traditional maritime tattoo like **HOMEWARD BOUND, SAILOR'S GRAVE**, or **ROCK OF AGES**, the message in a bottle has a decidedly maritime theme and is effectively rendered in the style typical of the early **SAILOR** tattoos, bold with heavy outlines. A note of parchment, rolled and tucked into the top of the bobbing bottle, is a last ditch call for help by someone stranded on an island. Tossed into the surf, the hope is that the current will carry it to someone who can provide rescue. Depending on the context, this type of tattoo can be a memorial to someone lost at sea, a reminder of the perils that await all sailors, or even a cry for help.

MICKEY MOUSE

Few cartoon characters have transcended animated entertainment in the way that this plucky little **MOUSE** created by Walt Disney has. Probably no other cartoon character has remained as popular and well-known as Mickey Mouse. He has become a symbol of the "happiest place on earth," of a hearkening back to childhood, and simply of the naive joy and optimism that define his character.

MINOTAUR

The minotaur is the Greek monster with a man's body and a **BULL**'s head that King Minos imprisoned in the labyrinth, an impenetrable maze from which no one could escape once they entered. Athenian youths were sacrificed to the minotaur by the Cretan king until the Athenian hero Theseus killed the monster, with the help of the daughter of the king. However, the minotaur is more than just a monster and devourer of sacrificed humans—he is actually the son of the wife of the king. She was made to fall in love with a bull when the king would not sacrifice it. Thus the minotaur becomes a symbol for the wrong that can be produced when responsibility is shirked, or a perversion of humanity. He has also come to be associated with the dark labyrinth and with what lurks in our subconscious.

MOAI

On Easter Island (Rapa Nui), in the eastern Pacific Ocean far west of Chile, tattooing was performed in historic times. Along with the abstract forms that characterize much of tattoo in the Pacific islands, there are also many realistic renderings on Easter Island. Not surprisingly, one of these is the famous *moai*, the remarkable and mysterious stone statue that is frequently found there in the form of giant heads.

MÖBIUS STRIP

Although the möbius strip may resemble the symbol for **INFINITY**, or a simple optical illusion, it is more than that. An actual physical strip can be

constructed of a rectangular piece of paper that is given a half-twist with the ends joined together. Discovered in part by the German mathematician who lent his name to the shape, it has only one side. In order to know whether you're looking at a tat-

too of a three-dimensional infinity sign or a möbius strip, imagine tracing a line down the middle of the strip. Without lifting your imaginary pencil, you'll be able to draw on "both sides" of the möbius strip.

MOCK WOUND

The tattoo of a mock wound or injury is an ironic bit of artwork. The act of inserting ink into the skin with a needle is itself damaging to the skin, which of course heals leaving only the ink visible. The artwork of a wound, though, shows a permanent image that never heals. Undoubtedly this type of tattoo plays on this irony and also appeals somewhat to the shock value of a wound, something that few people would really enjoy seeing. The symbolism behind these types of tattoos, some more elaborate than others, is so individualistic as to defy definition, but they often refer to wounds of emotion or spirit.

MOLECULAR STRUCTURE

The molecular structure of many elements and substances is diagrammed by chemists and biologists the world over in a type of universal symbolic language. Displaying the bonds between molecules as lines and the presence of individual molecules as letters that stand for the element ("H" for hydrogen and "O" for oxygen, for example), these structures have occasionally found their way into tattoo art and can be used to represent nearly any substance.

MONA LISA

The portrait of Mona Lisa by Leonardo da Vinci is one of the most recognizable paintings in the world and it has found its way into many facets of art, including tattoo. With her quiet gaze and the most subtle of SMILES, she symbolized feminine beauty for the Renaissance man. For today's tattoo enthusiast, the portrait has come to symbolize fine art itself. As with

other uses of famous persons in tattoo portrait art, we can only guess at the motivations behind the use of this image for a tattoo—fans of Leonardo, fans of the *Mona Lisa*, fine art aficionados—an ambitious undertaking for any tattoo artist.

MONDRIAN

Purely abstract art designs are both truly interest- ing and also inscrutable, especially in terms of sym- bolism in tattoo. Mondrian designs are named after the Dutch painter Piet Mondrian (1872–1944) who developed a style of simple lines and rectangles, mostly white, with the occasional small rectangle of black or a primary color. While many forms of tat- too fall into the category of art for art's sake, ab- stract art tattoos are some of the best examples.

MONKEY

Its agility and capacity for imitation have made the monkey a favorite in cultures that overlap with its habitat. From the baboon-headed depiction of THOTH in Egypt, to the three "hear no evil, see no evil, speak no evil" monkeys of the temple of Nikko in Japan, to the Mayan association with the SUN, monkeys have come to be known for humanlike intelligence under the mask of playfulness. In the CHINESE ZODIAC, people born in the Year of the Monkey are considered very clever and successful but impa- tient. In more recent times, monkeys have also come to symbolize some- thing primeval, cousins in the family tree of human evolution. Tattoos of monkeys frequently show them in some active pose since agility is part of their character, and their appearance is generally a happy and active one, easily recognizable even in silhouette.

MONKEY KING

Like the SUIKODEN HEROES of *The Water Margin*, the Monkey King from the Chinese novel *Journey to the West* has become a favorite character in Japanese fiction and an often-used image in tattoo. Written sometime in the 1500s, the story is loosely based on an actual journey undertaken by a monk named Xuanzang in the seventh century. Traveling west from

China to the home of Buddhism in India, he crossed the deserts and mountains of Central Asia to India in order to retrieve sacred Buddhist texts for translation into Chinese. While it would seem that Xuanzang might be the hero of the story, it is actually his companion, the irrepressible and exuberant Monkey King, with his supernatural Taoist abilities, who has captivated readers. Having been incarcerated by the gods for wreaking havoc in the celestial realms and eating the peaches of immortality, he is released to help the monk on his quest. Together they overcome all manner of natural and supernatural obstacles to finally achieve their goal. Tattoo images of the Monkey King capitalize on his dynamism, often showing him wielding a magic staff that could expand and contract to any size.

MO'O

The *mo'o* is a Polynesian **LIZARD** motif, first reported by Captain Cook on one of his South Pacific voyages. While many of the tattoos observed by these early Western travelers consisted of geometric designs, the lizard stands out as an exception. It was generally held in high regard and was even feared. In Hawaii, the giant lizard design was also known as an *'aumakua,* or personal god, and examples of tattoos of *'aumakua* are mentioned in historic references.

MOON

The moon is universally a symbol of change and growth, as well as of night and the passing of time, and it is a popular image in tattoo. Because of its cycle of renewal and regular phases, it is also linked with feminine aspects such as receptivity, nurturing, and life rhythms. In tattoo artwork it is sometimes shown realistically, in, for instance, a **CRESCENT** form, while other times it has a face and a night cap. Sometimes it is the color of cheese and other times a combination of deep, cold blues. People can be born under the influence of the moon while others are said to be driven to madness by it.

MOON AND SUN

The **MOON** and **SUN** image combines two symbols that each are rich in lore. The two together are completeness and the union of opposites. As heavenly bodies, both measure the passing of time, each in its own way, with the moon capable of giving off only the light it reflects from the sun. The moon as **YIN** is passive and receptive, compared to the sun's energy and **YANG**. The moon is **WATER** while the sun is fire, cold compared to heat, north and winter as opposed to south and summer. In tattoo artwork they are sometimes also depicted as male and female, with a bearded "man in the moon" and a feminine sun.

MOOSE

Although the moose is the largest member of the **DEER** family, it doesn't share much of that animal's symbolic history. It inhabits the forests of North America, where it is protected in national parks and reserves. Tattoo artwork that incorporates these giant animals plays upon their size and their association with nature and the wild. The male moose, a strong swimmer, is easily identified by its broad, extremely flattened **ANTLERS**, with a spread of up to six feet.

MORNING STAR

The morning star is a name that is given to Satan, whom the inverted **PENTAGRAM** within a **CIRCLE** symbolizes. It also draws its symbolism from the right-side-up pentagram, inverting its meaning of protection from evil. It is used to conjure or invoke evil forces and spirits in ceremonies and rituals of the occult.

MORRIGAN

Three **RAVENS** in a circular **KNOTWORK** pattern are the symbol of Morrigan, the Celtic goddess of battle, strife, and fertility. She could change from human to animal shape and if she appeared as a

raven, death was nearby. She was also a goddess of sexuality and tried to seduce the hero Cuchulainn, who refused her and was punished for it.

MOSQUITO

Where else would you expect to see a mosquito except on the skin? Like a **MOCK WOUND**, there is something ironic and comical about a tattoo of something one might expect to see on the skin in the first place. In the insect world, the mosquito, a parasite that spreads disease as it sucks the **BLOOD** of its victim, is also considered aggressive and relentless.

MOTH

The moth, sometimes called the night butterfly, can actually display some of the more brilliant and colorful patterns found among butterflies, but the most common are the small gray and brown variety. The moth carries with it a thread of symbolism derived from its most famous of behaviors. Because it is attracted to the light of **CANDLES** (or modern bulbs), it will injure and even kill itself as it strives to get closer. In this vein, it has come to be associated with self-destructive behavior, especially an unhealthy love, but it is also seen as demonstrating a willingness to die in pursuit of light.

MOTORCYCLE

The world of biker tattoos is a growing one that is losing its stereotypical image as the legion of bikers grows. But one motif in the biker tattoo repertoire that will likely never fade is the image of the motorcycle. The meaning of the motorcycle tattoo to a biker is not possible to succinctly summarize, encompassing, as these machines do, so much of the energy, resources, and time of these riding enthusiasts. Bike tattoos have been taken as representative of masculine ego and even male sexuality and these surely do play some part, though probably not completely (especially in light of the growing number of women bikers). In tattoo artwork, all manner of motorcycles are used, sometimes shown on the road, sometimes with a scantily clad woman, sometimes simply by themselves, and even occasionally with a **HALO**.

MOTORCYCLE ENGINE

Rivaling the motorcycle tattoo is the tattoo of just the engine. It is, after all, the power plant of the vehicle, the heart of the machine, so to speak.

Typically depicted in quite a bit of detail, the engine can be shown by itself but it is just as frequently part of a larger image that might include anything from FLAMES and a motorcycle company logo to goddesses and DEVILS. This tattoo is pretty much the domain of the motorcycle enthusiast, those who might spend their work and hobby time tinkering with the engine, fixing, tuning, and perhaps enjoying the Zen of it.

MOUSE

Although tattoos of a little mouse are many times of the more famous cartoon variety (such as MICKEY or Mighty Mouse), the generic mouse creeps into tattoo imagery as well. Their history includes the legend that they could scare ELEPHANTS and also that they originated from the mud of the Nile. Although mice have been associated with having ravenous appetites, they also came to symbolize the underdog, smaller and weaker but quicker and smarter. Tattoos of mice tend to capitalize on their diminutive size and often they are portrayed sweetly, as cute and furry little creatures.

MUSHROOM

Despite the fact that some mushrooms are poisonous, they symbolize good luck and even longevity in many cultures. Their medicinal and hallucinogenic properties are fairly well known as well. In tattoo artwork, mushrooms are sometimes simply part of the scenery and the foliage. In other images, they are central, even given personalities and faces, and are associated with their pharmaceutical qualities. Some tattoos even associate the mushroom with a vision quest (for which they were traditionally used in some cultures) or with death.

MUSICAL NOTES

Music notation drawn on a stave of horizontal lines likely began in C.E. 1025 in order to record chants. The shapes and parts of a note have evolved over time, but their purpose in recording the tones and their durations remain the same. The note head with stem pointed up or down, with or without a flag, is a tattoo symbol that generically represents music, and certain arrangements of notes in a tattoo may form a melody.

NATIVITY SCENE

In all Christian religious art, including Coptic tattoos, the Nativity has been a favorite theme. Since the fourth century, artists have been depicting the birth of Christ in a manger, with Mary and Joseph standing or kneeling nearby. Coptic tattoo artwork, favored by pilgrims to the city of Jerusalem for centuries, uses more schematic depictions of the three central figures, where faces are sometimes nothing more than an oval, with **DOTS** and lines to suggest features. Others are more ambitious, even showing some of the manger animals. Variations in design, even on a single theme such as the Nativity, were available to tattoo patrons of that era, not unlike the flash of today's tattoo parlors.

NAUTICAL STAR

The history of the nautical **STAR** is somewhat unclear but it likely derives from the significance of Polaris, the North Star. Because Polaris seems to be stationary in the night **SKY**, with the other stars moving around its central north pole location, it is a key reference point for navigation. In nautical charts of today, the position of north (or zero degrees) on a **COMPASS** is marked with a five-pointed star. While

other maritime tattoo symbols deal with different destinations, or the voyage and its perils, the nautical star is likely a symbol of the return home and the luck that is sometimes needed to reach it.

NAZI PARTY

Symbols of the Nazi party were typically well designed and capitalized on many ancient cultural symbols already in existence, such as the **EAGLE** and **SWASTIKA**. Today, the political movement that became popular in Germany in the 1920s, known as national socialism, is also widely associated with dictator Adolf Hitler, its most famous proponent. Because of his program of world domination, symbols of the Nazi party have also come to be associated with the many atrocities of World War II that were perpetrated by the Nazis. Today, Nazi symbols in tattoo are typically used by neo-Nazi and other white supremacist or hate groups. They are an attempt to connect with a group notorious for its brutality and they are evidence that well-designed symbolic imagery can be a lasting force.

NEFERTARI

The image of Nefertari is a famous one in Egyptology because her tomb contains some of the finest artwork known in all of Egypt, still in an excellent state of preservation. She was the first and favorite wife of the famous pharaoh Ramses II, under whose sixty-seven years of reign Egypt achieved unprecedented splendor and wealth. Her full name was Nefertari Meryt-n-Mut (Beloved of Mut, the great mother-sky goddess). In her tomb, she is shown in her fine gown, almost gossamer in appearance, and wearing a prominent headdress featuring the **VULTURE** that identifies her as a royal wife. Used in tattoo, she may symbolize nothing more than a particular connection with ancient Egypt or, alternatively, her pose with hands upraised may signal her supplications to the gods.

NEFERTITI

Probably one of the most famous of Egyptian faces is that from the bust of Nefertiti. With her high cheekbones, delicate features, long neck, and

seemingly cosmopolitan headdress, she is the epitome of Egyptian royalty. Unlike other Egyptian images used in tattoo artwork, she was a real person, the fourteenth century B.C.E. wife of the heretic pharaoh Akhenaton. Not only is her bust an exquisite and rare artifact that is symbolic of ancient Egypt, but her image has come to be used also as a symbol of timeless elegance and beauty.

NEW MOON

The new MOON or dark moon, which lasts for three days, is not lit by the SUN. In ancient times, the reappearance of the CRESCENT MOON was anxiously awaited and the time of the new moon sometimes represented ascent from the dark Underworld up to the light of the sky.

NIHO MANO

The *niho mano* is a pattern of TRIANGLES used in traditional Hawaiian tattooing. Sometimes arranged in a row, in opposing rows, or stacked in a PYRAMID, the *niho mano* is very likely a representation of SHARK teeth.

NINJA RAT

The RAT is the first sign of the CHINESE ZODIAC, whose characteristics include ambition, honesty, and a propensity for spending freely. In Japan's mythology as well, the rat is associated with wealth, and is sometimes seen with DAIKOKU, the god of wealth, one of Japan's SEVEN GODS OF GOOD FORTUNE, nibbling at his bales of rice. In Japanese tattoo art, the rat carries these general positive meanings and an additional association with *ninjutsu, ninja* spies who could become as invisible as rats in their stealthy maneuverings at night.

NKIM KYIN

Adinkra is a type of cloth made by the Ashanti (Asante) people of Ghana. The sacred symbols used in the cloths are many and represent all aspects of life—aesthetics, ethics, human relations, and religious concepts. The

traditional cloths are hand-stamped or hand-embroidered with these symbols in a vast checkerboard pattern. These attractive designs lend themselves naturally to becoming part of the tattoo repertoire as well, as in this example. This particular symbol, called the *nkim kyin*, symbolizes the changing of one's life and the ability to play many roles.

NO

The international symbol for "No," the circle with diagonal slash, is generally used with another image. Whenever it is used, it is placed over the other image and stands for prohibition of what that image (or sometimes word) represents. For example, the smoldering **CIGARETTE** with the circle and slash, one of the first uses of the "No" symbol, means "No Smoking."

NOH MASK

The Noh mask is actually many different types of masks used by the traditional Japanese actors of Noh theater. Noh performances are very stylized representations of traditional and well-known stories, developed in Japan during the fourteenth century. The masks are used to convey the identity and mood of the various characters, who number nearly eighty in the different tales. From the fanged and red-skinned masks of demons to the white ovals with high eyebrows that generally indicate someone of courtly rank, these objects are prized as treasures today. They also find expression in Japanese-style tattoos, sometimes juxtaposing masks of good and evil characters, or masks used in a well-known play.

NON COMPOS MENTIS

This Latin phrase means to not have mastery of one's mind. It has been used in the U.S. legal system to refer to people who are not of sound mind and hence cannot be held responsible for their actions. People choosing

this phrase for a tattoo are most likely not referring directly to a legal judgment but instead calling themselves a bit crazy.

NORMAN ROCKWELL POSTER

Norman Rockwell's *Only Skin Deep (Tattoo Artist)*, which appeared on the cover of *The Saturday Evening Post*, March 4, 1944, shows a tattooist sitting on a toolbox, tattooing a SAILOR seated before him. With a backdrop of the typical flash (posters of tattoo image samples for prospective customers) of the era, the tattooist has crossed out yet another name on the man's arm and is adding a new one to the list. As life imitates art imitating life, this poster has been used in tattoo designs itself. Rockwell was known for his ability to capture small-town America with both affection and a sense of the comical, and tattoo collectors capture much of the same with this tattoo, as well as a bit of nostalgia for a bygone era.

NUCLEAR RADIATION

The TREFOIL warning symbol for the presence of radiation and radioactivity is recognized the world over. Simple and bold, it lends itself well to tattoos and has been used in an infinite variety of sizes and colors. Its depiction in actual warning signs is less imaginative and generally makes use of either black or magenta on a background of yellow.

NYC/WTC/911

In the wake of the terrorist attacks on the Pentagon in Washington, D.C., and the World Trade Center towers in New York City, a number of patriotic tattoos rapidly came into being. Chief among these were initials such as "NYC" (New York City), "WTC" (World Trade Center), and the date ("9-11-01" or simply "911"). Although many used red, white, and blue colors, as well as stars, stripes, and American flags, others incorporated these newly symbolic letters and numbers into traditional tattoo designs, such as CELTIC KNOTWORK and CELTIC CROSSES, in a more subtle but no less meaningful expression of mourning and patriotism.

NYMPHS

Although frequently mentioned in the same breath as **FAIRIES**, nymphs are actually fairly distinct. Since they are both mythical creatures and perhaps most popular in fantasy art tattoo images, there is no "true" form of either—only certain traits upon which most people agree. Nymphs, unlike fairies, have their origin in Greek myth. Here they are associated with fertile nature, with mountains, groves, and **WATER**, and were generally shown as young and beautiful women who were both gentle and amorous. Though divine goddesses, they are not winged, as are fairies.

OAK TREE

In many places and times the oak was considered a sacred tree, associated with **SKY**-gods and kings, strength and life. Its **ACORNS** were one of the most important foods for Native North Americans and today it is a major source of lumber. Yet its bark has been used for medicinal remedies. The oak was the favorite tree of Zeus and **THOR** and was sacred to the Druids. Tattoos of the oak, or any tree, come in all manner of styles and even colors, but the true hues of the various rich browns and greens are used to beautiful effect. They are worn in different locations including the lower back or upper arm, and their position can dictate the shape that the heavy trunk and dense foliage will take and how the design will flow on the body.

OCEAN

The ocean is ultimately a symbol of dynamic and changing, if mostly hidden, life. Tattoos that use the ocean as a major theme may use any number of aspects. Whether cold and stormy or warm and clear, the ocean is somehow primeval and the source of life in many mythologies. Some tattoos will portray the ocean as if in a photograph, with perhaps a **BOAT** on a journey or a far-off continent or **LIGHTHOUSE**. Others focus on the underwater life to be discovered, as though one were submerged and awakened to the incredible array of shapes and colors that sea creatures and plants can take. Both types of tattoos speak to a transitory world of the senses, inundated with images of life.

OCTOPUS

This eight-armed sea creature has been used for decoration in ancient Europe from Greece to Ireland, although we know little of its meaning to these ancient cultures. Because of its ability to capture prey with its tentacles and devour it with its sharp beak, the octopus has sometimes been regarded as a beast of the Underworld. In tattoo art, though, the octopus takes on many different forms, from ornate blackwork designs to richly colored Japanese pieces, from small logolike forms of great symmetry to back pieces that trail tentacles all around the torso. It also has a particular, though certainly not exclusive, association with women—either images of octopi with women or tattoos of them on women with the tentacles wrapping themselves everywhere.

OCTOPUS (RAPA NUI)

Although we cannot say what significance the octopus may have had for the inhabitants of Rapa Nui (Easter Island), it is one of the few designs that we can at least identify with some surety. This highly stylized octopus motif is known to have been carved on the top of the head of a fragmentary MOAI, used in rock art on the island, and was also a historic-period tattoo.

ODIN RUNE

Odin was one of the primary gods of Norse mythology and principally a god of war. Slain warriors were permitted to join him in Valhalla, escorted by the Valkyrie, his maiden servants. However, there is no RUNE with the name of Odin. Instead, this is actually the *othala* rune, which became associated with Odin. It has been adopted by neo-Nazis as a symbol of their cultural heritage and an attempt to connect themselves with ancient Norse mythology.

OLIVE BRANCH

One of the most symbolic of trees and **BRANCHES** is the olive. From the ancient Mediterranean, we have received the dual association with peace and war. The Roman goddess Pax used it as her symbol and messengers suing for peace would carry an olive branch wrapped in wool. It was also used by Athena, however, and worn as a laurel on the head of military victors. In an Old Testament story, a **DOVE** brings back an olive branch to Noah, signaling an end to the flood. In tree form, it is sometimes associated with the World Tree or **AXIS MUNDI**, as in Islam where it is the symbol of universal man, of the prophet, and the paradise of the chosen. With its many branches and its dark-green, lance-shaped **LEAVES**, silvery on the underside, its beauty has been noted through the ages.

OLYMPIC RINGS

The five interlocking and different colored **CIRCLES** are said to symbolize the five inhabited continents of the world. Less well known is the association of the number four with the planet Venus in astrology. Every four years Venus returns to the same point in the **ZODIAC**, much like the four-year period between the games.

OM

Om (pronounced a-u-m) is the Hindu primeval and inaudible sound of creation, inexhaustible and the very center of traditional knowledge. It is written and painted but it is also the mantra of mantras. The symbol represents the four states of consciousness: sleeping without dreams, dreaming, awake, and satori (the transcendental state of enlightenment). As early as the sixth century, the written symbol was used to mark the beginning of an inscription, and today it is a very popular symbol in tattoo artwork.

OMEGA

Omega is the letter that occupies the twenty-fourth and last spot in the Greek alphabet. Used in **FRATERNITY** and sorority names, particle physics,

and chemistry as a part of other acronyms or names, omega is rarely seen alone. As with ALPHA AND OMEGA, though, it stands for more than just an end to the alphabet, signaling instead an ending and a finality for all things.

OM MANE PADME HUM

The most well known of the mantras of Tibetan Buddhism, *"Om Mane Padme Hum"* translates roughly from the Sanskrit as "Hail to the Jewel in the Lotus." It is a phrase that has many layers of meaning, where the jewel is the jewel of the consciousness (the mind) and the lotus is the HEART. At the same time, the Jewel in the Lotus is frequently associated with Avalokitesvara, the bodhisattva of compassion, also known as Chenrezig. Like the OM, with which the mantra begins, the Sanskrit characters have become a very popular religious tattoo.

ONE EIGHTY-SEVEN (187)

Although the number will change from state to state and for the specific crime as well, the number 187 can be found in California prison tattoos and is the criminal code for homicide in that state.

ONE HUNDRED PERCENT (100%)

Unlike the ironic aspect of the 1% tattoo, the 100% tattoo is most frequently associated with racism. Those who wear it are either expressing their "pure" white ethnicity or their desire for a "pure" white race.

ONE PERCENT (1%)

At some point in the 1960s, when bikers were feared as outlaws and criminals, the American MOTORCYCLE Association announced that only 1 percent of the riders in the country were actually outlaws. Proud to be considered part of that fringe element, then and now, bikers will still sometimes get the 1% tattoo.

ONI

The *oni*, or two-horned **DEVIL**, is a popular image in Japanese tattoo artwork today. This devil is probably the most common of the ghostly beings in Japanese cosmology and is typically depicted as rampaging, violent, and cruel. Almost always shown with horns, its face can be quite varied, similar to **NOH** masks, and is typically pink, red, or blue-gray. In older tales, the devil can apparently be converted to Buddhism and become a benevolent protector.

ORCHID

The orchid is a favorite among the floral tattoo motifs. The wild orchid was universally a symbol of fertility, especially in China where it was also a symbol of perfection. In England the purple spots on the petals were said to represent the blood of Christ, but the **FLOWER** also had other, even opposite, aspects, sometimes associated with death. Even so, it is a magnificent flower, with many varieties—the man orchid, the sun orchid, and the spider orchid are a few of the descriptive names given to them.

ORIENTAL CHARACTERS

Oriental characters, because of their combination of pictographic and letter qualities, are a favorite in tattoo art, most frequently in Chinese. Symbols for "good fortune" or "long life" and other generically positive attributes make up the bulk of these types of tattoos. Sometimes done in a straightforward solid black style, they can also appear in more complex tattoo work as brushed calligraphy or can even be done in a new school style. Like Egyptian **HIEROGLYPHS**, their appeal also lies in their antiquity. In this sense they take on a universal representation of something ancient in human culture as opposed to something specific to our own society and times.

OSIRIS

Depicted most frequently as the mummified, green-faced god and king of ancient Egypt, Osiris sits or stands with his arms crossed over his chest, one hand holding a crook, the other a flail (small whip). He wears the *atef* CROWN, composed of the white crown of Upper Egypt and two ostrich feathers. He was the god of fertility but, more importantly, he was the symbol of a dead and resurrected divine king. His role was that of ruler of the dead and giver of life, controlling sprouting vegetation and the annual flood of the Nile River. Probably one of the most recognizable of the Egyptian deities that are used for tattoo, he invokes the splendor of that ancient empire and its firm belief in the afterlife.

OTTER

The sea otter is typically regarded as the cute, energetic, and fastidious animal that dines on shellfish while floating on its back. For us, they have become symbols of the very properties that they can sometimes exhibit— inquisitiveness, intelligence, and friendliness. In ancient times, they were revered for their ability to dive below the surface of the WATER and their pelts were used in initiation societies in various parts of the globe, from North America to Africa. Because their pelts became so desirable in more recent times, the otter has also become symbolic of endangered species and the movement to preserve endangered wildlife.

OUROBOROS

The SNAKE that eats its own tail is the ultimate symbol of self-devourment and constant, cyclic, unending rebirth. Like the CIRCLE, it is continuity and that unity of opposite meanings that can be so powerful in symbolism. Known throughout world iconography from the Aztecs to the alchemists of Europe, the *ouroboros* is very popular and extensively used in tattoo art. As with all other personalized symbols in tattoo art, it is not unusual to see this serpent done in the styles of many different cultures and to see variations on its theme, as in an *ouroboros* given a single twist to transform it into a symbol for INFINITY.

OWL

The owl today symbolizes wisdom, which it did for the ancient Greeks as a **BIRD** that was sacred to the goddess Athena. In addition, though, it was also traditionally associated with its nocturnal hunting activity and known as a messenger of death or a conductor of souls in cultures as diverse as the Algonquin Indians of North America, the pre-Inca Peruvian Chimu of South America, and in ancient Egypt. As with many large birds, tattoo artwork is sometimes lavishly detailed when it comes to the owl, whether done in black line or color, showing the owl in flight or perched. Indeed, its quietly staring pose is perhaps one source of its association with knowledge and insight.

The owl, like many other animals that inhabited the Pacific Northwest, was used as a crest figure in many types of design. In some Northwestern cultures like the Haida, perhaps because it appears at night with silent flight and makes an eerie call, it is associated with death and the souls of the departed, particularly the souls of ancestors. In the typically abstract and highly stylized designs of this region, the owl has large, round eyes and a sharp, short beak.

OX

In the twelfth century C.E., a Chinese Zen master painted ten pictures that involved oxen. In these pictures of ox herding (accompanied by prose and rhyme), which have been repeatedly handed down over time, the reader is taken through a series of teachings or stages in an effort to achieve enlightenment. The oxen stand as symbols of the human ego that needs to be tamed and also as symbols of humanity's **BUDDHA**-nature, for in the end, all humans are one and the same. In addition, in the **CHINESE ZODIAC**, people born in the Year of the Ox are considered patient and quiet but also stubborn and with fierce tempers.

PADLOCK

The padlock, in a tattoo, is a symbol that something is locked up or secured. By extension, it also represents a sense of safety. In a romantic affiliation, padlocks also carry the sense of dedication and the idea that only one person carries the key to the lock, that is to say, the key to the **HEART**. In this example of true love, two hearts are bound together by a single lock.

PAGODA

The pagoda or multistoried shrine of Asia is probably one of the most recognizable pieces of architecture from this region, like the **TORII GATE**. The pagoda is essentially a **STUPA**, the commemorative monument of Buddhism. As with the stupa, it functions as a home for the sacred relics of the religion. As its tip reaches toward the **SKY**, it also represents spiritual ascent and an **AXIS MUNDI** (world axis).

PAH-KWA

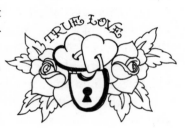

Said to ward off evil forces, the center of the design is the familiar **YIN-YANG**. Surrounding it are eight trigrams from the I Ching, an ancient Chinese divinatory text. Each trigram is com-

posed of three lines that are either whole (male) or broken (female). These particular combinations have the following meanings, beginning at the top and progressing clockwise: WATER from CLOUDS or streams; thunder; hills or mountains; water from a lake or marsh; fire, LIGHTNING, or the SUN; the EARTH; the wind or wood; and heaven.

PAISLEY

Although this pattern takes its name from the town of Paisley in Scotland, the design itself comes from the northern Indian region of Kashmir. The familiar TEARDROP shape, looking quite a bit like an elongated comma, reaches back to at least the time of the Arabic Mongol Muslim dynasty that ruled the Kashmir region from the sixteenth to eighteenth centuries. It was a popular pattern in the decorative arts of this dynasty and may be related to the form of the growing shoot of a date palm, gradually coming to be associated with fertility. In *mehndi,* the traditional art of adorning the hands and feet with a dark paste made from the finely ground leaves of the henna plant, the paisley is said to represent the mango and is a symbol of passion.

PALM TREE

Historically the palm tree has been symbolic of victory, regeneration, and even immortality, perhaps due to its very long and slender trunk and the abundant top foliage. Today, the palm tree has also come to symbolize a tropical paradise and even such warm weather U.S. destinations as California or Florida.

PAN

In Greek mythology, Pan is half human, half GOAT—with the horns, legs, and ears of a goat, but the arms and torso of a man. Frequently seen playing his trademark pipes and known as a god of the shepherds, Pan was agile and cunning in an animal way. However, he was most known for his insatiable sexual desire, which is the primary feature of his symbolic meaning.

PANDA

The panda BEAR, also called the giant panda, has been a much-admired and coveted creature in many parts of the world, although it is native only

to west-central China. Its black and white coloring, plump shape, and abundant fur give the appearance of a cuddly creature and it has been usurped as a symbol for the World Wildlife Federation. Although tattoos do not generally exploit this logo, the colorful scenes that sometimes incorporate pandas are certainly reminiscent of their life in the wild and their endangered status as a result of human encroachment.

PANSY

The pansy, a type of violet, is strikingly colorful and has many varieties. HEART-shaped or rounded LEAVES sprout from the base, while more oblong or oval leaves grow from the stems. The velvety FLOWERS typically occur in combinations of blue, yellow, and white. Traditionally, it is symbolic of thoughtful recollection, especially in relation to fondly remembering someone special.

PANTHER

The panther is a member of both the LEOPARD and puma families and is a predatory animal found throughout the Near East and in parts of North Africa. They are known for their savage cunning. In China the black panther is considered especially dangerous. Because of their characteristics in the animal kingdom, they have become associated with superior courage, strength, and fighting ability in the tattoo world. It is incongruous that the crawling form may have been adapted from a 1934 children's BOOK on mythology by old-time Milwaukee tattoo artist Amund Dietzel. An extremely popular design in its day, the panther is currently enjoying a bit of resurgence in popularity.

PARROT

The parrot has a long association with humans as a favorite pet. There are more than three hundred species of the bright-colored, tropical BIRDS, and they are today found throughout the globe. Parrots are a popular tattoo image, owing partly to their abundant color and to their place of affection as pets. Their images also recall their origins in the tropics.

PATRIARCHAL CROSS

The patriarchal cross is essentially a Latin cross with two beams instead of one and is also known as the cross of Lorraine, the archiepiscopal cross, and the cross of the Greek Orthodox Church. In the Roman Catholic Church it denotes a cardinal or archbishop rank and the upper bar represents the inscription placed on the cross by Pilate. In works of art, it is often seen carried by the patriarchs, prominent religious leaders. During the Middle Ages, Lorraine was a principality on the border between France and Germany. In the crusade that culminated with the siege and fall of Jerusalem in 1099, the victory was dedicated to the duke of Lorraine.

PAZYRYK STAG

The tattooed body of a Scythian leader dating from approximately the sixth to the second centuries B.C.E. has provided artwork that is copied in tattoo imagery around the world today. While he may have been almost fully covered during his lifetime, not all of his tattoos were preserved. On the right arm, from the shoulder to the wrist, are six fantastic horned animals, their hindquarters unnaturally doubled around. His right leg from the kneecap to the ankle is covered with a FISH, while on his chest is a TIGER with a spiraling tail. On the left arm are two STAGS and a leaping wild SHEEP with its hind legs also bent under. The images are fluid and powerful, if enigmatic. These migratory people, who wandered near the Black Sea, were renowned for their horsemanship and fighting ability and it has been suggested that the position of the hindquarters in these images is similar to that of an animal being brought down in the hunt.

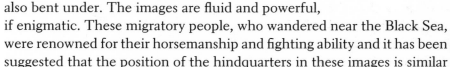

PEACE PIPE

The calumet is actually not just a peace pipe. It is a sacred pipe of prayer that can be used for peace or for war. For the Plains Indians of North America, it was an instrument that was a major means of communicating with the spirit world. The inhalation of tobacco smoke and its subsequent rise in the air embodied rising prayers. Calumets were so venerated that

they were referred to as people, and their parts were named after human body parts. The pipe also represented the universe, and the decorations given to it, such as FEATHERS or horsehair or paint, corresponded to parts of the universe. While the Plains Indians would likely not have used the calumet as a tattoo motif, it is an image to which people who are enamored of Plains culture gravitate.

PEACE SYMBOL

The peace symbol actually began as a British anti-nuclear symbol in 1958. While some sources claim that it was designed by Lord Bertrand Russell, others claim that it was commissioned by him but designed by J. Holtom. Although it resembles certain RUNES, we do not actually know the source of its inspiration. In keeping with its anti-nuclear origins, the symbol has historically been closely associated with various movements and protests. It has, however, spread throughout the world to such an extent that it has become a generic and benign symbol for peace.

PEACH

Much of the symbolism of the peach and the peach blossom results from its early appearance as a harbinger of spring. Along with spring come the associations of rebirth, fertility, and by extension marriage, especially in China. In Chinese culture, the immortals would feed on peach blossoms, and the peach tree could also be the TREE OF LIFE in the garden of paradise, bearing fruit once every three thousand years.

PEACOCK

Although today we rush to associate the peacock with vanity, as the male of the species struts his magnificent and upward-spreading tail feathers to attract a mate, the peacock has a rich Eastern heritage in symbolism. In its native India, many gods were portrayed riding this sacred BIRD. In China, it was the embodiment of beauty and dignity. For Muslims and other groups, the peacock is a cosmic symbol whose spread tail represents the

whole universe, or the full **MOON**, or the **SUN** at its highest point. Tattoos of the peacock are dominated by the brilliant and metallic blues and greens of its plumage and the distinctive, iridescent "eyespot" near the tip of the feathers, which is ringed with blue and bronze.

PEAHI NIU

The *peahi niu* is a Hawaiian crescent **FAN** whose design was used in traditional forms of tattoo there. The fan is considered by some as the most notable achievement in the basketry arts in Polynesia, and the crescent fan tattoo motif was apparently reserved for people of high rank.

PEARL

In the West, as in the East, the pearl is associated with wisdom. For Gnostic Christians it particularly symbolized hidden knowledge. Its natural form and beauty have long made it a symbol of something precious and the Gospels have used the pearl as a symbol of the sacred word of God. But its most universal association is with the **WATER** from which it comes; its shine, which is likened to that of moonlight; and the feminine from the shape of the shell.

PEARL (JAPANESE)

In Japanese tattoo, the **PEARL** is found in an abstract form that accompanies the dragon. The dragon is typically shown clasping the pearl in one claw, where it symbolizes wisdom, light (borrowed from the **MOON**), and immortality. It is a jewel, also loosely based on the closed **LOTUS** form, that contains the spiritual essence of the universe, used by the dragon to control the winds, rains, and even the movements of the planets. Both pearl and dragon are associated with the water, where dragons keep guard over the pearls at the bottom of the sea.

PEGASUS

The winged and flying **HORSE** of Greek legend, Pegasus, is alive and well in the world of tattoo imagery. He combines the strength and swiftness of the horse with the freedom of the **BIRD**. Although mythi-

cally associated with water (after his father, **POSEIDON**) and lightning bolts, today he is much more symbolic of an inspired poetic spirit.

PENGUIN

Penguins are the most highly adapted **BIRDS** for life in the ocean. Sometimes they are used as symbols of cold environs or specifically the Antarctic, which is their home. But aside from their natural environment, they are also known for their awkward and sometimes comical movement on land, waddling and sliding on their bellies, all the while dressed in seemingly formal tuxedos. In addition to symbolizing cold environments, cute animals, or other private items, people who wear a penguin tattoo may also be referring to participation in winter sports.

PENTAGRAM

The five-pointed star has a varied symbolic history across the globe and in the past, but its primary association in tattoo imagery is with Wicca, a religion from pre-Christian Europe that stresses nature and supernatural power, and whose practitioners occasionally call themselves witches. Sometimes surrounded with a **CIRCLE** or drawn with entwined **VINES** or other foliage, the pentagram is a general protection from evil, among many other specific meanings that practitioners have assigned to it. Only when the pentagram is inverted is it associated with evil.

PENTAGRAM WITH MOONS

Wicca (Old English for wizard) is a more recent combination of witchcraft and nature worship that is based on the traditional pre-Christian beliefs of certain peoples of Europe. A frequently used symbol for this group is the upright **PENTAGRAM** within a **CIRCLE** that is flanked on either side by an outward-facing **CRESCENT MOON**—one of which would represent the new **MOON** and one the waning moon. This in turn is based upon the symbol of the Goddess, which is a circle or **SUN** flanked by two crescent moons, without the pentagram.

PEONY

With its large and spreading red petals, which are slightly curled at the edges, in Europe the peony has been called "the ROSE without thorns," and has been a way to refer to the VIRGIN MARY. From the time of the ancient Greeks in the Western world, it has been associated with many folk medicine cures, treating maladies ranging from asthma to epilepsy and even keeping evil spirits away. It is a FLOWER that is associated with both dignity and honor. Although traditionally depicted in tattoo imagery in deep red, it is today also cultivated in white, varying shades of red, and yellow.

PEONY (JAPANESE)

The floral repertoire of traditional Japanese tattoo is not as extensive as it might first appear. In the ornate, complex, and extensive body coverage that is typically involved, it may seem as though entire gardens could appear. However, among the select FLOWERS that are used is the PEONY, a flower with a very long history that stretches over four thousand years in China and then in Japan. For the Chinese it was regarded as a symbol of wealth, good fortune, and prosperity. In Japanese tattoo, it symbolizes much the same. In addition, since the peony is part of an old Japanese card game (reported to have been played by gamblers sporting tattoos), it also suggests gambling, daring, and a masculine, DEVIL-may-care attitude.

PHARAOH

Almost all depictions of Egyptian pharaohs in tattoo art are actually versions of the funerary mask of Tutankhamen. Discovered by Howard Carter in 1922 in the Valley of the Kings, the golden and lapis blue mask has become synonymous with ancient Egypt and the very long line of ancient hereditary rulers, the pharaohs. Considered divine, they ruled with absolute authority and power. Other pharaonic images are drawn from the painted or inscribed scenes on the monuments and burial chambers of

Egypt. Nevertheless, Tut's funerary mask remains a favorite for its brilliant colors and immediate recognition.

PHOENIX

Probably the most important of the mythological **BIRDS**, and a favorite motif in tattoo artwork, the phoenix was known in ancient Egypt, Greece, China, and the Middle East. In the many stories that surround it, two aspects remain constant— its matchless splendor and the immortality it derived from rising from its own ashes. When the time of its death would draw near, it built a nest of aromatic twigs in which it would burn, simply from the heat of its own body. From the pyre, a reborn phoenix would rise. It is a symbol of the undying soul and ultimately one of regeneration, resurrection, and immortal life.

PI

Pi (π) is the Greek letter of the alphabet that has been made famous for its use in mathematics. It stands for a number that is approximately 3.14159265 and that has been calculated by computers to an extensive number of decimal places. It arises from the geometry of the **CIRCLE** and is the ratio of the circumference (the distance traveled around the circle) to the diameter (the distance traveled directly across). The pi tattoo could be a type of **FRATERNITY** tattoo but perhaps more commonly refers to its central role in finding a circle's dimensions or the seemingly unending quest to determine pi's value more and more precisely. Like the tattoo of a **MATHEMATICAL EQUATION**, its deeper meaning is probably only recognized by people familiar with its numerical significance.

PICTISH CIRCLE

The Pictish circle is an example of a Celtic key, or interlocking pattern, although it appears at first glance more like a **MAZE**. The word "pict" comes from the Latin word for "painted" as applied by the invading Romans to the painted or tattooed natives they battled in eastern and northeastern Scotland.

PIERCED HEART

The **ARROW** through the **HEART** has been shot by none other than **CUPID**, the ancient Greek god of love. Nevertheless, it is a very modern symbol for being in love. The arrow itself is a symbol of directed energy and penetration. Thus the **PIERCED HEART** can partly be seen as phallic and representing sexual love in addition to the less physical love of the unpierced heart.

PIETÀ

Like Michelangelo's **DAVID**, his pietà has resonated with viewers of the statue for centuries and has, of course, found a place in the world of tattoo imagery as well. Housed in St. Peter's Basilica at the Vatican in Rome, this statue shows a seated Mary holding the lifeless body of Christ draped across her supportive arm and lap. All pietàs (from the Italian for "pity") are images of the **VIRGIN MARY** mourning over the body of Christ. Although there is no such scene in the Bible, it is a symbol of lamentation in general and one with the specific emotional pull of a grieving mother.

PIG

Although the pig is frequently a symbol of gluttony, it has also been associated with fertility and prosperity in many cultures—from the swine goddesses of the Celts and Norse to Neolithic Malta, where there is an image of a sow nursing thirteen piglets. The ancient Egyptian goddess Nut was sometimes shown as a sow eating her own piglets (the **STARS**), which would disappear every morning but be reborn at night. In the **CHINESE ZODIAC**, people born in the Year of the Pig are considered brave and gallant. In tattoo art, pigs are most frequently given the modern Western connotations of either greed or hunger, and even sometimes shown as the meal or the chef. Occasionally they are also shown in cartoon form, exaggerating the infantlike quality they can exude when young and small.

PINK TRIANGLE

The inverted pink **TRIANGLE** that is today a symbol for the gay liberation movement and gay pride began as a symbol of hate. It was first used in Germany under Hitler's Nazi regime. Prisoners in Nazi concentra-

tion camps were labeled according to their "crimes" by various colored symbols, such as the yellow (for treacherous aggression) STAR OF DAVID for Jews. Homosexual prisoners wore the pink triangle. Its association with the modern gay movement began in the 1970s. Wearers of the pink triangle are associating themselves with others who have been persecuted in the past and subtly likening their persecutors to those who originated the symbol.

PIRANHA

This carnivorous little Amazonian FISH is identified by some tribes in the region with river spirits and, of course, death. Aggressive and unyielding, attracted to the scent of BLOOD, they will swarm over their prey, nearly defleshing the victim in mere minutes. The piranha tattoo evokes the fear with which the fish is usually associated and emphasizes the toothy jaws that are the business part of this fish.

PIRATE

A tattoo of a female pirate or buccaneer, since this is usually the gender of a pirate tattoo, is basically another form of the pinup girl, with a maritime theme. Usually buxom, she is more than just sex appeal, though, and seems to carry a sense of danger and adventure and perhaps a bit of feistiness and risk, depending on the nature of the tattoo. Few real women pirates were known, but they did exist, committing robbery on the high seas alongside their male counterparts.

PIRATE SHIP

The pirate ship is another among the long tradition of maritime tattoos and is typically done in the heavily outlined, bold colors of that style. Its most distinctive feature, other than being a masted ship generally shown under full sail cutting through the water, is the Jolly Roger. The black FLAG with the white SKULL AND CROSSBONES is sometimes credited to a French buccaneer by the name of Bartholomew Roberts who lived in the mid-1600s. However, the name of the flag is probably from the French for "red flag," the "Jolie Rouge," the red pennant that meant that no quarter would be given.

PISCES

Pisces (February 19–March 20) is the twelfth and last sign of the ZODIAC, falling immediately before the vernal equinox. Its symbolic sign is almost like a right parenthesis and then a left, connected in the middle by a dash that runs across their middles. One of the WATER signs, it is depicted traditionally as a pair of FISH, back to back and joined at their mouths by a sort of umbilical cord. This type of symbol translates to becoming a part of the greater whole, the OCEAN of humanity. Persons born during the interval when Pisces reigns are said to encompass the positive traits of being intuitive and spiritual and the negative traits of being vague and secretive.

PLAYBOY BUNNY

The famous logo of *Playboy* magazine is an icon that today reaches further than just brand loyalty. Found tattooed on both men and women, it is now a symbol of eroticism and adult entertainment all over the world, albeit with a classy and sophisticated tone. It was designed by Art Paul, the magazine's first art director, after Hugh Hefner chose the RABBIT in order to give the logo a look that played upon the rampant sexual activity associated with the rabbit. Putting the rabbit in a tuxedo added an extra bit of charm and suaveness.

PLUM BLOSSOM

In the large repertoire of elaborate Japanese tattoo, the selection of floral themes is actually remarkably small, given the Japanese fondness for FLOWERS. However, the plum blossom is one flower that does find a place in traditional tattoo work. In the east, the plum blossom is known as a symbol of purity and the fleeting joy and innocence of youth, since the blossom appears before the LEAF. It is also a symbol that spring is

near, since it blooms at the end of winter. The tree itself, also sometimes a subject of tattoo art, is a symbol of good omen.

POINTED CROSS

The pointed cross or cross *fitché* can be drawn in different ways, but it always has its lower vertical arm pointed, looking much like a **DAGGER**. It originated during the time of the Crusades when **KNIGHTS** brought crosses with them that were designed to be thrust into the ground for ceremonies in their camps. It also became a part of their heraldry.

POLAR BEAR

Found throughout the Arctic regions, the polar **BEAR** is a symbol of the wildlife of the great white North. Utterly adapted to the cold, they are comfortable swimming among the ice floats where they hunt **SEALS**. Like other large bears, they are ferocious and dangerous in the extreme. Because the polar bear is white, a realistic tattoo is not particularly easy to achieve, since white ink is rarely used by itself.

POPEYE

Popeye, the **SAILOR**, is a cartoon character that has endured in American tattoo since he first appeared in 1929. Fighting his nemesis Bluto, usually over Olive Oyl, Popeye is a symbol of strength—derived from eating his spinach. With his pencil-thin upper arms but enormous (and tattooed) forearms, he good-naturedly rescues all manner of children and damsels in distress. Early tattoos of Popeye sometimes only showed his head—captain's cap, sailor collar, corncob pipe, and one eye squinting—which was more than enough to recognize him.

POPPY

Neither the ornamental red garden poppy nor the golden California poppy yields opium (from which morphine, heroin, and codeine are produced). That particular variety is native to Turkey and has large bluish-purple or white flowers. In the cemetery gravestone symbolism of the West, the poppy was a symbol of sleep and, by analogy, the eternal rest of death. For the ancient Greeks, it had much the same association and also one of forgetfulness.

PORTUGUESE CROSS

The simple Portuguese cross, along with the **LATIN CROSS**, may be one of the most popular crosses used in tattoo artwork. It was also a favorite in the **COATS OF ARMS** of the crusader **KNIGHTS** of the Middle Ages, as well as in Portugal, of course, where it stood as a coastal navigational landmark and was used in the Portuguese Royal Coat of Arms.

POSEIDON

Poseidon (also known as "Neptune" to the Romans) was the ancient Greek god of the sea and earthquakes. An older and bearded, though vigorous, man, he is often depicted with his **TRIDENT**. For the ancients, he ruled the stormy and violent seas. For **SAILORS**, Poseidon tattooed on the leg meant that they had crossed the equator.

PRAYING HANDS

The image of two hands in a position of prayer is part of Christian tattoo iconography. The hands represent communication with God, ranging from rote recitations to more specialized requests. They are generically associated with personal spiritual activity. Most images of praying hands, in tattoo art and otherwise, derive somewhat from the famous portrait done by German artist Albrecht Dürer (1471–1528).

PRISON BARS

The prison bars tattoo, with or without the date of incarceration, is not just a signal that the wearer has served time. When the cell window is shown with the **SUN** or a perched **BIRD** visible, it is also a symbol of the longing for freedom and the wait for release.

PROPELLER AND WINGS

The propeller and **WINGS** are part of the symbolism of aviation. In tattoo art, they were most closely associated with early military aviators and were

typically combined with patriotic images and colors. Within aviation itself, a pair of wings denotes someone qualified to pilot a plane while a STAR denotes someone qualified to navigate one.

PROTECTION AGAINST EVIL

This interwoven triple TRIANGLE, like other inter-woven designs, was thought to have magic qualities that could bring success and provide protection from the forces of evil. This version has been observed on both an ancient Sumerian seal and on a picture stone from the early VIKING era in Sweden.

PUZZLE

Puzzle pieces are things that the human eye and mind automatically try to put together. If any symbolism underlies a tattoo involving the meandering, curved, and straight, though not random, lines between interlocking pieces, it is one of completeness, finding a fit, and working out something that seems confusing at first. One of the most famous of modern tattooed people is the Enigma, an entertainer who has had himself completely covered with a blue jigsaw puzzle pattern.

PWCCA

Although it may look like an acronym, *pwcca* is Welsh (where the "w" sounds like a double "o," hence "pooka"). Despite sometimes being taken to mean "Satan," and used in some demon-inspired tattoo artwork, *pwcca* is actually more akin in meaning to an evil household spirit, a mischief maker. The same type of imp is found in the English Robin Goodfellow, also known as Puck, or the Irish *puca*.

PYRAMID

The pyramids of the Giza Plateau, one of the Seven Wonders of the Ancient World, are still a marvel today and one of the most recognized symbols of Egypt. Many pyramids—of different time periods and different shapes—exist in Egypt, but they all share a common purpose as tombs for

royal or high-ranking persons. In tattoo art, pyramids are sometimes specifically drawn like those at Giza, accompanied by the SPHINX. Other times, pyramids are part of different types of symbols such as the ILLUMI-NATI. In general, though, they evoke associations with ancient culture and wisdom and have even inspired New Age spiritualism, which linked the structures with healing powers.

Q

QUATREFOIL

The quatrefoil, similar to the **TREFOIL**, is a Christian symbol. Instead of three round lobes, there are four, usually arranged in a diamond. It is taken from Gothic architecture and represents the four evangelists—Matthew, Mark, Luke, and John.

QUEEN

The queen is used much less often in symbolism and tattoo artwork than the **KING**. Where she is used, she oftentimes is the complement to the king or may simply represent femininity. To portray a woman as a queen places her in a superior category. For men, the word "queen" refers to homosexuality and a similarity to women.

QUETZALCÓATL

Quetzalcóatl, the feathered serpent, was one of the major deities in the ancient Mexican pantheon. In Aztec times (fourteenth through sixteenth centuries) Quetzalcóatl was revered as the patron of priests, the inventor of the calendar and of **BOOKS**, and the protector of goldsmiths and other craftsmen; he was also identified with the planet Venus. As the evening and **MORNING STAR**, Quetzalcóatl was the symbol of death and res-

urrection. Quetzalcóatl's calendar name was *Ce Acatl* (One Reed). The belief that he would return from the East (where he had traveled after being expelled by the God of the night SKY) in a One Reed year led the Aztec sovereign Montezuma II to regard the Spanish conqueror Hernán Cortés and his comrades as divine envoys, because 1519, the year in which they landed on the Mexican Gulf coast, was a One Reed year. The use of this image for a tattoo is most popular with the native people or those with an ethnic affiliation with the region. However, it is not unknown among those who have ties of interest, research, or even just travel.

RA

The **SUN** disk is the symbol of Ra, the ancient Egyptian god of the sun. As with other sun gods, he traveled across the **SKY**, but in a solar bark, like that which might have been used on the Nile, and he also used a second bark to travel through the Underworld at night. He was also the great creator and the totemic father of the pharaohs. As with other popular tattoos using ancient Egyptian imagery, the design hearkens back to a culture that still manages to capture the imagination and whose artistic influence has spread far beyond its borders. The sun disk, whether combined with **HORUS** or flanked by **WINGS**, is a bold and effective image.

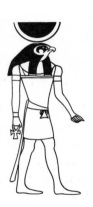

RABBIT

Although in the West we tend to see a "man in the moon" when we look up at night, other cultures have frequently seen a rabbit. North American groups as well as the Maya and Buddhists are just a few examples. The rabbit then takes on some of the characteristics of other lunar symbols—that of the life cycle, renewal, and new life. It is also associated with alertness, being fleet of foot, and with rampant breeding ability. In terms of fertility, the rabbit was associated with both the Greek gods Aphrodite and her son **CUPID**. In the **CHINESE ZODIAC**, people born in the Year of the Rabbit are considered articulate and ambitious but virtuous to the point that even their gossip is generally kind.

RADIATION DANGER

The danger sign for radiation was probably first used in the United States and it serves to mark dangerous light sources that can be harmful to the eye or skin. A straight line represents the beam of light while a sunburst at the end of the line represents the light energy that the beam carries, not unlike other types of sun symbols used prehistorically.

RAINBOW

In Christian symbolism, the rainbow represents a covenant or promise by God, appearing after the great flood of Noah. The rainbow in other symbolism elicits similar interpretations. This gigantic SKY phenomenon was sometimes considered an expression of divine benevolence but more often it was a pathway between heaven and EARTH, a unification of the two that signalled harmony.

RAINBOW FLAG

The rainbow flag has been used as a symbol for gay and lesbian community pride since it was created in 1978 by Gilbert Baker of San Francisco. Although other groups have used the RAINBOW color scheme or actual pictures of rainbows in their symbolism, drawing on the wider meaning of the rainbow, tattoos of rainbow flags are often combined with other gay or lesbian symbols.

RAM

Tattoos of the ram, although they might symbolize the astrological sign of ARIES, are oftentimes more realistically rendered than is usual for a ZODIAC sign. The primary feature is, of course, the large curling horns. The horns are used by the ram, a male bighorn SHEEP, to battle with other males in head-butting jousts. Rams thus become symbols of natural instincts and strength, as well as masculinity, aggression, and a procreative force of life.

RASTAFARIANISM

The Rastafarian movement is a combination of political and religious elements popular among the black population of Jamaica and elsewhere. It

centers on the belief that Haile Selassie I, the former emperor of Ethiopia, was a divine messiah. His name before becoming emperor was Ras (Prince) Tafari, from which the religion derives its name. Rastafarians believe that they are reincarnated Israelites who will one day be redeemed from oppression and rule over the white race from their homeland of Africa. This symbol, now part of some Rastafarian **FLAGS**, is derived from Haile Selassie, who adopted the title **LION** of Judah, based on the name of one of the original twelve tribes of Israel, and from which the Jews received their name.

RAT

The symbolism of the rat is curious and dual. In the West, rats are regarded as frightening, filthy, and insatiably hungry rodents. In the East, they may also represent greed (based on their appetites) but are more associated with fertility and numerous offspring, as in Japan, China, and Russia. For the ancient Greeks and Hindus, rats could both bring and cure disease. The rat in tattoo images seems to draw from all of these various associations, whether in **CHINESE ZODIAC** "Year of the Rat" designs; associated with the Japanese **DAIKOKU**; with the steed of **GANESHA**; or used in frightening motifs where they are furtively scurrying about.

RAVEN

Although ravens (and **CROWS**) are typically used in tattoos as omens of ill will or symbols of the dark side of the psyche, they have not always had this association. In Japan and China the raven is a symbol of family affection, while in the Book of Genesis the **BIRD** is a symbol of clear-sightedness. It is, however, a bird of prey and in this respect was affiliated with the gods as their messenger, especially in terms of bringing death or conveying souls (as with Odin and the Valkyrie).

RAVEN (PACIFIC NORTHWEST)

The raven is the great trickster and transformer of all the Northwest Coast supernatural beings. He helped the Creator finish the world but he also loved to play pranks on people. Quick and curious, he was also mischievous. Although he was always out to please himself and have a good time, his adventures ended up benefiting mankind—bringing water and salmon, teaching fishing and hunting, and even releasing the MOON, SUN, and STARS.

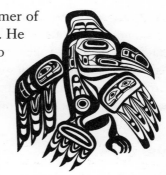

RECYCLING

Three ARROWS chasing one another in a CIRCLE, or folded over and pointing tip-to-tail in a TRIANGLE, is the recycle symbol. Like other symbols taken from modern packaging, such as the BAR CODE, there is something comically ironic about its use as a tattoo, since the symbol is typically applied to disposable materials that can be reused for manufacturing more products.

RESURRECTION

This tattoo shows a theme of great importance in Christian art: the resurrection of Christ from his tomb, three days after dying on the cross. This is the event celebrated at Easter and one that prefigures the resurrection of all believers. However, resurrection of the dead is also known in Judaism as well as Islam.

REVERSE SWASTIKA

Also known as the *sauvastika* or the left-hand SWASTIKA, this reverse or mirror image of the swastika has generally stood for misfortune and bad luck. It has been associated with night and also the terrifying goddess KALI.

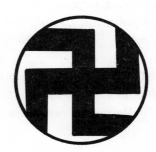

RHINOCEROS

For most modern peoples, the rhinoceros represents a stubborn, ferocious, and tenacious animal that has poor eyesight but is aggressive and ready to charge. It is also emblematic of the wilds of Africa and tropical Asia where its habitat still survives. Previously, though, the rhinoceros was symbolically connected with the likes of the UNICORN, and its horn was believed to have medicinal powers and bring happiness.

RIBBON

Although a ribbon might not seem to carry much meaning at first glance, there are many types of ribbons, many of which occur in tattoo art. A simply tied ribbon as might be found on a gift denotes something special and pretty, perhaps generosity. A blue ribbon is an award, usually given to the winner of first place in a contest. A yellow ribbon, based on a popular song, has come to be associated with loved ones who are away but remembered at home. Inspired by the yellow ribbon, the simple upright loop of a red ribbon has become a symbol for AIDS awareness, and a pink version has become associated with breast cancer awareness.

R. I. P.

Although it fits, the letters "R.I.P." used as an epitaph do not actually come from the words "rest in peace." Instead, they are from the Latin phrase that means the same thing, *"requiescat in pace"* or "may he (or she) rest in peace." In tattoo art, the saying is used in two main ways: as part of ghoulish cemetery or death scenes and IN MEMORIAM.

RIVER

The river, moving WATER, and the waterfall are all important motifs in Japanese tattoo, generally providing a backdrop for the main images of FLOWERS, gods, and mythical beasts. Their function is to provide a structure on which to position other tattoo images (perhaps CHERRY BLOSSOMS and a KOI) and yet tie them together in a "flow" where they lie naturally on the body, even on large expanses of skin. In symbolic terms, water represents life and a constantly changing form. Physically and symbolically, we can go with the flow, swim against the current, and also tread water.

ROAD

The road is part of the journey, but there are many journeys that it can represent. A certain pursuit, a new direction, a path to health, or even life itself can be the road. This type of tattoo will necessarily be specific to the wearer and is an opportunity to create personal symbolism on many levels. For instance, the rocky road is one of obstacles, while the forked road and the crossroads signal a choice to be made.

ROCHISHIN

Rochishin was one of the 108 heroes of the SUIKODEN, an illustrated Japanese novella of the early 1700s. He is notable among that great number because he is so easily identified in Japanese tattoo work today. Kaosho Rochishin became a monk to escape punishment for a murder he committed but later went on to legendary achievements as a sort of hero-bandit. He was tattooed with CHERRY BLOSSOMS and is usually shown wearing a ROSARY and using the staff as his weapon.

ROCKET

Today the rocket is fashionable as a type of retro symbol of 1950s kitsch and even the B science fiction movies of the period. Early in their development, rockets symbolized both war-making and the race to reach outer space. Formerly part of a vast and sometimes frightening unknown, today rockets make up a nostalgic view of that time of adventure.

ROCK OF AGES

Taken from the famous hymn of the same name written in 1776, these words are equally well known in the world of tattoo. The traditional Rock of Ages tattoo varies in its details but the main features are a shipwrecked woman clinging to a cross that is perched on a small rock outcropping in a stormy sea. It is both a maritime and a religious tattoo, as are many of the early

Western tattoos, and both it and the hymn take inspiration from the Bible, where Christ is referred to as the spiritual rock.

ROME

The image of the great she-WOLF, ready to suckle her young, is a symbol for Rome and its founding. In Roman legend, the founders of Rome were Romulus and Remus, who were sent floating down the Tiber River as infants, coming to rest at the future site of the city. There a she-wolf and a woodpecker, sacred animals to their divine father Mars, the god of war, fed them until they were found by humans. They eventually grew to maturity, conquered the man who had set them adrift, and founded a town that was to become Rome.

ROOSTER

According to seafaring tradition, a PIG tattooed on the left foot and/or a rooster on the right would keep a SAILOR from drowning. The idea was that since neither of these animals can swim, they would want to get back to shore as quickly as possible. Apart from the maritime association, though, the rooster is seen today in tattoo art with a wide-ranging symbolism. Famous for their aggression, roosters are used the world over for fighting and betting purposes. In fact, the Goths used the rooster as a war symbol. They are also associated with their early morning announcement that the sun has risen, and thus with Apollo by the ancient Greeks. In the CHINESE ZODIAC, people born in the Year of the Rooster are considered deep thinkers and loners, whose emotions can swing from high to low. On account of the rooster's flowing and arching tail FEATHERS and its red-colored head comb, Buddhists have associated it with pride and passion while Japanese Shintoists paint its likeness on drums that signal a call to prayer.

ROSARY

A rosary, or string of beads, is an aid in reciting prayers or meditations as a religious exercise. The practice and beads are known and used in Christianity, Hinduism, Buddhism, and Islam, each with its own special number of beads, traditional bead materials, means of use, and special features (such as a CRUCIFIX or guru bead). In the predominantly Christian West, it takes its name from the ROSE, a symbol of Mary.

ROSE

Like the LOTUS in Asia, the rose is the preeminent floral symbol of the West. With their deep red color, they have historically been associated with BLOOD and hence Christ in Christian iconography. Roses have been used in heraldry, FREEMASONRY, alchemy, and in festivals of ancient Rome and Greece. In modern iconography, they are part of love symbolism and are synonymous with that which is beautiful. In tattoo art, roses are likely the most frequently appearing FLOWER, sometimes complete with stem and thorns. As in other symbolism, their meanings in tattoo vary widely with each use, though most uses are based on the beauty and romantic symbolism for which they are so well known.

ROSE OF NO MAN'S LAND

See ANGEL OF NO MAN'S LAND.

ROSIE THE RIVETER

Rosie the Riveter rose to prominence in the United States in 1942, during World War II, in two ways. She was popularized by the hit song, "Rosie the Riveter," and in the image from the "We Can Do It!" poster of the same era. Over 6 million women worked at industrial jobs during the war to ensure the production of war and other machinery while their husbands, brothers, fathers, and sons were away in the military. The poster shows a woman wearing a blue work shirt, red bandana tied on her head, slogan button on her collar, while pulling up one sleeve as she flexes that arm, raising a fist, to make a muscle. The image became an icon of patriotic service and is still used today as a symbol of a woman's "can do" attitude and self-reliance.

ROSY CROSS

The cross with a ROSE at its center or between the arms of a CROSS OF EQUAL LENGTHS is known as the rosy cross. It is widely known as the symbol of the Rosicrucians, whose name is derived from it. Likely founded in the seventeenth century in Germany, Rosicrucianism is fundamentally a mystical brotherhood with some occult beliefs and practices. The rose placed between the arms of the cross represents the unfolding of spiritual reali-

ties and the rose at the center of the cross represents the **BLOOD** of Christ spilled there, while the **FLOWER** form brings to mind regenerative life.

RUNE

Runes are a writing system, an ancient alphabet, also called *furthark,* used in Northern Europe from about the third to the seventeenth centuries, in the three main variants of Germanic, Anglo-Saxon, and Old Norse. Much has been read into their individual meanings and historical associations, some of them being quite complex. Indeed, virtually no modern "reading," divining, or interpretation of runes is the same, sometimes varying radically from one interpreter to the next. They are found sprinkled throughout tattoo imagery in various combinations as either **BIND RUNES,** individual symbols, or entire words or phrases.

S

SACRED GROVE

The sacred grove, or *nemeton,* is a Celtic design that essentially represents a place of open air worship and the center of the ancient religion, Druidism. Without formal temples, the grove served the same purpose as a house of worship. Nemetona was the Celtic goddess guardian of the grove. The word "druid" means "knowing the oak tree."

SACRED HEART

The sacred **HEART** is one of the most popular tattoos done in the West. The image of **JESUS**'s heart, which represents his great and sacrificial love for mankind, is venerated as an object of devotion in the Roman Catholic Church. Many variations have been created but the essential characteristics often depicted are a wounded heart encircled by a **CROWN** of thorns and radiating light. Tattoo versions will frequently include **FLAMES** of passion and may represent the heart in a number of ways: in a flat two-dimensional view, as a realistic organ, or as a sort of three-dimensional spouted flask.

SAGITTARIUS

Sagittarius (November 22–December 20) is the ninth sign of the **ZODIAC,** occurring just before the winter solstice of the Northern hemisphere

(hence the summer solstice of the Southern hemisphere). Along with **ARIES** and **LEO**, this is one of the fire signs. In pictorial form, Sagittarius is the **CENTAUR** archer. Typical Sagittarian individuals are characterized as having an ego that grows wider or deeper, seeking its limitations and attempting to overcome them. Hence they aspire to heights and are driven to ideals that also appear as inflation of the ego and their own importance.

SAILOR

Part of maritime tattoo, the image of a sailor usually occurs in conjunction with other naval themes—perhaps he rides a **SHARK** or cavorts with a pinup girl.

SAILOR GIRL

Unlike the male **SAILOR**, the sailor girl is strictly pinup material. Although she might wear the white cap and a pinafored uniform, it is not unusual for the neckline to be cut low and the whole outfit to be quite tight-fitting.

SAILOR'S GRAVE

Sometimes the sailor's grave symbol includes an **ANCHOR** or a perching, spread **EAGLE**, but its defining characteristic is the sinking ship, still partially visible above the surface of the **WATER**. The design stems from a long tradition of sailor memorials and it commemorates the men and ships that have been lost at sea. This type of design, and others of the maritime school, are typically done with heavy outlines, bright colors, and dark shading.

SAINT WITH CHILD ON HORSE

This Coptic tattoo design illustrates a theme little known in Christian art. It shows a haloed saint riding a **HORSE**, holding the reins in his right hand,

with a haloed child riding behind him. In his left hand he holds a scepter or **SPEAR** with a cross. The Coptic interpretation of the design is that it represents Mar Corios, a soldier born during the reign of the Roman emperor Diocletian (C.E. 245–316), known for persecution of Christians. The soldier was challenged by his captain, who learned that he had been converted to Christianity, and he replied that he did not believe "in Roman things." He was martyred defending his faith. The child is his servant, who was martyred with him.

SALMON

In the Celtic world, the salmon, along with the **BOAR** and the wren, was an especially spiritual creature and one of the symbols of sacred wisdom, spiritual nourishment, prophecy, and inspiration. The salmon was an important food source to the people of Northern Europe and it was also believed that eating salmon from a special well could bring second sight and knowledge of all things. Because they swim upstream in search of their birthplace before spawning, salmon have also become associated with perseverance and courage.

SALOME AND THE HEAD OF JOHN

The biblical story of Salome has given rise to operas, movies, classical art, and the occasional tattoo. According to the **GOSPELS**, Herod had John the Baptist imprisoned for criticizing Herod's marriage to the divorced wife of his half brother (and the mother of Salome) but was reluctant to have him killed due to his popularity with the people, who believed him a prophet. However, when Salome danced for Herod and his guests on his birthday, he was so pleased that he "promised with an oath to give her whatever she asked." Prompted by her mother, she asked for the head of John the Baptist, which Herod reluctantly had to then grant. No mention is made of John spurning the love of Salome nor of an erotic "Dance of the Seven Veils," but these are lasting fictional images that have blurred Salome's symbolism into one of corrupt desire.

SAMURAI

Images of samurai brandishing their famous **SWORDS** or wearing their distinctive helmets have been used in Japanese tattoo art since at least the time of the **SUIKODEN** heroes. The samurai were the warrior caste of feudal Japanese society, famous for their swordsmanship but equally famous for the strict code of honor by which they lived and died. Bravery, stoicism, and loyalty to the point of committing ritualized suicide rather than suffering dishonor were the hallmarks of these soldiers. Tattoo artwork, patterned after Japanese woodblock prints, can sometimes depict samurai in grisly scenes of violence. Just as often they are portrayed as poised to strike, with the sword held high. They are an opportunity for vibrant color as well, since their clothes (kimonos) were sumptuous.

SAMURAI HELMET

The **SAMURAI** helmet is an image that can be used by itself in Japanese-style tattoo artwork. Although part of the total body armor that warriors used in battle, the helmets are distinct and can be highly ornamented. The helmet is made of metal and usually incorporates a back-flap that extends down over the neck, and the front of the helmet often includes a mask in the form of fierce demons, used to inspire fear.

SATURN

Saturn is easily the most impressive of the planets in our solar system, with its expansive equatorial rings. It has always been visible as a point of light in the **SKY**, but it wasn't until Galileo looked with his telescope in 1610 that the rings were first seen. Today, nothing calls the planets to mind more than this distinctive image. Whenever planets are used in tattoo art, it seems that Saturn is among them. In Greek mythology, the reign of the god Saturn in the early days of the universe was a sort of golden age. In astrology, echoing the planet's slow orbit around the **SUN** (twenty-nine years), Saturn embodies the principle of concentration and the power to rigidly make fixed the existing state of things, opposing change.

SATYR

Like the more famous example of **PAN**, the satyr is a man but with the horns, legs, and feet of a **GOAT**. Satyrs were portrayed among the followers of **BACCHUS**, the god of wine, and the associated drama festivals included bawdy farces known as "satyr plays" (the origin of the word "satire"). Satyrs were particularly known for their pursuit of sexual gratification, chasing after **NYMPHS** in the forest.

SCALES

Although it is much more common to have the image of an animal with scales (such as a dragon, a serpent, or a **FISH**) tattooed, more unusual tattoo designs will occasionally use only the scales. Here the wearer impersonates or emulates one of these creatures and perhaps also borrows some protective quality associated with it.

SCALES OF JUSTICE

Scales used for weighing and measuring are an acknowledged symbol for justice in many different cultures, for the very reason that they are instruments of measure and precision. In ancient Egypt, **OSIRIS** weighed the souls of the dead against a **FEATHER. MICHAEL**, the **ARCHANGEL** of the day of judgment, holds a pair of scales, and they are also noted in the Qur'an, to name just a few examples. The scales imply balance as well. Since souls are never unblemished, nor lives lived perfectly with a pure history of good deeds to be measured, it is instead hoped that the good will balance the evil.

SCARAB

The scarab, or dung **BEETLE**, is one of the most popular of ancient Egyptian tattoo designs. For the Egyptians it represented the **SUN**'s cycle and also resurrection since, in its daily activities, it rolled a ball of dung in front of it. Scarab designs will many times show the solar orb being rolled in the same way. Apart from ancient depictions of this end-

less cycle, the scarab could also be found in the form of jewelry, as an **AMULET** or talisman, and was sometimes shown with the spreading **WINGS** of **HAWKS**. In this sense the scarab symbolizes not only the hope of resurrection but also protection from evil.

SCARECROW

Devices for the farmer who could not be all places at all times, scarecrows were designed to look like the farmer. Placed near cultivated fields, they were intended to scare **BIRDS** (like **CROWS**) and other animals, keeping them away from planted seeds and crops. The scarecrow is popularly portrayed as a set of clothes stuffed with straw, with a bag for a head, wearing a hat, and hung on a pole or crude cross in an awkward standing position. Scarecrows in tattoo art tend to take on a decidedly more sinister and scary look, true to their name.

SCORPIO

Scorpio (October 23–November 21) is the eighth sign of the **ZODIAC**, with Mars as ruler. Pictorially, of course, this sign is shown as a **SCORPION**. As with other **ARROW** symbols, Scorpio is associated with the masculine and with dynamism. In ancient Egypt, a scorpion symbol was thought to offset the scorpion's venom and so represented healing and resurrection. People born during the influence of this astrological period are said to possess positive and negative traits related to strong emotions: persistence to the point of stubbornness and discernment that may turn to jealousy.

SCORPION

For obvious reasons, the venomous scorpion has long been associated with deadly menace, aggression, and the ever-present capability to kill. Although in mythology it sometimes exacts righteous vengeance, the scorpion's role is usually one of bringing death. But, like the deadly serpent, its very power also made it magical and gave it the ability to heal.

SCROLL

The scroll, resembling a white, horizontally flowing RIBBON, in tattoo art-work symbolizes the presence of an important message. Scrolls across, under, or above tattoo designs generally convey messages such as "Not Forgotten," "Mom," "DEATH BEFORE DISHONOR," personal names, initials, or dates, to name but a few.

SEAGULLS

In maritime tattoo, the seagull represented a SAILOR lost at sea. This is not unlike its symbolism in other contexts, where the mournful call has been taken as a sound of wailing or lamenting. In heraldry, the seagull represents a seaside community where these BIRDS dwell. But, like many birds, the seagull is also used to symbolize ascension and freedom.

SEA HORSE

The sea horse, like other creatures of the sea, symbol-izes the life of the OCEAN. Many sea horses are of diminutive size and tend to live among plants near shore, grasping them with their tails. In heraldry, the sea horse symbolized the power of the sea or bravery at sea, a cross between the sea environ-ment and the strength of actual HORSES. In tattoo symbolism, they can resemble the tiny and deli-cate varieties popular in FISH tanks or they can even take on some of the aspects of large ser-pents or even dragons.

SEAL

Seals and sea lions are those playful aquatic acrobats that are so graceful in the water but that need to live part-time on the land, since they are mam-mals. With their sleek dark bodies, they can dart about with great speed and they are benevolent and curious and thus of natural interest to hu-mans. The seal represents all of these characteristics as a symbol. In leg-end, it is thought that seals may have inspired tales of MERMAIDS.

SEASHELL

People the world over collect seashells because of their endless variety. In tattoo art, they sometimes accompany other OCEAN images such as sand, surf, or ocean animals. They obviously evoke thoughts of the sea. But in the symbolism of some cultures, seashells also have an association with life, even life after death, and also resurrection, possibly because of the abundance of life in the sea or the notion that life may have originated there. The scallop shell, for instance, is an emblem of Venus as well as the female sexual organ. In Christian art, the scallop shell often signifies pilgrimage, particularly to the shrine of St. James in Santiago de Compostela, Spain.

SEMPER FIDELIS

"Semper Fidelis," or the shortened version of "Semper Fi," is the U.S. MA-RINE CORPS motto. It is Latin for "Always Faithful" and is a popular accompaniment to other Marine images such as the ANCHOR and the BULLDOG. Like the words "DEATH BEFORE DISHONOR," the phrase can be used alone as well, but usually is not.

SETH

Seth, the eternal antagonist of HORUS, was the ancient Egyptian god of storms, disorder, and warfare. He represented the very necessary and creative elements of violence needed to create energy and life in the world and is sometimes also associated with chaos. He is shown in different variations but generally with a human body, slanting eyes, erect square-tipped ears, and a long, curved, pointed snout. He, like the other gods, also holds a staff and the ANKH.

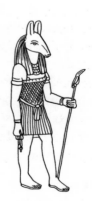

SEVEN

After THREE, one of the most significant and symbolic of the numbers must be seven. In all the major religions and many ancient cultures, it is sacred. From the Plains Indians to the ancient Sumerians and from the Maya to the Dogon, the number seven has had various special purposes. Today we have seven days in the week, seven deadly sins, the seven virtues, and even

seven colors of the **RAINBOW**, to name only a few occurrences of seven. In tattoo artwork, seven is a lucky number, as in the **DICE** game of craps, and usually depicted with other luck symbols such as a **HORSESHOE**, or four-leaf **CLOVER**, or even as three **SEVENS**.

SEVEN GODS OF GOOD FORTUNE

The *Shichi-fuku-jin* ("Seven Gods of Good Fortune") are very popular deities in Japan and a very popular motif in Japanese tattoo artwork, grouped together or done individually. They each control different aspects of happiness and every one must be given its just due if one is to be fortunate in all things. Frequently, they are portrayed in comical styles, emphasizing their happy nature, and each has its own special accountrements and magical tools. The seven gods are **BISHAMON, DAIKOKU, EBISU, FUKUROKUJU, JUROJIN, HOTEI,** and **BENTEN.**

SHAMAN

Images of shamans play a role in tattoo artwork emphasizing Native American motifs. The shaman was the spiritual leader and usually also the primary healer for a group. Shamans are not restricted to North America, and were present in many cultures throughout the world. Oftentimes, shamans effected their cures and exercised their powers on a different plane of consciousness, to which they had to travel, braving dangerous and sometimes malevolent forces or beings. Their work was linked to the supernatural, although the supernatural was understood by many peoples to be part of the world and everyday existence. As a group, shamans stood near the apex of their societies and yet somewhat outside, both courted and feared for their talents. Tattoos of shamans show them in their ritual regalia, with headdresses and perhaps various other objects of power.

SHAMROCK

The shamrock (from the Irish *seamrog* for seamar **CLOVER**) is a symbol based on clover, revered by the Druids as a sacred plant. It is a three-leafed design used as an emblem not only for the Irish and for Celtic culture but also later for the Christian Trinity. As such, it became an attribute for Ireland's patron

saint, St. Patrick, who has been represented killing a SNAKE with a cruciform staff topped by a shamrock. Despite the legendary "luck of the Irish," it is the four-leaf clover that is lucky and the three-leaf that is Irish.

SHARK

While many FISH in the sea are predators, the shark is particularly fascinating to humans perhaps because it is a threat to us. Shark tattoos emphasize their rows of razor-sharp teeth and the dorsal fin, which signals their presence when they are just below the surface. They are vicious when attacking and can be thrown into a frenzy by the scent of BLOOD. Both feared and worshipped in seafaring societies the world over, the shark has inspired tattoo artwork in many abstract and realistic forms.

SHEEP

In the CHINESE ZODIAC, people born in the Year of the Sheep are considered elegant and accomplished but are also afflicted with shyness and pessimism. In Christianity, the sheep, the GOOD SHEPHERD, and the LAMB all take part in the symbolism of peace and wholesome goodness, purity and protection. While people may count them in order to fall asleep, sheep also have the connotation of being easily led and acting unthinkingly like the rest of the group. In tattoo art, it is not just the white sheep that is depicted but instead, many tattoos use the black sheep, which is more rare in nature. The black sheep of any group, particularly of a family, is the disreputable member, the odd person out, or the singularly different individual.

SHIELD

In a tradition that reaches back to Medieval Europe, the shield is the main component of most heraldic devices and has its roots, of course, with a piece of military defense equipment. All manner of animals, colors, FLAGS, CASTLES, FLOWERS, crosses, and other symbols are included in a COAT OF ARMS and are displayed within the boundary of a shield. Shields used alone in tattoo artwork are frequently in recognition of family lineage or achievement.

SHIVA

Also known as Siva or Siwa, this Hindu god is one of great complexity. With his four arms outstretched and his one leg raised in the great cosmic dance

of creation and destruction, he is surrounded by **FLAMES** and wears a garland of **SKULLS** in the most famous depictions. He is a combination of opposites, both the destroyer and giver of life, a symbol of sensuality and also a conveyor of souls. In this same vein, he is also sometimes shown as a combination of male and female. While perhaps not a common tattoo in Hindu parts of the world where his image is considered particularly powerful, it is gaining in popularity in the West as knowledge of Eastern religions spreads and resonates.

SICKLE

The sickle or scythe is a shape that finds its way into tattoo artwork in different forms. As part of Communist revolutionary symbolism, the sickle of agriculture is paired with the **HAMMER** of industry. The **GRIM REAPER** uses one to collect souls. But no matter the particular use to which it is put, it is a tool of the harvest cycle and as such it becomes associated with both death and growth.

SIGNATURE

A signature takes on mainly two different meanings in the world of tattoo imagery. In most styles of tattoo, it is not customary for tattoo artists to sign their work. In the style of Japanese tattoo, however, the **HAN** or signature block can be integrated into a large design, usually in an inconspicuous spot. The other type of signature that occasionally occurs in tattoos is that of famous people, specifically as autographs that accompany portraits.

SÍSIOOHL (KWAKIUTL)

The Sísioohl (or Sisiutl) of the Pacific Northwest was one of the most frequently depicted of the supernatural characters. It is a double-headed serpent but with a horned, human head in the middle. The Sísioohl was central to the themes of the warrior, symbolizing power, strength, and invulnerability as well as the ability to cause death. The Sísioohl would come to the warrior at his command. Its body could act as a self-propelled canoe; its glare could cause a man to die by turning his joints backward. The **BLOOD** of the Sísioohl rubbed on the body of a warrior made him invulnerable.

SIX SIX SIX (666)

Although Christians and atheists alike have long debated the meaning of the number 666 (originally derived from Revelation 13:18, "the number of the beast"), the symbolic meaning that it typically carries today is one of demonic evil—a sign of the devil himself.

SIXTY-NINE (69)

The number 69 sometimes carries with it an erotic symbolic meaning derived from its appearance. The number 9 is visually the same as the number 6, turned upside down. Placed together, as in the number 69, they represent two people, facing each other, one inverted, in the act of simultaneous oral sex.

SKATE (HAIDA)

As with all traditional tattoo subjects of the Pacific Northwest, the skate (looking like a stingray) was not just a FISH to the Haida, it was a supernatural being. As such, it could only be destroyed through extraordinary means. If, for example, it were to be cut in half, it could simply reweave itself. However, if a whetstone were placed between the two halves, it would grind itself into nothingness.

SKELETON

The skeleton is a tremendously powerful symbol. It is the personification of death. Long after the body's flesh is gone, perhaps even for thousands of years, the skeleton remains, a simple reminder of the end to which we all come. But skeletons are rarely seen lying in coffins. In tattoo artwork, they are animated, dynamic, and acting very much as though they were alive. While at first these images might seem morbid or threatening, they are very much a part of religious symbolism and are used to celebrate the brevity of life.

SKINHEAD FIST

The skinhead FIST is an allusion to a white power or Aryan fist but with the letters "s-k-i-n" tattooed on the fingers. Skinheads are a fragmented group

of largely young people often depicted as physically fit, young white men dressed in blue jeans, T-shirts, and heavy steel-toed boots. Their dogma is one of white supremacy and violent intolerance. The shaved hair, as implied by the name, is a reaction against the hippie movement and also a pragmatic consideration, as it is impossible to grab in street fights.

SKULL

Of all the skeletal parts, the skull is uniquely human. Its symbolism, as with the **SKELETON**, is one of human death. Many organizations have used the skull in their symbolism, typically as a means of intimidation or fierceness. Many cultures have actually worshiped skulls as sources of power, displayed them as war trophies, and even used them as chalices for sacred drinks. In tattoo artwork, skulls are used as substitutes for all types of faces or heads, and even as beads on necklaces. They take on the same symbolism of the skeleton, as well as a *memento mori* (Latin for "remember you must die"), a reminder of mortality.

SKULL AND CROSSBONES

Unlike the more general symbols of death such as the **SKULL** and **SKELETON**, the skull coupled with a pair of crossed, long **BONES** has had specific meanings. In the seventeenth and eighteenth centuries it was used as the **JOLLY ROGER** among pirate seamen. And, as underlies all death symbolism, there is the notion of rebirth, on which the **KNIGHTS** Templar likely capitalized when they adopted the skull and crossbones as their symbol. In addition, the crossed bones have been interpreted as an allusion to the **CRUCIFIXION** of Christ. On a bottle, they symbolize poison.

SKY

Tattoos of the night sky with the **STARS, MOON,** and planets are a more popular use of the sky than daylight scenes. The daylight sky is not generally used as symbol in itself, but instead is part of larger scenes. It is not unusual to see the blue sky and **CLOUDS** as heaven, for example, or rays of

light projecting from the horizon to signal twilight. A dark and cloudy sky heralds something more serious and perhaps ominous as well. Symbolically, whether it represents heaven or not, the sky is part of higher spiritual thought, a sort of measure against which aspirations and possibilities are compared.

SMILE

The smile, or more specifically, the smiley face symbol, was first used in the 1960s in America and Europe. In general, a smile corresponds to happiness and welcome. From the counterculture of the 1960s, the smiley face was also linked with the type of ecstasy that could be created with a drug experience, such as that from LSD, or acid.

SNAIL

To move at a "snail's pace" is to move with some deliberation and to move very slowly. In its behavior the snail symbolizes unhurriedness, and it can also be associated with self-sufficiency, as it carries its house on its back. For the Aztecs and other cultures, the snail was a lunar symbol, with connotations of death, rebirth, and the cycle of life's spiral, like the snail's shell.

SNAKE

The snake takes a preeminent place in the world of symbolism and is especially popular in tattoo art. It holds fundamental associations with life and rejuvenation from the shedding of its skin, as well as death, since it is sometimes able to kill with a venomous bite. Dwelling underground, the snake symbolized the Underworld for many cultures, such as those in Egypt, Central America, and North America. In Norse mythology, a giant snake is wrapped around the EARTH, symbolizing the sea. In the CHINESE ZODIAC, people born in the Year of the Snake are considered quiet and wise, if vain. The biblical serpent of Genesis was the embodiment of Satan but was later put upon a pole by Moses to save his people, and finally interpreted as Christ himself, lifted upon a different kind of pole to save the world. Of particular importance is the snake biting its own tail (OUROBOROS), which stands for the cycle of eternal return, or for eternity in general. The snake is ever present in tattoo art as menacing predator,

coiled around the **DAGGER** in a position to strike, or languidly undulating across the skin, sometimes assuming a phallic symbolism or perhaps one of temptation. The great weight of the history of its symbolism draws tattoo wearers to it, and its use in a myriad of tattoo designs eventually reflects all of its symbolic variety.

SNAKE COILED AROUND DAGGER

The **SNAKE** and the **DAGGER** together are almost a direct translation of the two individual symbols combined. Although the snake is an incredibly complex symbol into which much can be read, here it is predominantly one of fighting ability, both stealthy (also suggested by the dagger) and deadly.

SNOWFLAKE

The snowflake is a crystal of ice, created in the atmosphere as **WATER** freezes. Many times snowflakes form hexagonal patterns, beautifully intricate and delicate, but no two are exactly alike. They have thus been used to represent individuality and also truth and wisdom. Although the ice is clear, tattoos of snowflakes and wintry scenes in general take on a blue color, a cool color, and one associated with water. A snowflake immediately calls to mind winter or high elevations and the associated cold and snowy landscape that accompany these.

SOMBRERO AND BLOODY DAGGER

The sombrero with a bloody **DAGGER** is a prison tattoo for the members of Nuestra Familia (Our Family), one of the oldest Hispanic prison gangs. Sometimes the tattoo is also flanked by the letters "N.F."

SPADE

Although the word "spade" today is mostly used as a synonym for a shovel, the suit in playing cards is more likely derived from the Greek word for **SWORD** (*spatke*). As a suit in a deck of playing cards, spades are associated with fighting, destiny, and death. In the tarot deck, they are actually the pictorial sign for sword.

SPARK PLUG

A spark plug tattoo might be used among engine, auto, or **MOTORCYCLE** enthusiasts but its symbolism is more widely understood. The spark in the image, the **HALO** of light or starburst that surrounds the small device, tells the viewer that a sudden and intense release of energy is happening. In the engine, the spark plug fits into the cylinder head and provides the spark that ignites fuel, beginning a controlled explosion that drives a piston, creating movement. If the engine is the power plant and heart of the machine, the spark plug is the electric firing that begins the whole process. Tattoo images capitalize on all these associations, sometimes combining them with a checkered **FLAG** to emphasize a racing win or personifying them with faces. Most often, though, they show the act of sparking and providing raw energy and power.

SPEAR

More than just a weapon, the simple linear and sometimes upright form of the spear makes it an axial symbol, a center around which other forms revolve, and also a phallic symbol. Famous spears include the one used to pierce the side of Christ as he was crucified or that carried by Achilles, which could heal what it had wounded. They were used as symbols of strength, awarded for bravery, and at times also denoted kingship.

SPHINX

The sphinx is a mythical creature with the crouching body of a **LION** and a human head, best known from the monumental ancient Egyptian sculpture at Giza, but also known in Greek myth. At Giza, the sphinx bears the head of the pharaoh Chephren (ca. 2600 B.C.E.), symbolizing his superiority and invincibility. The female sphinx of Greek tradition challenged travelers near Thebes to solve her riddle, consuming those who could not. It was finally Oedipus who was able to provide the answer to her question: What is it that has one voice and yet becomes four-footed and two-footed and three-footed? The answer is man, who crawls on all fours in infancy, walks on two feet when grown, and leans on a staff in old

age. The sphinx immediately killed herself upon hearing the correct answer and in the Greek form is associated with proverbial wisdom and the desire to answer the riddle of human existence, with which humanity is constantly faced.

SPIDER

Most cultural traditions perpetuate the image of the spider as a treacherous creature that cannot be trusted. It sits on its web, waiting to entrap prey, and may even kill its own spouse, as in the case of the **BLACK WIDOW**. By and large, this is the symbolism on which most tattoo artwork of spiders is based. Of course, there are exceptions to this rule, such as in West Africa, where there are many amazing tales of the spider as a hero and champion of mankind, a cunning trickster who gives mankind corn and the hoe. According to the Greeks, the young girl Arachne was so gifted at the art of weaving that she dared to challenge the goddess Athena to a contest. While Athena wove majestic portraits of the gods and their punishments of mortals, Arachne wove the loves of the male gods for mortal women. In response Athena flew into a rage and struck Arachne with her shuttle. Arachne tried to hang herself but Athena saved her and changed her into a spider, ever dangling at the end of her thread. Arachne's was the fate to which humans were doomed if they dared to challenge a god.

SPIDER WEB

The **SPIDER** web tattoo design, often found on the elbow, shoulder, or under the arm, is sometimes used as a symbol of prison time. In some groups, it is also reputed to show that the wearer has killed someone, perhaps a minority. In Japanese tattoo, the delicate and detailed web may also appear in the underarm hair. In Japan, the spider has the dual symbolism of good luck if seen during the day and bad luck if seen at night. The need for the spider to create something of beauty in order to kill and survive is a contradiction not unlike others presented in Japanese tattoo art.

SPIRAL, CLOCKWISE

From primitive rock art to Grecian frescoes, from Zuni Pueblo to Tibet, spirals are symbols known in every culture worldwide. As such, they take on many varied meanings, but the great majority of these center on grand

themes of cosmic energy or the movement of the soul along a universal path. The clockwise spiral is a fundamental element that is strongly associated with strength, movement, power, and also WATER. It gives the appearance of motion, rotating outward from the center and expanding, and also seemingly growing. In Japanese tattoo, it is representative of swirling wind.

SPIRAL, CLOCKWISE TRIPLE

The clockwise triple spiral is related to the Celts. It is a type of triad or TREFOIL, and may result from the use of the number THREE in their culture: three main deities, three war goddesses, three queens of Ireland, the three kings, and the three realms of the Celtic cosmos—heaven, air, and EARTH. In a grander scheme, a passage through time is implied in past, present, and future. On a more practical level, it also suggests a tripling of power.

SPIRAL, COUNTERCLOCKWISE TRIPLE

Also known as the triskele or the spiral of life, the original version is simply a depiction of three legs in counterclockwise rotation. Like the CLOCKWISE TRIPLE SPIRAL, the counterclockwise version was associated with the Celts, and is also associated with the Isle of Man, the island between Great Britain and Ireland, in a stylized version of the TRISKELION. In this context, it may have much the same symbolic meaning as the clockwise triple spiral, as variants of each other. It was adopted by the early Christian church as a symbol of the triune god. It has also been broadly interpreted as a representation of multiple travels, or migrations, and multiple returns or homecomings, in keeping with the symbolism of the single counterclockwise spiral. Both the clockwise and counterclockwise versions are used in Celtic tattoo designs.

SQUID

"Squid" is a nickname for submariners and it is not unusual in maritime tattoo to see a squid that stands for a submarine SAILOR. The squid is the subject of other tattoo designs as well, though, whether part of sea scenes

or as an individual portrayal. Sometimes drifting and other times darting around, the squid can reach an enormous size and also can be found in deep water. It is thought that myths of sea monsters may have their foundation in the observation of these larger species. Little is known of them, however, and for OCEAN-goers they rightly represent some of the mystery of sea.

Although the squid was a traditional Haida tattoo, we do not know its significance in traditional Haida culture, except to say that it was not used as a family crest (as are so many other designs). For the nearby Nootka people, however, the squid was the first master of fire. In their tale, the DEER steels fire from the squid (he lives both on land and in the sea) and gives it to mankind. The tattoo itself, like other historic tattoos of this region and era, is essentially line art, curved and flowing but simple. It shows the squid with two eyes, a mouth, and two curved arms and legs.

SS LIGHTNING BOLTS

The *Schutz Staffeln*, or SS, was formed within the Nazi party as a protection unit at a time when it was subject to physical resistance from other political parties. The LIGHTNING bolt symbol is similar to the capital letter "S" as well as to Nordic RUNES. In the runic alphabet the "s" character has become associated in Germanic countries with sun, strength, battle, victory—words that all began with an "s" in the old Scandinavian language. Although not a rune, a single lightning bolt is sometimes referred to as the victory rune.

STAR

Of course the most notable aspect of a star is the light that it exudes. Many are the examples of churches, caverns, and even tombs with stars painted on the ceilings. Their place in the dark night SKY as symbols of heavenly beauty is also the source for their associations with hopes, dreams, and inspiration. They are also sometimes associated with the souls of those who have died and they figure in many ancient cultures and religions as omens of great import. The star in tattoo is done in many different styles and can be a straightforward five-pointed star with radiating beams of light or something more abstract, as if seen through rippled glass. But bright yellow light is almost always one aspect of the design.

STARFISH

Although at first glance the starfish appears to be a symbol of the wealth of marine life and life in the OCEAN in general, it also has some specific symbolic associations. In Europe it became a symbol of the undying power of love and in Christianity it symbolized Mary as she guided her followers through the storms of love. Part of these associations may stem from its resemblance to a STAR and also the ability of some species to regrow a severed arm.

STAR OF DAVID

The HEXAGRAM has been associated with Judaism and the Jewish kingdom for at least 2,000 years and today appears on the FLAG of Israel. The six-pointed STAR is actually composed of two equilateral triangles, one pointing up and one down. In this basic geometric sense, it can be seen as the union of opposites, a simple unity that at the same time results in something complex.

STAR OF ISHTAR

The eight-pointed STAR has been a symbol for Ishtar, or the Venus goddess, since approximately 2000 B.C.E. in the area of ancient Babylon. Ishtar was the queen of the heavens and also the goddess of fertility and childbirth. The two four-pointed stars, one behind the other, totaling eight points, refer to the eight years it takes for Venus to return to the same place in the ZODIAC. Today, the symbol appears on the FLAG of Iraq, the modern country of the Euphrates-Tigris region.

STARRY NIGHT

The Starry Night is arguably one of the most famous paintings of Vincent Van Gogh, and is well known in the art world. Like other great paintings and sculptures, this image or portions of it have been reproduced in tattoo artwork. The swirling yellow STARS in the blue night SKY that seem to ro-

tate over a quiet village are a disquieting view of what should be a peaceful scene. The painting was done only thirteen months before Van Gogh committed suicide, a reminder of the struggle with mental illness that he faced until his death at the young age of 37.

STATUE OF LIBERTY

A globally recognized symbol of the United States, the "lady with the torch" and the CROWN of sun's rays stands on Liberty Island in New York Harbor. A gift from France in 1886 commemorating the friendship between the two countries, she has been called the Mother of Exiles and she stands today as a symbol of liberty, freedom, independence, and hope. For many immigrants, she also represented their aspirations for a new home and new beginnings.

ST. DIMIAN

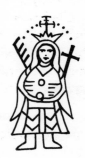

St. Dimian is a fourth-century Coptic saint who wears the traditional dress that was common in Upper Egypt. Though the daughter of a chieftain there, she converted to Christianity and was eventually martyred for her unpopular faith. She is also shown wearing a CROWN with a HALO and holding a palm BRANCH and cross.

ST. FRANCIS

Among the Catholic saints, St. Francis of Assisi is often shown with small BIRDS as they fearlessly alight on his hand. His association has therefore been extended to beloved pets. He is mostly known within the church for founding the Franciscan orders, whose hallmarks are consecrations to poverty and charity.

ST. GEORGE AND THE DRAGON

Although George is the patron warrior-saint of England as well as the order of the Garter, his exploits took place in the Holy Land sometime in the third century. In the most famous legend, he rescues a Libyan king's daughter

from a dragon, slays it, and as a reward asks that the king's subjects be baptized. It is a theme much represented in art, both Western and Coptic, and the saint is frequently portrayed as a youth wearing **KNIGHT**'s armor with a scarlet cross. In Coptic tattoos, his distinctive characteristics are those of the armored uniform, shown mounted on a **HORSE**, and attacking a dragon with a lance or **SPEAR**.

STIGMATA

The stigmata are the marks that appear on a person's body corresponding to those suffered by **JESUS** at his **CRUCIFIXION**—namely on the hands or wrists and feet (from being nailed to the cross), in the side (from being pierced by a **SPEAR**), at the head (from the **CROWN** of thorns), the shoulders (from carrying the cross), and on the back (from being whipped). They are generally assumed to accompany higher realizations of spirituality among Christians such as **ST. FRANCIS** of Assisi, who gave the first report of the miraculous occurrence on his own body. Stigmata tattoos generally appear on the feet and at the wrists, resembling bleeding and open wounds.

STORK

The stork is most frequently associated with the bringing of babies, dangling from slings suspended from their beaks. In history the stork has often been associated with good fortune, owing partly to its ability to kill **SNAKES** and also its link with **WATER**, which is always a life-giving symbol. In the East, the stork is a symbol of longevity and also familial love and devotion.

ST. PETER'S CROSS

St. Peter's cross is named after the famous disciple of **JESUS** and the first pope of the Catholic church. He was reportedly martyred on a cross that was turned upside down. His killers felt that he was not worthy to be crucified in the manner of his lord.

STUPA

The stupa is a small, hemispherical temple building built in Buddhist parts of the world. It has been symbolized by a creative ideogram in the West

that appears as a kind of stack of other symbols. At the base is a **SQUARE**, representing the **EARTH**. On top of the square is a **CIRCLE**, which symbolizes the element of **WATER**. Next is a **TRIANGLE**, which is fire. Balanced on the point of the triangle is a crescent shape, or chalice, turned upward, symbolizing air. Finally, at the top, in the bowl of the crescent, is a **FLAME**, representing ether or the fifth element. It is essentially a portrayal of the organization of the universe, ascending in levels of existence or planes, culminating in release.

SUIKODEN HERO

The *Suikoden* (Japanese for *The Water Margin*) is actually a Chinese folk story that became popular in Japan when it was translated into Japanese in the eighteenth century. It tells the tale of 108 hero-outlaws in their exploits against oppressive and corrupt rulers, a la Robin Hood. Its importance to tattoo, however, was realized in 1827 when a series of illustrations based on the heroes of the novel were done by an up-and-coming artist named Utagawa Kuniyoshi. Some of the heroes themselves are tattooed while others can be recognized by a particular scene or setting. These popular images inspired tattoo artwork that imitated that of the heroes, and also reproduced the artwork of Utagawa Kuniyoshi, creating tattoos of the tattooed characters. Much of Japanese tattoo finds its genesis in this period and the images first created then are still common today in traditional Japanese tattoo motifs.

SUN

Countless religions and cultures have used the symbolism of the sun, the dominant and supreme heavenly body in our **SKY**. As it destroys the darkness and ushers in the new day without fail, it has always been associated with not only light and energy but also life and life-giving force. The essence of any solar design is a **CIRCLE**, or solar disk, many times surrounded by rays of light. Solar deities and solar cults in virtually all parts of the globe and in all time periods are universally associated with the highest and best in any situation. Sun tattoos are a very popular type of tattoo, often used in combination with the **MOON**, thus expressing totality. In either form, they are sometimes given a face and even limbs or they may be completely abstract and filled with spirals. The hot colors of yellow, orange, and red are common.

The sun does not figure prominently in Pacific Northwestern mythology, although it was a major crest for some Haida families. The sun is shown as a round, humanlike face, usually surrounded by a **HALO** or fringe of points, denoting rays. A **BIRD** beak, usually like that of the **HAWK**, might jut from the face. As in other cultures, it represents life's abundance and its warmth radiates healing and peace.

SUNFLOWER

As a result of its sun-ray pattern of petals around a large circular center and the way it will turn to follow the **SUN** throughout the day, the sunflower is aptly named. Brightly colored and easily identified, it is suited to tattoo artwork as both a type of floral pattern and as a type of sun symbol. It represents constancy and, in the same vein, is part of a Greek myth where a young maiden (Clytie) pines away for the sun god (Helios), sitting outdoors gazing after him daily and turning her face toward him constantly, until at last she is changed into a sunflower.

SUN WHEEL

The sun wheel, also known as the ring cross, the **WHEEL CROSS**, and sometimes as a shortened **CELTIC CROSS**, was a well-known symbol in Northern Europe but also common in ancient America and in parts of the Mediterranean. Because of its ancient use in Nordic regions, it has received renewed attention from modern fascist and Nazi organizations. The combination of **CIRCLE** and cross led to its use in Christian art to represent a **HALO**. In prehistory it was likely a type of **SUN** symbol, with an association of power. In tattoo art, these sorts of details in the design will dictate the specific meaning that it is given.

SUPERMAN LOGO

The stylized red "S" inside an inverted **TRIANGLE**, with the top corners clipped, is taken from the popular comic strip character Superman, who wears it proudly on the chest of his caped costume. Many times in tattoo art, the logo is modified in terms of either color or the letter. But no matter the changes, bearers of this logo are clearly associating themselves with

some lofty or superhuman attributes, including not only strength and speed but perhaps also strength of character.

SUR

In the world of prison tattoo, almost any part of a convict's past can play a part in the effort to create self-identity in the midst of the group. The initials "SUR" stand for "Southerner."

SWALLOW

For the most part, the swallow is a symbol of good luck and is a favorite **BIRD** in traditional tattoo design, typically done in blue or red and also commonly appearing in pairs. The earliest source of this symbolism likely lies in the bird's association with the coming of spring. The swallow is also associated with homecoming and resurrection, likely attributes derived from its natural behavior. It is not uncommon to see the swallow tattoo accompanied by **NAUTI-CAL STARS**, another traditional or old-school tattoo associated with homecoming. In addition, early sailors received a swallow tattooed on each side of the chest to show that they had travelled five thousand miles. The chest placement for two swallows remains a popular one today.

SWAN

The swan is a **BIRD** that has been laden with multiple layers of meaning throughout the centuries. Its overwhelming symbolism, though, is one of grace and purity, taken from the sweep of the neck and the white plumage. Said to be prophetic, swans would even see their own death and give a mournful cry, a legend that is the source of the saying "swan song." They have been associated with various gods (Zeus and Apollo) and their cry was also thought by Christians to symbolize the pure Savior as he cried out from the cross.

SWASTIKA

It is unfortunate that the swastika (from the San-
skrit word for "well-being") was adopted as a politi-
cal symbol by Adolf Hitler and Nazi party from
1935 to 1945. Because of that short period, it has
come to be one of the most heinous and offensive
symbols recognized today. And yet, that modern
connotation belies the positive symbolism that pre-
ceded it for millennia. Known from North America
to China and used by the Celts and ancient Greeks,
it is based on the simple cross. But, with ends bent, the cross takes on a
sense of movement. In the Buddhist tradition of India it is referred to as
the "seal on BUDDHA's heart" and decorates his chest and also the temples.
It is the central and revolving wheel in ancient religions, the whirlpool of
creation, the cycle of the universe, and the crux.

SWORD

The sword is a symbol of the warrior but principally a warrior of virtue,
even righteousness and justice. It has long been a symbol of power, espe-
cially in heraldry, and in some cultures skill with the sword was considered
an art form. In myth, swords are oftentimes the gift of the gods to special
individuals or are magical in some way, as with Excalibur, the legendary
sword of King Arthur. In tattoo artwork, it is not uncommon to see swords
done in fairly elaborate designs, perhaps jeweled with ornate handles, and
even specific to a certain culture.

SWP

Among white supremacists, the SWP tattoo is yet another identifier, al-
though not specific to any particular group such as the Ku Klux Klan. It
stands for "supreme white power."

T

TAMATORI-HIME

The Tamatori-hime is the Japanese diving girl who
cavorts with a dragon while brandishing a **SWORD**.
Unlike **KANNON** and **BENTEN**, she is beautiful but
also overtly sexy, sometimes topless but almost
always wearing a tight wraparound skirt. She is a
pinup girl who has been used in traditional Jap-
anese tattoo to the point that she carries some
of the respectability of this ancient art form, illus-
trated by the likes of Utagawa Kuniyoshi, the same
artist who popularized the **SUIKODEN HEROES**.

TARANTULA

The tarantula takes on much of the symbolism of the larger group of
SPIDERS of which it is a part. But, with its slow movement, distinct hairy ap-
pearance, and the fact that it doesn't usually spin a web and is generally
harmless, the tarantula has found a home for some of its own symbolism in
Native North American folklore involving "Old Mother Tarantula," who is
a helping figure to mankind.

TAROT CARDS

The symbolism of the tarot cards is ancient and could easily fill an entire
book itself. Their true origin is unknown but they are found as early as the
fourteenth century in Europe. Used today for fortunetelling, they likely

began as a regular deck of cards for games. In tattoo art, the themes from the cards are borrowed and at times the cards themselves are even reproduced. With images such as the magician, the EMPEROR or EMPRESS, the lovers, death, or the FOOL (to mention but a few from the major arcana portion of the deck), the imagery and symbolism are rich and yet specific. Their iconography is a mixture of personages and items, colors and numbers, with Medieval, Christian, and occult overtones.

TASMANIAN DEVIL

Although cartoon characters make up a large part of the tattoo designs that are done, only a few are discussed here. The Tasmanian Devil is a very popular character where the Bugs Bunny animated cartoons are shown and he is present everywhere in the tattoos of the United States. Perhaps wearing a SAILOR hat, or holding a pint of beer, or wearing a Hawaiian lei, he is easily customized. His defining characteristic is his whirling and tornadolike mode of travel, eating any animal in his path. But his appeal lies in the fact that all of this is done without malice. He is a tremendous force of animal energy that is instinctual and not planned or plotted. In fact, he is somewhat of an innocent, easily and often duped by the clever Bugs Bunny.

TAURUS

Taurus (April 21–May 20) is the second sign of the ZODIAC, located between equinox and solstice. Pictorially, Taurus is represented by the BULL, and in keeping with this image, it is linked with an animal nature, a lust for life, and a capacity for work. People born during this astrological interval are said to be dependable and practical but also possessive and obsessive.

TEARDROP

The teardrop tattoo placed just at the outside corner of the eye has several meanings in prison. In general it shows that time was served and that it was indeed a sorrowful time. It has also been used specifically either to commemorate a loved one who died while the prisoner was serving

time or to symbolize the number of people that a person might have killed.

TEDDY BEAR

The teddy bear has been an enduring stuffed animal toy for children from its inception up to the present day. Given as toys or tokens of affection, they offer a sense of comfort and soft cuddliness. They are named after Theodore "Teddy" Roosevelt, the twenty-sixth president of the United States. On a hunting trip in 1902, he refused to shoot a small cub, inspiring a group of toy makers. The toys became an instant success and spread worldwide. Teddy bear tattoos have the same wide variety as that of stuffed animals and they generally retain cute and childlike characteristics.

TETRAGRAMMATON

The Hebrew consonants "YHWH" spell the name of the God of the Israelites as revealed to Moses (also given as Yahweh). Although it was eventually considered too sacred to speak, it has not escaped use in tattoo artwork and is typically done in Hebrew letters.

TEZCATLIPOCA

Tezcatlipoca (*Tezcatl* = "mirror," *popoca* = "smoking") was the Aztec god of warriors and the avenger of misdeeds. He was also a wizard and a master of black magic who was usually depicted with a black stripe across his face or a mirror on his chest, in which he saw all deeds and thoughts of humankind. Human sacrifice was introduced into central Mexico through his cult. For one year before they were to be sacrificed to *Tezcatlipoca*, young, handsome men were chosen to live in luxury. At the end of that year, during the fifth ritual month (*Toxcatl*), they climbed the steps of a temple and were sacrificed by having their hearts cut out. In a sense, *Tezcatlipoca* (symbolic of the night, north, and winter) is an opposite and a complement to QUETZALCOATL (symbol of the morning and evening stars, learning, and the east).

THIRTEEN AND A HALF (13½)

The number 13½ is a prison tattoo that stands for the judge (1), the jury (12), and the "half-assed" sentence.

THOR

Thor, the Germanic word for "thunder," was a favorite god amongst the ancient Nordic peoples of Northern Europe. He is generally shown as a red-bearded warrior of great strength, wielding his famous **HAMMER**, a symbol of the **LIGHTNING** that accompanies thunder. Considered the son of Odin, the greatest deity in the Nordic pantheon, he was a proponent of mankind, a saving hero, and he achieved quite a bit of popularity. The tattoo of Thor is immediately recognizable since he always bears the hammer and wears the traditional dress of a **VIKING** warrior, notably the heavy helmet. He is also sometimes depicted riding over the **CLOUDS** in a chariot drawn by two **GOATS**.

THOR'S HAMMER

Apart from a three-dimensional depiction of the Mjölner (Thor's hammer) that might accompany a design with **THOR**, the Mjölner is frequently a two-dimensional decorative motif that was used for hundreds of years during the **VIKING** era, and recognized as a symbol of pre-Christian religion. It was worn as an **AMULET**, found on **RUNIC** stones, and carved on monuments and could be quite ornate. The **HAMMER** itself was forged by dwarves and used to battle giants, and it had many marvelous qualities, including that of returning to the thrower like a boomerang.

THOTH

Thoth is the **IBIS**-headed Egyptian god of writing, the great scribe and adviser of the gods. It was Thoth who weighed the **HEARTS** of the deceased at their judgment and reported the results to **OSIRIS**. He is shown with the long, downward-curved beak of the ibis, holding in his hands the scribe's pad and stylus, poised in writing.

THREE

Undoubtedly, three is the most symbolically significant of all the numbers. For Hindus, the manifestation of the godhead is threefold as Brahma, VISHNU, and SHIVA, while for Christians it expresses the perfection of the divine unity of three persons into one God. For Buddhists there are the Three Jewels of the BUDDHA, the dharma, and the sangha. We can also look to the fundamental aspects of existence such as past, present, and future; or body, mind, and spirit; or even birth, growth, and death.

THREE DOTS

Hobos in every part of the world used graphical symbols to leave messages for one another, frequently having to do with the potential for good begging in the vicinity. The symbol that consists of three DOTS arranged triangularly and tattooed on the skin between the forefinger and the thumb is known as hobo dots in Sweden and has a protective significance. The three hobo dots are said to represent faith, hope, and love. In recent times, in the United States, it is a tattoo associated with Latino gang membership.

THREE ONE ONE (311)

The number 311 is another way of representing the Ku Klux Klan, or the KKK. The eleventh letter of the alphabet is the letter "k" and three times eleven equals "KKK." It can either demonstrate group membership or sympathy with their racist ideology.

THREE SEVENS

More than just a single SEVEN, the three sevens are especially lucky, emphasized by the important number THREE. It is also the case that three sevens on a slot machine are typically a win.

THREE WISE MONKEYS

The origins of the three MONKEYS who "see no evil, hear no evil, speak no evil" are not clear. They are most notably associated with Japan, particularly with a centuries-old carving at the shrine of Nikko. However, they were likely introduced to Japan from China by a Buddhist monk sometime

in the seventh century C.E. In this original import, the monkeys reportedly were associated with the blue-faced deity Vadjra and espoused the belief that if we do not see, hear, or speak evil, we too will be spared evil. In more modern interpretations, they represent an attempt to remain uninvolved in order to escape evil situations.

THUNDERBIRD

The thunderbird is a mythical animal that is known to several Native groups in North America. It is a **BIRD** of enormous strength, a powerful spirit from whose beak **LIGHTNING** flashes and whose beating **WINGS** create thunder, true to its name. In many designs, the wings are outstretched to the side of the body, as though the bird is in flight and ascending. Other details vary according to the aesthetic sense of the particular culture that uses it.

THUNDERBIRD (PACIFIC NORTHWEST)

The **THUNDERBIRD** is one of the better-known figures of Pacific Northwest mythology and one of the more popular images in tattoo design. Living in the mountains, the thunderbird was huge and powerful, able to catch and lift a **KILLER WHALE**. The ruffling of its **FEATHERS** produced thunder. The opening of its eyes produced **LIGHTNING**. The distinguishing marks of the thunderbird are the exaggerated horns and the massive, curved upper beak over a curved lower one. The talons and legs are emphasized to a greater degree than for other **BIRD** forms and the wings are usually extended straight out in a powerful pose.

THUNDERBOLT

Thunderbolts are typically the weapons and the great display of the gods, with the force to both create and to destroy. From Zeus to Indra to **THOR**,

the **LIGHTNING** bolt accompanies both judgment and battle, and for the Maya it even represented the written word of god. In heraldry the bolts are sometimes gathered like a group of **ARROWS**, another reference to weapons. In folklore, they are a sudden and chaotic expulsion of energy from the heavens, producing all manner of unusual and magical results, including fire.

TIGER

The beautiful and the dangerous may find no more perfect union than in the tiger. It is the ideal animal symbol of strength, ferocity, and jungle wildness. Its preeminence among the big **CATS** and all feline hunters makes it a symbol of warriors and elites. In the Far East it is considered the king of all animals. Its distinctly striped coloration, alternating black and orange, with white in the face and underbelly, makes it a fascinating subject for tattoo design, one that is often done in full color. In the **CHINESE ZODIAC**, the tiger is the third sign and people born in the Year of the Tiger are as mercurial as their symbol: short-tempered and yet capable of great sympathy, prone to suspicion but also full of courage and power. In Chinese mythology, the tiger is sometimes considered the opposite of the dragon.

TIKI

The word *"Tiki"* comes from the Maori culture of New Zealand as well as from the people of the Marquesas. In both of these references, Tiki is chiefly interpreted as the name of the first man. Eventually, though, Tiki came to be more widely associated with humanlike carvings from stone or wood that resembled a small **TOTEM POLE**, which were imbued with supernatural, especially procreative, power.

TOGETHERNESS

The two intersecting **CIRCLES** are a symbol for togetherness, where each circle represents an individual. Variations on this theme include combining the symbols for **MALE** and **FEMALE**, and the **LESBIAN LOVE** and **GAY LOVE** symbols.

TOMAHAWK

From the Algonquin *otomahuk* (to knock down), the tomahawk was the war **AX** (and **TOOL**) of the Native American peoples of eastern and central North America. It symbolized war, as did certain clubs, and to "bury the tomahawk (or hatchet)" had the ritual and symbolic significance of ending hostilities and beginning a peace accord.

TOMBSTONE WITH NUMBERS

While a tombstone with a name is typically done **IN MEMORIAM**, a tombstone done strictly with a set of numbers is a prison tattoo that shows the number of years of jail time that have been served.

TOOLS

Tools are many times reflective of either occupations or hobbies. Examples such as the wrench or screwdriver are typical in terms of tattoo designs, either of which might be associated with working on machinery or engines. Tools could more generally be thought of as symbols of the working person or even of those who work with their hands.

TORII GATE

This famous landmark symbol of Japan, when used in tattoo art, is generally in the company of other symbols of Far Eastern religion and philosophy. The torii is a symbolic Shinto gateway, an entry into a sacred space or point on the landscape. Often done in red, an important symbolic color, they are spread throughout Japan but probably originated in China and perhaps, before that, in India. The torii gate symbolizes a separation between the mundane world and the divine and, furthermore, an actual movement from one to the other in the landscape.

TORNADO OR HURRICANE

The tornado and hurricane are two of the most awesome displays of power in nature. But, as can be seen in the use of **LIGHTNING** or **THUNDERBOLTS**, these aspects of the natural world project something into the human con-

sciousness that outweighs their effect. The tornado or hurricane can be extremely destructive and frightening. In some religions, the gods make themselves known in the form of a whirlwind, which can also be a means of transportation, a connection between heaven and **EARTH**. But it is overwhelmingly the destructive and threatening aspect that is stressed in tattoo artwork. Often depicting furiously spinning funnel **CLOUDS** with all manner of objects lifting off the ground, these tatoos sometimes also have a face or arms added to the funnel.

TOTEM POLE

Although "totem" is an Algonquin term, the totem pole is part of the rich traditional cultures of the Pacific Northwest. The word "totem" refers to a guardian or ancestral being, usually supernatural, that is revered and respected. The animal totems thus identify the lineage of the family or household and they are displayed as a type of family crest. The pole may present several animal and human forms, stacked one on top of another, carved along the length of the pole. Each image has meaning and when put together they become part of a story or myth. But the actual meaning of any group of images is nearly impossible to know, unless told by a member of the family.

TOUCAN

The toucan is a native of the tropical climates of Central and South America. Their enormous and brightly colored, canoe-shaped bills contrast sharply with their generally black-feathered bodies. Perhaps more than any other **BIRD**, the toucan represents the rich and varied wildlife of the American tropics, including the Amazon.

TREBLE CLEF

In **MUSICAL NOTATION**, the treble clef is also known as the G clef because it looks like a fancy "G" and because it circles the second line of the musical staff, which is the location of the G note. It is a symbol that is most apt, of course, for musicians as well as music aficionados. The **BASS CLEF** is also done as a tattoo, but less frequently.

TREE OF LIFE

Like the spiral or **MANDALA**, the tree of life is a symbol that has arisen in many parts of the world. From the Nordic version, **YGGDRASIL**, to the Tree of Knowledge in the Garden of Eden, and also the **BO TREE** under which the **BUDDHA** was awakened, the tree of life serves to connect the human with the divine, the earthly with the heavenly, the mundane with the spiritual. Its symbolism is deep and varied but most of the themes revolve around life, growth, and regeneration, as well as a sense of connection.

TREFOIL

The **TREFOIL** is composed of three joined **CIRCLES**, although the center of the image is empty. It emphasizes the number **THREE**, important in many different religions and cultures. In Christian contexts, of course, it stands for the Trinity (Father, Son, and Holy Spirit), and it has been a popular architectural element in church stonework and windows.

TRIANGLE

The symbolism of the triangle naturally draws upon the symbolism of the number **THREE**, but it is also a fundamental geometrical figure. It is used in a wide variety of contexts. Inverted, it has been used to symbolize the female, and upright it can be associated with fire. It also contains the **ALL-SEEING EYE** and is part of the **ILLUMINATI** symbol as well. For the ancient Maya it was a **HIEROGLYPH** for the sun-ray, and two overlapping **TRIANGLES** in opposite directions form the **STAR OF DAVID**.

TRIBAL

The tribal tattoo was undoubtedly one of the most popular types of tattoo done in the 1990s. While many different peoples and cultures in history,

many of them tribes, have practiced tattoo, the word "tribal" applies to them only loosely for this style. The modern "tribal" tattoo style is not taken from any one specific area or group of people and yet it is reminiscent of many due to its bold and solid black patterns, much like those of Polynesia and the Pacific. Rather than easily recognized symbols or figures, tribal tattoo art relies upon sweeping solid curves with sharp points, as well as the untattooed spaces left in between the black curves, to form intricate patterns. However, the tribal style can be applied to any type of image and can and has been used to portray everything from **ROSES** to **JESUS**.

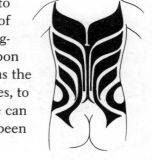

TRIBAL MASK

In many early societies, the mask was a ritualistic way for the wearer to summon and even become a supernatural being. In warfare, masks could mark allegiance but also be used to intimidate an enemy. In the East, the world itself is but a mask of God, while in theatrical traditions masks are a way to remove the persona of the actor, allowing the viewer to identify more closely with the character.

TRIDENT

The trident, the triple-pointed **SPEAR**, is actually an early fishing tool. It has, however, also been used as a weapon by both Roman gladiators and the gods of the sea. It is the emblem of **POSEIDON** and also of **SHIVA** (for his **THREE** aspects) but it is also sometimes put into the hands of the Christian **DEVIL**, as a means of torture.

TRIQUETRA

The triquetra (Latin for "three-cornered") is an ancient Celtic design that emphasizes the all-important number **THREE** and also the **TRIANGLE** form, but it is done in the endlessly looping and interweaving **KNOTWORK** style typical of the Celts. Like the **TREFOIL** it has been used in Christian symbolism to represent the Trinity. The particular resemblance of each leaf to the **FISH** symbol used to represent **JESUS** has also led to the interpretation of the triquetra as three fish symbols combined.

TRISKELION

The triskelion (Greek for "three-legged") or triskele is an old symbol, dating to at least the Bronze Age and known from a **SHIELD** design in Athens as well as the walls of Irish megaliths. In a strict sense, it is composed of **THREE** legs bent at the knee in a spiral formation, usually within a **CIRCLE**, and is associated with rotation. It easily transforms, however, to more abstract designs of three spiraling elements such as the **COUNTERCLOCKWISE TRIPLE SPIRAL**. As with other triple symbols, it has been absorbed into Christian iconography as a Trinity symbol.

TROUT

The trout possesses symbolic significance as a Celtic figure of knowledge and power and even a Celtic goddess known as Ban Naomha, who swam in the sacred well of the **SUN** and could answer questions with her gift of second-sight. In tattoo art, though, the trout is essentially representative of a favorite pastime, sport fishing. Shown in the various colors of the different species (such as the golden or rainbow trouts) and often accompanied by **WATER**, there is sometimes also a lure or fishing line in the scene.

TURTLE

Because of its longevity, the turtle has frequently served as a symbol for long life. In several different cosmologies across the world, a giant turtle's back is the origin of dry land in the midst of the sea or even allows the turtle to carry the world on its back. In modern interpretations it has become a symbol for a steady if slow pace, something dependable and methodical. Because of the large number of eggs that it lays, it was also sometimes a symbol of fertility. The hard shell and the ability of the turtle to withdraw into it for protection has also been associated with strength. In the maritime tradition of tattoo, it marked a seaman who had crossed the equator.

TWELVE

Twelve is seemingly the number into which divisions naturally fall in terms of months, hours, and even the **ZODIAC**. From the twelve tribes of Is-

rael and the twelve apostles to the twelve **KNIGHTS** of the Round Table and the twelfth major arcana **TAROT CARD** (the hanging man, who marks the end of a cycle), twelve is repeatedly the number of completion and order.

TWO

The number two is associated with duality and division and so also sometimes with confrontation. Many examples in everyday experience can be thought of in terms of opposites or dualism: black and white, night and day, male and female, on and off, body and spirit, heaven and **EARTH**, sacred and profane, love and hate, to name only a very few. Like other numbers in tattoo design, two would not commonly appear as a written numeral itself. Many designs, however, come in pairs, such as **LOVE/HATE**, a **SUN** and **MOON**, or a pair of **SWALLOWS**. The design that combines opposites expresses an all-encompassing totality.

TWO BIRDS IN A TREE

In the Coptic tradition of receiving a tattoo to commemorate a pilgrimage to the Holy Land, this design is more evocative of the local culture as opposed to Christian themes. Two **BIRDS** that resemble pigeons stand at the base of a tree that has five **BRANCHES**, with pointed leaves and fruit. The pigeons may represent the birds used in Coptic marriage custom. Two live pigeons are encased in hollow sugar balls. These **BALLS** are whirled around to disorient the birds. Shortly, the balls are smashed and if the birds fly off, it is a good omen; if they are still dazed and stay, it is a bad one.

UFO

UFO stands for unidentified flying object, otherwise known as a **FLYING SAUCER**, which is many times the subject of fantasy-related tattoo art. Although sightings of UFOs have likely been taking place for some time, the **U.S. AIR FORCE** started to keep track of them in 1948. They have stirred the imagination in many ways, spawning all manner of books, movies, artwork, magazines, television shows, and websites. The notion that other intelligent beings exist and have visited our planet is indeed a popular one and attractive to many people.

UNICORN

The unicorn, the legendary white **HORSE** with the single horn projecting from the middle of its forehead, is a symbol of majestic purity and strength. According to Medieval sources, only a virgin could catch a unicorn, and if waters were poisoned, the unicorn could purify them by making the sign of the cross with its horn. In ancient China, the unicorn was a symbol of kingship. Today, the unicorn is also associated with ancient mysteries or knowledge, with a decidedly enchanted or magical tone.

UNION JACK

The Union Jack, today's British **FLAG**, is a red, white, and blue combination of crosses. The crosses of **ST. GEORGE** (red cross, representing England), St. Andrew (white diagonal cross, Scotland), and St. Patrick (red diagonal

cross, Ireland) are superimposed on a field of blue. It is a symbol of Great Britain and is incorporated into the flags of some members of the Commonwealth.

UNITED STATES AIR FORCE

The United States Air Force is the branch of the U.S. military responsible for air warfare, defense, and also space research. As with other branches of the military, in all countries and time periods, the insignia used are often turned into tattoo artwork. For many military organizations centered around aviation, **WINGS** are a major ingredient in the design. In this design, the American **EAGLE** and flag are main elements but it is the propeller that represents aircraft.

UNITED STATES ARMY

The United States Army is given the general task of preserving the peace and security of the nation, and maintaining its defense. Of all the branches of military service, the Army contributes the largest number of ground forces. Having its origin in 1775 in the War of Independence, the Army's symbols are consummately and fundamentally those of the nation: the **EAGLE**, the **FLAG**, and occasionally also such symbols as the **CANNON**, artillery shell, musket, bayonet, and **SWORD**, to name a few.

UNITED STATES COAST GUARD

Although the symbol for the United States Coast Guard is a pair of crossed **ANCHORS** behind a circular field, displaying the founding date of 1790 and a central **SHIELD**, the form that it takes in tattoos is quite a bit more variable. The shield symbolizes the Coast Guard's central mission of keeping those whom they serve safe from harm. The anchors carry much the same

meaning as that for **SAILORS** in general. The U.S.C.G. seal also includes the words *Semper Paratus,* meaning "Always Ready"—a fitting motto for search and rescue. Many times in tattoo artwork, the anchor is the primary symbol used for the Coast Guard, rather than the official shield or seal. An additional "U.S.C.G." helps to differentiate it from a naval anchor.

UNITED STATES MARINE CORPS

The emblem of the U.S. Marine Corps, like much of military regalia, is laden with symbolism. Adopted in 1868, it is composed of three components: the **EAGLE**, globe, and **ANCHOR**. The eagle is the national symbol of the United States but it also carries in its beak a streamer with the motto of the Corps, "**SEMPER FIDELIS**." The globe was actually borrowed from the emblem of the Royal Marines, emphasizing their close connection. However, the Royal Marines' emblem shows the Eastern hemisphere, while the U.S. Marine Corps' emblem shows the Western hemisphere. The globe has also taken on the meaning of "global" Marine Corps involvement. Finally, the anchor is not just a plain anchor but a "fouled" anchor, highlighting the close ties between the Marine Corps and the **U.S. NAVY.**

UNITED STATES NAVY

The United States Navy has a history that is completely entwined with the history of tattoo in this country. "**SAILOR** tattoos" are largely those of naval personnel and no small amount of them symbolize their branch of military service. Although naval and maritime tattoos are incredibly variable, the letters U.S.N. or the distinct white sailor's cap can help to identify the Navy specifically, as opposed to something that is more broadly nautical. However, the **ANCHOR** is the preeminent Navy symbol, both in the service and in tattoo.

URN

The urn, or funerary jar, typically carries the ashes of a person who has been cremated. In this sense, it takes on the association of a house or resting place for the deceased. Although urns can also serve as sources of **WATER** or even to hold **FLOWERS**, they are most usually used as a cemetery symbol of death.

VAJRA

The *vajra* (or *dorje* in Sanskrit) has the meaning of **"THUNDERBOLT,"** "diamond," and "scepter." It is a ritual implement, typically made of brass. Essentially a small pole that is the same at both ends, each end is composed of four curving prongs that meet at the tip (like a small cage). The center piece, between the two halves, is typically a **LOTUS** or perhaps two from which the prongs project. The *vajra* is used to symbolize the active male principle and enlightenment and evolved from the thunderbolt-scepter wielded by Indra. Occasionally, it is also paired with the bell (the female symbol of wisdom). In art, the *vajra* is an attribute of the gods, including **BUDDHA**.

VALHALLA

In the mythology of the Norse, Valhalla is the great afterlife reward of slain warriors. In the palatial hall of Odin, these dead heroes would feast and drink and engage in their favorite activity—fighting with one another. Placed in some location high in the **SKY** and at the end of a **RAINBOW** bridge, Valhalla will remain their home until Ragnarök (Doom of the Gods, or Doomsday), the end of gods and men.

VAMPIRE

This mythical creature was part of folk belief that was widespread over Asia and Europe, but primarily in the Slavic areas. Sometimes taking the

form of a **BAT**, the vampire is a dead person who must suck the blood of the living, who then traditionally become vampires themselves after being drained. Vampires are consumed by a lust for life, albeit a destructive one. Ghoulishly depicted but impeccably dressed, both male and female vampires are pale-skinned and red-lipped and will usually have larger than normal incisor teeth.

VENUS OF WILLENDORF

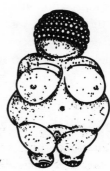

The Venus, sometimes also called the Aphrodite, of Willendorf is a small limestone statue that is one of the earliest pieces of prehistoric human artwork known, dated to ca. 28,000 to 25,000 B.C.E. Her large belly and breasts, with little detail given to much else, have led to her interpretation as a fertility figure and have also played some part in theories about early goddess cults.

V FOR VICTORY

In 1941, British Prime Minister Winston Churchill instigated the "V for Victory" campaign of World War II. The Morse code of the letter "V," dot-dot-dot-dash, was also used as a code for the program, and because it was reminiscent of the first four notes of **BEETHOVEN**'s Fifth Symphony, this tune was also used. The "V," with or without the word "victory," was a tattoo design used at the time, occasionally even accompanied by the **DOTS** and dash.

VICE LORDS

The word "Lords," short for "Vice Lords," as well as the initials "VL," a **PENTAGRAM**, or an outline of a hand with the thumb, index finger, and middle finger extended are all used as tattoo symbols for the Vice Lords. Arguably the oldest and largest street gang in Chicago, they are predominantly African American with strong Nation of Islam beliefs. Many factions have been spawned, each with its own variation on the tattoo, such as the "CVL" for Conservative Vice Lords.

VIKING DAGGER

One of the most striking characteristics of Nordic and **VIKING** Age metal artwork is the ornate and highly elaborated animal designs that are incorporated. Undoubtedly the animals had some symbolic meaning for both the artisans and owners of the pieces. The great energy and dynamism of the designs are particularly well suited to the weaponry, where the hilts and hand guards are frequently decorated. In Northern Europe, where Viking images are more prevalent in tattoo work, the Viking **DAGGER** melds the popular dagger tattoo with local cultural flavor.

VIKINGS

The depiction of Vikings or Norsemen is naturally a more popular motif among people with close cultural or geographical connections to these peoples and their traditions. Known for their ferocious and energetic fighting and seafaring abilities, they are often shown in tattoo artwork as helmeted warriors, sometimes in battle, or en route, or ensconced in **VALHALLA**. Altogether, the central theme is typically one of strength and valor. Even the buxom women in Viking images, perhaps really another form of the pinup girl, wear helmets or carry **SWORDS**.

VINE

Vine symbolism revolves around the natural aspects of any vinelike plant, one of vibrant life and growth. In both Old and New Testaments, the vine is much like the **TREE OF LIFE** in the sense that it brings life and has been used to represent one who is heaven sent. The vine is also known for bearing fruit (especially grapes), thus representing a blessing. Eventually, after the grapevine was cultivated it also became associated with wine, another symbol of life and knowledge. Even as early as the time of the ancient Sumerians, the written sign for "life" was typically a vine **LEAF**.

VIOLIN SOUND HOLES

The image of black violin sound holes, which look like long, curved and opposing "f"s, tattooed low on a woman's back is a direct reference to a well-

known photograph by Man Ray (1890–1976), a surrealist photographer who created *Violon d'Ingres* in 1924. While parodying the notion that women are art, he also manages to show that this might actually be so.

VIRGIN MARY

The Virgin Mary is one of the preeminent symbols of the Catholic church. The revered and saintly Mother of God, she symbolizes purity, spirituality, and compassion and is an archetype of both the mother and femininity. Her image permeates Catholic tattoo imagery, is often combined with the **SACRED HEART**, and is even known in the form of the **PIETÀ** and of course the **VIRGIN OF GUADALUPE**. Her hands are sometimes shown spread open as she welcomes the suffering, or held up in blessing, or perhaps even clasped in prayer, but her expression tends to remain one of quiet contemplation with perhaps a hint of sadness, with eyes cast downward.

VIRGIN MARY OF GUADALUPE

The Virgin of Guadalupe symbol is immediately identified by the presence of the large oval **HALO** of light **(MANDORLA)** that surrounds her stand-

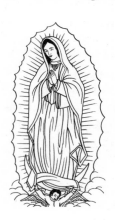

ing form. In addition, the halo is punctuated at intervals with rays of light that create distinctive small peaks at its outer edge. In December of 1531, in Villa de Guadalupe Hidalgo, a northern neighborhood of what is now Mexico City, the Virgin appeared to an Indian convert named Juan Diego. After a second appearance the famous image was created and eventually came to be called the Virgin of Guadalupe. Ultimately the Catholic church adopted her as the patroness of what was then known as New Spain, and in 1810 she was co-opted as a symbol for Mexican independence.

VIRGO

Virgo (August 23–September 22) is the sixth sign of the **ZODIAC**, just before the equinox, and ruled by Mercury. Pictorially, Virgo is shown as a young maiden carrying a sheaf of wheat, reminiscent of various fertility and harvest goddesses. People born dur-

ing this astrological interval are said to be modest and analytical but also capable of being overly critical and worriers.

VISHNU

Vishnu is the divine preserver of Hinduism and the supreme being of the Hindu trinity (along with Brahma and **SHIVA**), the protector of the world, mankind, and the dharma (moral order). In a couple of his more famous incarnations or descents to the world (avatars) he was both Rama and **KRISHNA**. Vishnu is shown often as a beautiful and dark man with four arms, who might hold a conch shell (representing creation and transience), a discus or chakra (the wheel of existence), a club (authority), a **LOTUS** (representing creation or purity), or he may simply display different hand gestures (*mudras*).

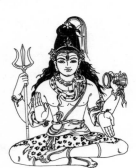

VOLCANO

For thousands of years, volcanos have inspired awe and fear in those who live in their vicinity. For the Greeks, volcanic activity was a sign that the great blacksmith of the gods, Hephaestos (known as Vulcan to the Romans), was at work in his shop. From Vesuvius in Italy to Pele in the Caribbean, volcanoes are ultimately examples of the terrible and destructive power of nature, and their eruptions have been interpreted as the anger of the gods. In tattoo artwork, lava sometimes vividly erupts from their tops and flows down their sides.

VOODOO DOLL

The use of voodoo dolls by practitioners of voodoo, the folk religion of Haiti, is likely not a traditional part of the religion. Originating in West Africa and brought to the Caribbean, where it mixed with Roman Catholicism, voodoo is a religion that focuses on the spirit world and communication with it. Use of the dolls may have begun in New Orleans, one of the places where voodoo is practiced. The doll is used to represent a particular

person and spells for good or ill are cast on the doll, with pins used to reinforce the spells.

VULTURE

The vulture is perpetually the symbol of death because it feeds on carrion. Nevertheless, because it manages to thrive in this way and to transform the dead into new life for itself, it has also been a symbol of regeneration in some cultures. According to the Maya, for example, the vulture ensured the return of the rains after the dry season, while for the ancient Egyptians the vulture-goddess, Nekhbet, protected childbirth.

WASP

The wasp is a flying and stinging type of insect, the most recognizable of which might be the yellow jacket, although the hornet is also well known. Because some species can be communal, with their activities centered around a queen, they are at times associated with the notion of community and occasionally, by extension, with female energy.

WATER

Though virtually never a design in and of itself and yet part of many others, the symbolism of water runs deep in the human subconscious. Its centrality to many myths and legends cannot be underestimated. From stories of creation to cleansing floods, water has, most importantly, symbolized both life and fertility as well as death and destruction. In tattoo art it includes the OCEAN of the SAILOR'S GRAVE or the ROCK OF AGES, the stream against which the Japanese KOI valiantly struggles, and even the water that may pour from the URN of AQUARIUS.

WATERFALL

As with the RIVER, a waterfall is not an uncommon backdrop for Japanese-style tattoos, particularly tattoos such as the KOI or KINTARO. In Chinese symbolism, from which much of Japanese tattoo imagery is ultimately derived, the waterfall represents the feminine while the mountain or cliff is the masculine. The downward fall of the WATER is the natural complement to the upward climb of the rock.

WELL

In a symbolic sense, the well is often much more than just a source of WATER, life, or plenty. The wishing well is a part of mythology that is given the sacred character of not only granting wishes but also knowledge. In tattoo art, the well is also a country motif, a design that is reminiscent of a more rural and simple life and time.

WEREWOLF

Although appearing as a normal man during the day, a full MOON causes this person to change into a wolf-man, more man than WOLF, really. The belief in these legendary and transformative creatures occurs in some form all over the world, but is not always based on wolves. In fact, there is even a psychiatric condition (lycanthropy) known for people who believe that they are wolves.

WHALE

The whale is everywhere the most majestic and fear-inspiring creature of the sea. It was probably the "great fish" that swallowed Jonah and the sea monster slain by Perseus. In this type of symbolism, the whale is an animal of the Underworld, a dark and powerful force but not undefeatable. In tattoo artwork, different types of species are shown, sometimes the KILLER WHALE and other times the gray or the blue whale, but almost always breaching, rising significantly above the surface.

WHALE (PACIFIC NORTHWEST)

Among the traditional Native cultures of the Pacific Northwest coast of North America, the WHALE is the most revered of creatures. Like other cultures worldwide, there exists among the Haida a tradition that sees the whale as a part of the land. Nevertheless, whaling was a supremely important activity and the successful whaler likely enjoyed enormous prestige. Like the other very stylized and high-contrast designs of this region, the whale is similar to the KILLER WHALE in many respects but without the dorsal fin.

WHEEL CROSS

Also known as Odin's cross or the **SUN** cross, and resembling the **CELTIC CROSS**, the wheel cross has become a symbol of the **KU KLUX KLAN**. Before its use as a white supremacy symbol, however, the wheel cross was used worldwide as yet another type of **SUN** symbol. In accord with the early Christian church's propensity for co-opting earlier pagan symbols, this cross was adopted by the Roman Catholic Church as a type of consecration cross, used at the inauguration of churches.

WILD AT HEART

The **HEART** symbol is combined with many others in tattoo design, including words such as "wild." In these cases, the heart symbol is a visual substitute for the word "heart" and the "wild at heart" or "wild heart" meaning is created by an almost direct interpretation.

WINGS

Although wings can be associated with **FAIRIES**, other flying spirits, and even demons, they are most often shown in tattoo artwork as those of **ANGELS**. They are placed on the back and appear in various sizes, sometimes large enough to achieve almost complete coverage. **FEATHERS** and wings have always been associated with the spirit, lightness, and the heavenly realm. Wings can mark a realization of the sublime, or at least a striving to transcend the human condition, as well as release and even victory.

WISHBONE

Sometimes called the "merrythought" in the British Isles, the wishbone is a **BONE** that is found near the breastbone of fowl such as chicken and turkey. When carving one of these game **BIRDS** for a meal, the wishbone is traditionally removed intact and then left to dry. Two people (usually children) will then each take hold of either side and pull it until it breaks. The person with the larger half receives his or her wish (if it's kept secret). The whole wishbone is thus a symbol of potential luck to come.

WITCH

The witch is typically a woman who practices black witchcraft, often with the help of a demon or an animal familiar. At Halloween, popular caricatures wear tall black hats that resemble those of the **WIZARD** and she is shown riding a flying broom. Today, the term is also applied to a practitioner of Wicca, which is nature-centered and not demonic. In myth and symbolism, the witch is a woman of formidable power and magic and she represents a transference of the darker and negative impulses to a specific character.

WIZARD

Images of the wizard are more prevalent than the **WITCH** in tattoo art, no doubt due to the largely negative associations of the latter. The wizard, while not a completely positive character, is one of some neutrality. His characteristics include both age, implying wisdom, and the capability of conjuring magic and casting spells. Physically, he typically has a long, flowing white beard and he may wear a tall conical hat while wielding a staff or holding a **CRYSTAL** ball. The wizard is a representative of the supernatural world. He corresponds to mysticism and ancient knowledge and the will to dominate the forces of nature.

WOLF

The wolf, although it is a predatory pack animal, is sometimes shown in tattoo art as solitary and baying at the **MOON**, many times with a Native American theme. Wherever this animal occurs in the world, though, it has been the subject of fables and myths that portray it as cunning and ferocious. In Norse mythology the chief god, Odin, must slay the mighty wolf Fenris but is himself killed in the process. Occasionally, though,

wolves will suckle human children who generally go on to fulfill some special destiny, such as Romulus and Remus and Genghis Khan.

WOLF PRINT

The wolf print is a tattoo design that is essentially an extension of the **WOLF** design noted above. The paw print, however, is more subtle evidence that the wolf has been or may still be present. It might even suggest being able to track the animal, despite its elusive qualities.

XXX

A triple X in tattoo design is sometimes a sign on a bottle to show that it contains alcohol. The "XXX" in this case originated from the marks that were painted on alcohol barrels to show the number of times that they had been used. Three uses marked that the alcohol barrel had reached the end of its life. The triple X has also been used to rate adult material, especially movies, in a system that originated in the 1950s. Because the use of the "X" rating to describe movies with adult content was escalating to "XX" and "XXX" and because it was increasingly linked with pornography, the rating was changed in 1990 to NC-17: "No one 17 and under admitted."

Y

YGGDRASIL

Yggdrasil is the huge and evergreen ash tree in Norse mythology that spreads over the entire world and links **EARTH**, hell, and heaven. Beneath its roots flow rivers that are the waters of wisdom. It is the classic **TREE OF LIFE** and **AXIS MUNDI**, linking the realm of the gods with that of humans.

YIN-YANG

The ancient Chinese symbol of cosmic duality is an immensely popular one. Originally yin (the black side) and yang (the white) represented two sides of a valley, one in shadow and the other in **SUN**. Over time, it has come to encompass all such contrasts by uniting to express completeness within the **CIRCLE**—dark and light, male and female, positive and negative, active and passive, heaven and **EARTH**. The small dots of opposite color in each field symbolize mutual dependence, such that light and shadow are not in conflict but rather depend on one another for completion. The yin-yang is a distillation of one of the deepest philosophies of China, whose abstract conceptions of time and space, or cause and harmony, have resonated with people of all backgrounds.

ZIG-ZAG MAN

In the nineteenth century, during the battle of Sevastopol, a Zouave (a soldier in a French infantry unit) had his clay pipe broken by a bullet. He got the brilliant idea of rolling tobacco in a piece of paper torn from his bag of gunpowder. By so doing, he invented the world's first **CIGA-RETTE**. For one hundred years, as a tribute to that soldier, the image of the Zouave dressed in his bright uniform has been used on all Zig-Zag's cigarette paper products. In modern times, the Zig-Zag man has also come to be associated with **MARIJUANA** and a whole subculture of people that roll their own.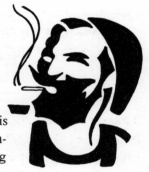

ZIPPER

A zipper design is a bit of tattoo irony, suggesting that, like clothes, the wearer's skin might be opened with a tug on the slider. It is particularly linked with surgery, where the skin is actually opened. From a cesarean section to open-heart surgery, the zipper has been popular placed over scars, and if open sometimes shows the interior of the body, much like a **MOCK WOUND**.

ZODIAC

The zodiac is the chief organizational structure by which the cosmos is understood in astrology. In Babylon, Judaea, ancient Egypt, Persia, India,

Tibet, China, North and South America, and Scandinavia, astrologers utilized the zodiac. The symbol is a circular shape with divisions around the rim that correspond to the **TWELVE** constellations. The astrological aspects are dependent on the angular relationships between planets and **STARS** in the **SKY** and their relationship to references based on the earth. Each constellation or zodiac sign has biological and psychological significance in terms of interpretation. Taken as a whole, the zodiac is an outstanding example of a complete cycle that still reveals the interrelatedness of its parts.

ZODIAC (CHINESE)

Like the Western **ZODIAC**, the Chinese version is also divided into **TWELVE** symbols. These, however, do not correspond to cycles within the year but instead to a long cycle of twelve years. Every year the zodiac sign will change, and every twelve years it will repeat. These are the signs and their years:

Rat	1912	1924	1936	1948	1960	1972	1984	1996
Ox	1913	1925	1937	1949	1961	1973	1985	1997
Tiger	1914	1926	1938	1950	1962	1974	1986	1998
Rabbit	1915	1927	1939	1951	1963	1975	1987	1999
Dragon	1916	1928	1940	1952	1964	1976	1988	2000
Snake	1917	1929	1941	1953	1965	1977	1989	2001
Horse	1918	1930	1942	1954	1966	1978	1990	2002
Sheep	1919	1931	1943	1955	1967	1979	1991	2003
Monkey	1920	1932	1944	1956	1968	1980	1992	2004
Rooster	1921	1933	1945	1957	1969	1981	1993	2005
Dog	1922	1934	1946	1958	1970	1982	1994	2006
Pig	1923	1935	1947	1959	1971	1983	1995	2007

ZUNI FETISH

Zuni is a pueblo in New Mexico, near the Arizona border, and the source of an interesting and small sculptural item called a fetish. Although many groups in the American Southwest may have used fetishes, it is the Zuni who have achieved a reputation for producing finely carved examples. The most famous of the animal forms is probably the **BEAR**, which nearly resembles a crescent in profile. Lashed to its back with twine is sometimes

an arrowhead or perhaps a tiny bundle of
turquoise or coral, an offering to the animal
spirit. Native Americans believed that a spirit
could reside in a fetish, a power that could be
used for good or ill. That power was one that
had to be cultivated. Fetishes could belong to
the tribe, a clan, and also to individuals who would
ritually feed them and keep them in protected places.

Acknowledgments

Because the choice of a tattoo is personal and reflects the desires and tastes of the wearer in a very permanent way, much of tattoo art tends to provide little insight into the lives of the artists who create it. Despite analogies to the contrary, it seems to me that skin is rarely the blank canvas of wide-open opportunity that is part of other art mediums and that tattoo artists must work under a great many constraints. As right and proper as that might be, it is nevertheless a pity that something more of the artist is not transmitted, especially when it comes to one such as Greg James. For those familiar with the industry, his name is well known. His reputation is not only one of artistic achievement and award-winning tattoos, but it is also one of personal integrity and a humility that seems at odds with his talent and yet is entirely consistent with the natural kindness and graciousness that is part of his character. His direct contribution to this book is obvious in the outstanding collection of illustrations that accompanies the text. He was able to put aside the natural tendencies to create elaborate colored or shaded flash and instead produced line art that could be reduced to near thumbnail size. Also, because he is steeped in the tradition of his profession, he was able to provide many insights into tattoo symbolism. Ultimately, though, his influence on this project cannot really be understated since it was essentially his idea that I write a book about tattooing in the first place, all those many tattoo sessions ago.

In that same vein, the inspiration for the specific topic and form of this book is not mine but rather belongs to Lisa Considine, former senior editor for Simon & Schuster trade paperbacks. I credit her with the notions (1) that what is specifically of interest to people considering a tattoo is what tattoo to get and what different tattoos mean, (2) that a tattoo encyclopedia would be of enduring value to those people, and (3) that the encyclo-

pedia format was an appropriate one. She was completely on target in her assessment and I just wish that I had thought of it all instead. It has been utterly refreshing to work with someone who considers the subject as interesting as I do and who is willing to dive into the minutiae for which I thought only I would have the patience. In addition, my sincere thanks go to Amanda Patten, editor at Simon & Schuster, who took on this project midstream. This book benefited both from her sense of how best to bring this information to a wide audience plus her critical editorial eye on every line of every page. It was an enormous task and I appreciate her energy and patience.

But the first steps in bringing ideas for a book about tattoos to the attention of publishers were taken by my literary agent, Jane Dystel. Her aid in helping me to refine my initial ideas and approach were absolutely crucial. Her advocacy and her continued support in this lengthy process have been both impetus and comfort to me and I consider it my great good fortune to be associated with her.

I have tried to write a book about the symbolism of tattoos that treads the middle way—avoiding overly deep psychological and cultural analysis that may not apply and yet giving each design some serious consideration. In doing so, I am indebted to two communities. The compilation of the works of psychologists, sociologists, historians, anthropologists, archaeologists, and the writers of works on myth, religion, and symbolism inform many of these definitions. At the same time, the particular spin or slant that an image receives when used as a tattoo is something that can only come from the tattoo community. I benefited not only from researchers and writers on the subject of tattoo but from the tattooists and the tattooed themselves. And, while I'm on the subject, I would specifically like to thank Robert Benedetti, the owner of Sunset Strip Tattoo in Hollywood, California, and the fine artists who tattoo there, for the good nature with which they and their clients took my intrusions and impositions as I worked and chatted with Greg James.

Finally, though, at the conclusion of so many words of thanks, I am once again mystified that there are none that seem quite right for the person in my life who makes it extraordinary: my husband, Mark. In a way that I cannot comprehend, my burdens are less than half because he shares them, but my happiness is more than doubled.

Tattoo Category Index

ANIMAL

It has been estimated that roughly twenty-five percent of all tattoos utilize animals. Many people relate to the physical and behavioral qualities that their animal totems possess, including prowess, beauty, and temperament. These creatures become a way for us to express emotions, instincts, and even experiences. Although what individuals associate with a particular animal has a great deal to do with the symbolic meaning that they personally ascribe to it, many animal images seem to speak directly about ferocity or grace, swiftness or strength, purity or poison, based mostly on the common perceptions that we have of them. Animal symbolism is among the most ancient of representational tattoo styles. And as described in the entries, some animals have a great many historical or mythological associations—symbolism that is deeply rooted and that varies greatly from culture to culture, even for the same animal.

Alligator	Boa	Crab
Antlers	Boar	Crane
Armadillo	Bobcat	Crow
Badger	Buffalo	Deer
Bat	Bull	Dinosaur
Bear	Cat	Dog
Bear Claw	Cheetah	Dolphin
Bird	Cobra	Donkey
Bluebird	Cougar	Dove
Blue Marlin	Coyote	Duck

Eagle
Eagle Grasping
 Arrows
Eel
Elephant
Falcon
Fish
Foo Dog
Fox
Frog
Gecko
Giraffe
Goat
Gorilla
Great White Shark
Grizzly Bear
Hammerhead Shark
Hawk
Hippopotamus
Horse
Hummingbird
Iguana
Jackal
Jaguar
Jellyfish

Koala
Lamb
Leopard
Leopard Spots
Lion
Lion (Chinese)
Lizard
Lobster
Makah Sea Wolf
Monkey
Moose
Mouse
Octopus
Otter
Owl
Ox
Panda
Panther
Parrot
Peacock
Penguin
Pig
Piranha
Polar Bear
Rabbit

Ram
Rat
Raven
Rhinoceros
Salmon
Seagulls
Sea Horse
Seal
Shark
Sheep
Snake
Squid
Starfish
Stork
Swallow
Swan
Three Wise Monkeys
Tiger
Toucan
Trout
Turtle
Vulture
Whale
Wolf
Wolf Print

ART

The influence of all manner of art on the world of the art of skin is immense, particularly in the West, where tattoo traditions are relatively young and which incorporate many aspects of other cultural traditions. From abstract art to the sculptures of Michelangelo or from Paleolithic cave art to the graffitilike new school style of tattoo, many famous images are transplanted directly into the symbols that people select for tattoos. This brief sample of influential works and artists has been a part of tattoo symbolism.

Birth of Venus Measure of Man Pietà

Creation of Adam Mona Lisa Starry Night

David Mondrian

Mandelbrot Norman Rockwell

 Poster

BIKER

Although bikers, like other tattooed people, will wear the entire gamut of symbols from which to choose, there is also a set of tattoos that relates particularly to their experience and history. Certainly the symbols of their ardent pastime—motorcycles and riding them—are well represented, as are the designs of club colors and names, brand names, and logos. Tattoos that express a certain degree of independence, even lawlessness, are also part of the repertoire.

Born to Ride Hell's Angels Motorcycle Engine

FTW Motorcycle One Percent (1%)

Harley-Davidson

BUDDHIST

Buddhism, like the other great religions of the world, uses a system of symbols that echoes and reinforces its basic tenets. The Buddha himself discouraged the use of images, but over the centuries a variety of forms have entered Buddhist iconography, including the Buddha. Combined below is a mixture of portrait icons, abstract symbols, and written script.

Bo Tree Mala Stupa

Buddha Om Vajra

Buddha, Fat Om Mane Padme

Dharma Wheel Hum

CARTOONS

Cartoon characters have been a favorite part of tattoo design in Western culture. Taken from newspaper comics (such as *Garfield* or *Calvin and Hobbes*), comic books (from *Batman* to *Witchblade*), works of fiction (*The*

Hobbit or *Alice in Wonderland*), both Western and Japanese animation (*Ariel, The Little Mermaid,* or *Battle Angel Alita*), and even video games (Lara Croft), today's cartoon characters can be sexy pinup girls, superheroes, humorous animals, or completely mythical creatures that were never even illustrated in their original publication. Here, as with animal symbols, people will take on the characteristics for which a cartoon character is famous. It is virtually impossible, however, to provide a comprehensive catalog of the cartoon and animation characters that have been used in tattoos because it is almost a surety that if the character exists, it has been used in a tattoo somewhere at some time. Also, as noted in the introduction, some tattoo symbols simply do not lend themselves to deep analysis and so to ascribe symbolic meaning to them seems forced. A familiarity with the cartoon character itself is usually all that is needed in order to understand what it likely symbolizes. By design then, the enormous category of cartoon character tattoos has only been sampled.

Betty Boop	Hobbit	Popeye
Caterpillar with	Jiggs	Superman
Hookah	Mickey Mouse	Tasmanian Devil
Cheshire Cat		

CELTIC

It is difficult to know how closely the Celtic-inspired tattoos of today resemble those of the people observed in the first century. While Celtic designs come predominantly from the peoples of the British Isles, Celtic society has its roots in Austria, Germany, and France, perhaps going back as early as the second millennium B.C.E. Indeed, the Celts are but one of the Indo-European groups who occupied Europe, Persia, the subcontinent of India, and some other parts of Asia. In tattoo imagery, though, it is the artwork of the Celts in Ireland, Highland Scotland, the Isle of Man, Wales, and Brittany that dominates—intricate and interwoven knotwork animals and letters are the mainstay. The fantastic illuminated manuscripts that have come down to us today began to be produced in the Celtic West sometime after about C.E. 500. Religion survived in the monasteries, where artist monks labored to produce these ornate and lavishly illustrated Christian manuscripts, such as the *Book of Kells*, the *Lindisfarne Gospels*, and the *Book of Durrow*. Much of Celtic tattoo art is modeled on ornamentation from these manuscripts. Interlaced and interlocking curves and

loops form animals, people, crosses, and abstract designs. There is often a symmetric and balanced effect in the midst of even the most complicated designs. In some instances, the looping elements are all derived from a same single strand, in a never-ending loop that comes back to itself.

British Fighting Dog
Celtic Bird
Celtic Cat
Celtic Cross
Celtic Deer
Celtic Dog
Celtic Dragon
Celtic Sun

Celtic Tree of Life
Celtic Wedding Ring
Claddagh
Harp
Interlocked Armband
Interlocked Beard
 Pullers

Knotwork
Luckenbooth
Morrigan
Pictish Circle
Sacred Grove
Triquetra

CHRISTIAN

The Christian world has had a love-hate relationship with tattoos for centuries. While the abundance of Christian-themed tattoos is testament to the popularity of the practice among Christians, the official position of various church officials through time has occasionally included prohibitions of one type or another. People on both sides of the issue will cite biblical scripture in support of their positions, as is also the case with other religions and their attitudes toward tattoos. Below is a selection from the numerous types of designs that are drawn from the rich symbolic tradition of Christian art and tattoos.

Alpha and Omega
Alpha Mu Omega
Aureole
Chalice
Christian Fish
Crown of Thorns
Crucifix
Crucifixion
Forgiven
Golgotha
Good Shepherd
Gospels
Grail

Halo
Holy Lamb
Holy Trinity
IHS
INRI
Jesus
John 13:35
John 3:16
Labarum
Madonna
Quatrefoil
Sacred Heart
Salome and the Head of John

St. Francis

Stigmata

Trefoil

Virgin Mary

Virgin Mary of Guadalupe

COPTIC

All of the Coptic tattoo designs used in this encyclopedia are redrawn from the work of John Carswell in his well-known book *Coptic Tattoo Designs*. In it, he collected woodblock images used by tattooist Jacob Razzouk as ready templates for his work in Jerusalem in 1956. They are a charming mixture of local and Christian culture and they are part of a long tradition of pilgrimage tattoos that has taken place in that part of the world since the time of the Medieval crusaders.

Angel of the
 Apocalypse
Annunciation, The
Archangel Michael
Cross, Three
 Crowns, and Star
Eagle, Double-
 Headed

Head of St. John the
 Baptist
Last Supper
Madonna and Child
Nativity Scene
Resurrection

Saint with Child on
 Horse
St. Dimian
St. George and the
 Dragon
Two Birds in a Tree

CROSSES

Although the crosses listed below are almost all associated with Christian tattoo symbols, they are listed separately here simply because of their great variety and popularity.

Coptic Cross
Cross Gemmata
Cross of Equal
 Lengths
Cross of Golgotha
Cross of Hope
Cross of Philip
Cross of the
 Archangels
Cross of the
 Evangelists

Cross of the Pope
Cross Over Globe
Crossed Cross
Crutch Cross
Diagonal Cross
Diagonal Cross with
 Vertical Line
Greek-Russian
 Orthodox Cross
Heart with Cross

Jerusalem Cross
Latin Cross
Lutheran Cross
Maltese Cross
Mantuan Cross
Patriarchal Cross
Pointed Cross
Portuguese Cross
St. Peter's Cross
Wheel Cross

EGYPTIAN

The use of ancient Egyptian motifs in tattoo, as with most of the styles, does not include the type of tattoos that were or are actually performed in Egypt. Instead, these tattoos draw upon the art history of Egypt and particularly the dynasties of the pharaohs that produced the tombs and monuments with which we are all familiar. Ancient hieroglyphs are used to spell all manner of modern words in various languages or to form personal cartouches. The funerary mask of Tutankhamen, the bust of Nefertiti, the sphinx, and the pyramids are used in tattoo art. But perhaps the most common types of designs are the images of the ancient gods, taken from the colorful painted tombs, and the talismans used by the Egyptians themselves, such as the scarab and the eye of Horus.

Amun	Hieroglyphs	Pharaoh
Ankh	Horus	Pyramid
Anubis	Ibis	Ra
Bastet	Isis	Scarab
Bes	Nefertari	Seth
Book of the Dead	Nefertiti	Sphinx
Eye of Horus	Osiris	Thoth

FLORAL

Flowers, trees, garlands, and even forests have become a standard part of tattoo repertoire the world over. Drawing inspiration from the natural world, as with animals and insects, the depiction of floral motifs can range from a simple sunflower to a World Tree or from an anklet vine to a primeval jungle scene. Seasons, sentiment, and geography can be implied in floral designs. But even without knowledge of any of these underlying factors, we all seem to appreciate their innate aesthetic appeal and beauty.

Acorn	Cherry (Cherries)	Grape Vine
Apple	Chrysanthemum	Ivy
Bamboo	Clover	Lily
Black Rose	Daisy	Maple Leaf
Bonsai Tree	Flowers	Mushroom
Branches	Garland	Oak Tree

Olive Branch	Peach	Rose
Orchid	Peony	Sunflower
Palm Tree	Plum Blossom	Tree of Life
Pansy	Poppy	Vine

HINDU

Unlike Buddhism, where the Buddha urged that his image not be used, the artwork and symbolism of Hinduism is centered around the many different depictions of the different gods. Like the religious artwork, tattoos with a Hindu theme use many of these same sacred and familiar images.

Brahma	Hanuman	Lakshmi
Five Forces of	Kali	Shiva
Nature	Krishna	Vishnu
Ganesha	Krishna and Radha	

INSECTS

Although one might not readily turn to the category of insects when envisioning a tattoo, one of the most popular designs done for women today is the beautiful butterfly. However, everything from bees to crickets and black widows to scorpions has been used in tattoo artwork and they remain popular design elements. Just as with the category of animals, insects have many historical and mythical roots and their symbolic associations can vary wildly from one culture to another.

Ant	Centipede	Moth
Bee	Cricket	Scorpion
Beetle	Dragonfly	Snail
Black Widow	Grasshopper	Spider
Butterfly	Ladybug	Tarantula
Caterpillar	Mosquito	Wasp

JAPANESE

In Japan, tattoo practice diverged from that of its neighbors in China and evolved into a tradition of design and symbolism now known throughout the tattoo world and acknowledged as one of the most aesthetically devel-

oped. In traditional Japanese tattoo, it is common for large portions of the skin to be covered with large flowing designs that may follow a theme and incorporate backdrops of stylized water, clouds, or wind. Buddhist and Shinto deities, mythical creatures, and figures from popular legends and stories are incorporated along with the ever-present floral motifs (such as the cherry blossom, chrysanthemum, and peony) that make Japanese tattoo distinctive. It is also not uncommon to have these backdrops done with black and gray work, reminiscent of the Japanese brushwork known as *sumi*.

Benten	Hagoromo	Ninja Rat
Bishamon	Han	Noh Mask
Catfish	Hotei	Okame and Hyottoko
Cherry Blossom	Japanese Dragon	Oni
Chrysanthemum	Jurojin	Pearl (Japanese)
(Japanese)	Kabuki	Peony (Japanese)
Crane (Japanese)	Kanji	Rochishin
Daikoku	Kannon	Samurai
Ebisu	Kintaro	Samurai Helmet
Fan	Koi	Seven Gods of Good
Fudo Myo-o	Kyumonryu Shishin	Fortune
Fukurokuju	Maneki Neko	Suikoden Hero
Geisha	Maple Leaf	Tamatori-hime
Ghost of Tomomori	(Japanese)	Torii Gate
Goban Tadanobu	Monkey King	

LETTERING

Many alphabets from many languages are represented in tattoo symbolism, including Arabic, Chinese, cuneiform, Hebrew, Japanese, Sanskrit, and runes, plus several Western alphabets and fonts. The classic American tattoo font is reminiscent of the show card and Western fonts of early circus signs, where tattooed people could sometimes be seen in sideshows making their living. Today, the Gothic or Old English font is frequently used in American gang tattoos. Tattoo lettering changes with the times, of course, from the funky sixties balloon letters up through the graffiti styles of today. Probably, the most common use is still in the tattooing of personal names or "Mom" and "Dad" by people who commemorate a special relationship or an important person in their lives, effectively keeping that

person always near. Because lettered tattoos are read, and so not in need of much interpretation, the following are just a few examples of the types of lettered tattoos that can be found.

Amen	Non Compos Mentis	Oriental Characters
Hold Fast	Omega	Signature
Love and Hate		

LUCK

Good luck symbols are entirely specific to the times and cultures from which they are derived. Tattoo imagery is filled with these sorts of images, alone or in combination. Some of the most common symbols are the number seven, a horseshoe, and a four-leaf clover. But there is also the occasional nine-lived cat with halo, birthstone, or even a rabbit's foot. Early Christians would carry saintly relics, Muslims sometimes carry verses of the Qur'an, Egyptians wore scarabs, and even Neanderthals had natural amulets of animal teeth or claws. The following are some of the most popular tattoo symbols of luck.

Dice	Lady Luck	Three Sevens
Horseshoe	Shamrock	Wishbone

MARITIME AND MILITARY

Sailors from the early days of tattooing would probably not have thought of themselves as participating in "tattoo culture." Tattoos were simply part of being a sailor. But the use of tattoos has become something more mainstream in the West, joining other world traditions where tattooing is prevalent, if not well understood or well accepted. Tattoos with a maritime theme were first popularized by those for whom they had some meaning—sailors. Anchors, ropes, ships, and lifesavers are all designs drawn from the everyday experience of these early travelers. Later images of the "Sailor's Grave" and "Homeward Bound" expressed part of what occupied the sailor's thoughts. In addition, their own customs and myths created new uses for tattoos to mark certain achievements and also to provide protection.

While esprit de corps is implied in the maritime category, it is the central theme of the military tattoo, where camaraderie is born of shared risks

and service during combat. Military tattoos show allegiance to group and country and use the specific emblems of military organizations, units, and even events, as well as more generically aggressive images, such as weapons.

Maritime
Anchor
Anchor Cross
Battleship
Clothesline
Full-Rigged Ship
Homeward Bound
Maritime Dragon
Maritime Pig
Maritime Rope
Message in a Bottle
Nautical Star
Pirate Ship
Rock of Ages
Rooster
Sailor
Sailor's Grave
Ship Lights

Military
Bulldog
Death Before Dishonor
Foreign Legion
Propeller and Wings
Semper Fidelis
United States Air Force
United States Army
United States Coast Guard
United States Marine Corps
United States Navy

MISCELLANEOUS

The miscellaneous category is the holding place for tattoo symbols that either defy categorization or whose category would be so small as to only include a few listings. In it you will find tattoo symbols of group movements ranging from white supremacists to sexual liberation and from anarchists to communists. Classic flash (posters of tattoo image samples) symbols of the modern world, icons of pop culture, death symbols, flags, and even a Greek god or two are all included in the largest listing of entries below.

Aegishjalmar
Alcohol
Alien Head
All-Seeing Eye

Amulet
Anarchy
Angel of No Man's
 Land

Archangel
Arrow
Atomic Radiation
Automobile

Tarot Cards
Teddy Bear
Thor
Three
Three Dots
Three One One
(311)
Thunderbird
Thunderbolt
Togetherness
Tools
Tornado or
Hurricane

Treble Clef
Triangle
Tribal
Tribal Mask
Triskelion
Twelve
Two
UFO
Union Jack
Urn
V for Victory
Vampire
Venus of Willendorf

Viking Dagger
Vikings
Violin Sound
Holes
Volcano
Water
Waterfall
Well
Wild at Heart
XXX
Zig-Zag Man
Zipper

MYTHIC

The human imagination is a rich place from which to mine images for use in tattoo, as has been done since some of the earliest attempts at representational tattoo that we have, most notably the mummies of Pazyryk. But we can easily look to the present day for this type of imagery as well. The most commonly tattooed of the mythic creatures would likely be the dragon, both in the East and West, conjuring all manner of associations with either evil or good, water or sky, persecutor or protector. In addition, though, are the myriad and varied epics of the Norse, the Greeks, the Celts, the Japanese, the Maya, and numerous other peoples that are populated with both mythic creatures as well as fantastic places and people. Nor should we overlook the smaller folk such as the fairies, goblins, and leprechauns. Mythic images from our fantasy worlds are as instantly recognizable to us as those from the real world and they carry the same symbolic weight, if not more.

Amazons
Bacchus
Castle
Centaur
Cerberus
Cupid
Eagle Eating
Snake

Elf
Fairy
Father Time
Genie in the Bottle
Gnome
Goblin
Godzilla
Green Man

Griffin
Hermes Wing
Hydra
Icarus
Janus
Leprechaun
Lilith
Lion with Sword

Medusa	Pentagram with	Unicorn
Mermaid	Moons	Valhalla
Merman	Phoenix	Warrior
Minotaur	Rome	Werewolf
Nymphs	Satyr	Witch
Pan	Thor's Hammer	Wizard
Pegasus	Trident	Yggdrasil

NATIVE AMERICAN

Native American tattooing, referring to the region of the New World sometimes called the Americas, strikes an interesting combination of both traditional images that were used before European contact and taking an art historical approach that uses all manner of pre-Columbian art as inspiration for tattoos. The tattoos of the Pacific Northwest peoples, such as the Haida, are now a popular group of images used by people from numerous other traditions who admire the stylized, bold, and high-contrast designs. At the same time, much tattoo artwork involving Central and South American themes uses both the carved and painted images left by the artisans of prehistory, such as tattoos of the Aztec Calendar Stone. In North America, though, while images of tomahawks, peace pipes, medicine shields, and dream catchers are certainly not uncommon, there are also a great number of depictions of Native Americans themselves. It is a prevalent practice, especially in the United States, to view the indigenous peoples who first lived in North America as somehow more connected with the earth, more noble, and more honorable. It is a romantic notion that plays upon some real characteristics of these early peoples but adds to it their tragic recent history, which resulted from European and American expansion. Ironically, the often seen tattoo of a Plains warrior wearing a feather headdress (as well as the buffalo, etc.) has actually become emblematic of something authentically American.

Aztec Calendar	Buffalo Spirit	Peace Pipe
Stone	Dream Catcher	Quetzalcóatl
Aztec Eagle-Knight	Indians	Tezcatlipoca
Aztec Sun	Kachina	Tomahawk
Buffalo Skull	Medicine Shield	Zuni Fetish

PACIFIC NORTHWEST

In a rare exception to the rule that much of indigenous tattoo in the New World was stamped out or swept away with the influx of European culture, a few tattoo symbols were collected from the various groups in the Pacific Northwest of North America. Part of a much larger complex of imagery and symbolism, the highly abstract designs of this region have attracted the interest of modern collectors of art as well as the art historian. Below are some of the symbols used in tattoos of both the past and present for which we have some traditional definitions.

Bear (Haida/ Kwakiutl)
Cod (Haida)
Dogfish (Haida)
Eagle, Double- Headed (Haida)
Evil Spirit (Haida)

Frog (Haida)
Grizzly Bear (Tlingit)
Killer Whale (Haida)
Owl (Haida)
Raven (Pacific Northwest)
Sísioohl (Kwakiutl)

Skate (Haida)
Squid (Haida)
Sun (Haida)
Thunderbird (Pacific Northwest)
Whale (Pacific Northwest)

PINUP GIRL

The pinup girl became a staple of World War II soldier and sailor locker doors, where photographs and posters of glamorous women were "pinned up." These images of bathing beauties, and also nudes, made their way most famously into airplane nose art. However, they have also become an ever popular staple of the tattoo industry.

Bettie Page
Betty Grable
Cowgirl

Devil Girl
Gibson Girl

Hula Girl
Sailor Girl

POLYNESIAN

Polynesian types of tattooing became immensely popular in the 1990s and many have been grouped together and modified in a style known as tribal. Spurred on by a resurgence of cultural identity and pride as well as demand and appreciation in the West, the tattoo designs of the Pacific islands have spread far and imbedded themselves in all manner of tattoos that are not strictly or solely tribal. Animals, names, crosses, flowers, and

Jesus all have lent themselves to a tribal treatment, which essentially consists of a solid black design based on bold arced lines that generally end in curved flourishes. Although much of traditional Pacific island tattooing is geometric, such as that of Tahiti or Samoa, designs are also sometimes representational, as in Hawaii, or full of spirals, like those of the Maori. The tribal style of the West hearkens back to all of these motifs and yet does not necessarily imitate any single one of them specifically. The wide geometric similarity of the styles in the islands is likely dictated by their shared tools, which resemble small rakes that are tapped with sticks or small mallets. The rakes' linear row of teeth is repositioned on the skin and then tapped to create lines and triangles and combinations of these that larger designs use as building blocks. Traditional Polynesian or tribal tattooing has found a global audience, though perhaps it is still most popular in the areas from which it originated. In those areas, tattooing is today seen as a way to demonstrate connection with the past, pride in culture, and disregard for the views of the West, which once did its best to see the practice of tattooing put to an end. The following are some traditional Polynesian symbols with their associated meanings.

Arai Te Uru	Hei Tiki	Niho Mano
Aso	Hoaka	Octopus (Rapa Nui)
Birdman	Koa'e Kea	Peahi Niu
Borneo Rosette	Koru	Tiki
Frigate Bird	Moai	
Hawaiian Bird Motif	Mo'o	

PORTRAITS

Portrait tattoos fall into two main categories: memorials and famous people. In most instances of portrait work, famous people are drawn from all ranks of life and mythology and are selected to represent something special to the bearer of the image. These famous people typically include rock stars, movie stars, and sports heroes but also images of the Dalai Lama, Abraham Lincoln, or Charles Lindbergh. At times, these portraits of famous people might also be memorials. More often, however, portrait tattoos of private people are memorials, permanent reminders of departed loved ones. Portrait tattoos can be almost photo-realistic since they are generally based on actual photos and they are nearly always done using a

black fine-line approach. A list of the famous people who populate portrait tattoos could fill a book in itself and, as with cartoon characters, their interpretation is largely a matter of familiarity with the achievements of the person and is not necessarily symbolic. Only a few examples are given.

Beethoven, Great Omi Lincoln, Abraham
 Ludwig van Guevara, Che

PRISON/GANG

Prison and gang tattoos have a reputation for being crude, although this is certainly not true of them all. While many of them are done under less than ideal circumstances and with unconventional tools, prison tattoos at times achieve high levels of artistic achievement and they are certainly charged with symbolism. They can be composed of images that are typical of a person's heritage and hence race. They also frequently have to do with the crimes for which an inmate is serving time and are also simply representative of the prison experience. Conversely, gang tattoos are typically not elaborate and are performed expediently. For a gang member the main purpose is one of group identification and affiliation and lettering is a major component of these types of tattoos.

Aryan Brotherhood	Hourglass	Teardrop
BC	One Eighty-Seven	Thirteen and a Half
Brick Wall	(187)	(13½)
Chollo	Prison Bars	Tombstone with
Clock	Sombrero and	Numbers
Crips	Bloody Dagger	Vice Lords
Dagger and Skull	SUR	
Guntower	SWP	

RELIGIOUS

In the modern world, religions have crossed national and geographic borders and find expression in a stunning variety of tattoos. Any artistic style is likely to be used to portray a design with a religious theme. Be they Muslim, Christian, Coptic, Hindu, Buddhist, Jewish, or others, many people

publicly proclaim their faith with a tattoo. These designs may range from a tiny cross to a large back piece of the entire crucifixion scene or from the Sanskrit syllable om to a large portrait of the Buddha on a lotus. Some religious tattoos are a protective measure to ensure a good life or entry into an afterlife, while others are a form of proselytization. Many times religious tattoos are done with the conventions that mark them as expressions of the sacred, such as a halo, mandorla, or simply a somber treatment.

Angel
Bhimsen
Cherub
Conquering Messiah
Crescent Moon with Star
Devil
Ek Onkar
Emperor
Empress
Eve
Fool
Hand of Fatima
Jacob's Ladder
Kalachakra
Lotus
Mandala
Mandorla

Menorah
Pagoda
Praying Hands
Protection Against Evil
Rastafarianism
Rosary
Rosy Cross
Shaman
Star of David
Star of Ishtar
Tetragrammaton
Totem Pole
Voodoo Doll
Wings
Witchcraft
Yin-Yang

ZODIAC

Many cultures adopted the use of a zodiac, including Babylon, India, Egypt, Europe, China, and Tibet. The study of the stars, planets, sun, and moon and their alignments has spawned symbols based on those astrological arrangements and their associations with life on earth. Animals, mythical beings, and abstract symbols combine to represent the cosmic and psychological elements that are the concern of astrological interpretations. Today, the symbols that are most used are those associated with the zodiacs that have come down to us through Europe and China. Each one of the individual signs, representing certain periods of time in each tradition, is characterized by a variety of symbols. Tattoos exploit all of these,

used individually or in combination, sometimes portraying the entire circle of symbols.

Aquarius	Leo	Taurus
Aries	Libra	Virgo
Cancer	Pisces	Zodiac
Capricorn	Sagittarius	Zodiac (Chinese)
Gemini	Scorpio	